TV News Anchors AND Journalistic Tradition

PETER LANG
New York • Washington, D.C./Baltimore • Bern
Frankfurt • Berlin • Brussels • Vienna • Oxford

KIMBERLY MELTZER

TV News Anchors AND Journalistic Tradition

How Journalists Adapt to Technology

PETER LANG
New York • Washington, D.C./Baltimore • Bern
Frankfurt • Berlin • Brussels • Vienna • Oxford

Library of Congress Cataloging-in-Publication Data

Meltzer, Kimberly.
TV news anchors and journalistic tradition: how journalists
adapt to technology / Kimberly Meltzer.
p. cm.
Includes bibliographical references and index.
1. Television journalists—United States.
2. Television broadcasting of news—United States. I. Title.
PN4784.T4M45 070.1'95—dc22 2009046845
ISBN 978-1-4331-0896-9 (hardcover)
ISBN 978-1-4331-0895-2 (paperback)

Bibliographic information published by **Die Deutsche Nationalbibliothek**.
Die Deutsche Nationalbibliothek lists this publication in the "Deutsche
Nationalbibliografie"; detailed bibliographic data is available
on the Internet at http://dnb.d-nb.de/.

Cover image: CBS "Evening News" anchor Katie Couric, NBC "Nightly News"
anchor Brian Williams, left, and ABC "World News" anchor Charles Gibson
are interviewed on the NBC "Today" show in New York Wednesday May 28, 2008.
(AP Photo/Richard Drew) Reprinted with permission of the Associated Press.

The paper in this book meets the guidelines for permanence and durability
of the Committee on Production Guidelines for Book Longevity
of the Council of Library Resources.

© 2010 Peter Lang Publishing, Inc., New York
29 Broadway, 18th floor, New York, NY 10006
www.peterlang.com

All rights reserved.
Reprint or reproduction, even partially, in all forms such as microfilm,
xerography, microfiche, microcard, and offset strictly prohibited.

Printed in the United States of America

To my family

Table of Contents

Preface	ix
Acknowledgments	xi
CHAPTER 1: Introduction	1
CHAPTER 2: The Emergence of Television Journalists and the Rise of the Anchor	13
CHAPTER 3: Appearance, Personality, and Emotion of Newsroom Anchors	49
CHAPTER 4: The Impact and Consequences of Anchors' Appearance, Personality, and Emotion	95
CHAPTER 5: How Journalism Restores Order When Its Borders of Practice Are Crossed	147
CHAPTER 6: Conclusion: What Community Discussion about Anchors Reveals about Journalism	169
Appendix 1	181
Appendix 2	185
Bibliography	187
Index	211

Preface

The merger of television and journalism is a struggle that has raged for over five decades between the journalistic community and its traditional standards, practices and values and the novel elements that television has introduced into journalistic practice. At present, this struggle rests in a stalemate. Neither television journalists and executives nor the larger journalistic community of which they are a part will concede their ground. This book traces the parameters of that struggle as seen through the lens of TV anchors over the half a century that it has been waged. It argues that while many of the features of television journalism are the cause of resentment and disapproval by the greater journalistic community, the positive aspects of these features and the opportunities they afford for journalistic authority and attention are cause for them to be tolerated by the larger community. Through this arrangement, the relationship between TV journalism and the journalistic community, while tense, is sustained.

If we believe that journalism is instrumental in a democracy which values an informed citizenry, diversity of opinions, and checks on leaders and power, then it follows that it is important to know how this essential institution functions. In the United States, the processes which govern the development and maintenance of journalistic norms and practices are largely internal. It is only by peering into this internal realm that we can fully understand the inner workings of the field and its practitioners, and how they are influenced by, and themselves influence, outside forces.

Acknowledgments

At The Annenberg School for Communication at the University of Pennsylvania, I would like to thank Barbie Zelizer for her wisdom, vision and direction on the project which became this book. Along with Barbie, I would also like to thank my esteemed advisors, Michael Delli Carpini and Elihu Katz, for shepherding me through to the completion of this project. Thank you also to the entire ASC faculty and staff, past and present, including Beverly Henry, Karen Short, Julie Sheehan, Donna Burdumy, Regina Medlock, Carmen Renwick, Lizz Cooper, Kyle Cassidy, Aaron Simmons, Suzanne Faubl, Deb Porter, Rich Cardona, Sharon Black, and Mirka Cortes. Thank you to my classmates and friends.

I have eternal love and gratitude for my wonderfully supportive family. A special thank you to my brother, Jason, for providing valuable advice.

In the Communication, Culture and Technology program at Georgetown University, thank you especially to Michael Macovski and Diana Owen for their guidance on aspects of the book publishing process, and all of my CCT colleagues for their encouragement.

At Peter Lang Publishing, thank you to my editor, Mary Savigar, Sophie Appel and the production staff, and reviewers of the manuscript. I am so pleased to see this book come to fruition in your capable hands.

Chapter 1
Introduction

This book has been a long time in the making. The seeds of interest in understanding the network television news anchor phenomenon were planted well before I began my graduate studies. When a 22-year-old who has visited New York City only a handful of times lands her first job out of college as Katie Couric's assistant at the *Today* show in Rockefeller Center, the experience makes a lasting impression—one so strong that it sticks with her in academe until she eventually finds a way to turn it into a scholarly endeavor. After working closely with other anchors, I observed that while the job entailed some of what I thought of as "real" journalism, it also entailed many things that, to me, were not.

Thus it was by an uncanny coincidence that the realization of this project coincided with a period of unparalleled upheaval in network television news. Upheaval took place on all possible fronts: heralding the transition into the third generation of the network nightly news anchors, a flurry of press surrounded Brian Williams' replacement of Tom Brokaw at the helm of NBC's *Nightly News*. For the better part of a year (2005–2006), speculation abounded as to what long-term shape CBS *Evening News* would take, such as the possibility of CBS experimenting with a multi-anchor or rotating anchor format on the evening news (Carter & Steinberg, 2005), until veteran newsman Bob Schieffer succeeded Dan Rather on an interim basis before Katie Couric was named as a permanent replacement in April 2006. Prior to that, commentators believed that "the marquee matchup" would remain between Brian Williams and Peter Jennings (Steinberg, 2005d). However, with Jennings's passing from lung cancer, ABC scrambled to find a successor and emerged with not one anchor but two. Young and attractive, Elizabeth Vargas and Bob Woodruff were paired to anchor ABC's *World News Tonight*. However, less than six months after the pairing, with Woodruff recovering from serious injuries sustained while on assignment in Iraq and Vargas preparing for maternity leave, ABC named Charles Gibson the sole anchor of its evening newscast. In the same year, Ted Koppel departed ABC *Nightline* in December 2005 (Steinberg, 2005), and since

signed on as a columnist for the *New York Times*, an editor for The Discovery Channel and a contributor to National Public Radio. In March 2006, Mike Wallace announced his retirement from *60 Minutes*, and Anderson Cooper replaced Aaron Brown on CNN. By early 2008, after less than 2 years in the post, Katie Couric's departure from the failing *CBS Evening News* was considered "imminent." Dozens of magazine covers, newspaper front pages and television programs bellowed each announcement. These announcements in turn, sparked an outpouring of journalistic discourse that asked what it all meant and then debated the possibilities offered. In sum, 2005–2006 was a period teeming with changes in the network television news landscape.

For a researcher of this timely topic, the ongoing announcements of new developments and deafening hubbub about the anchor changes were a mixed blessing. While they affirmed my belief in the importance of studying television anchors as a phenomenon that is very much alive in contemporary discourse, they instilled a fear faced by any researcher of a subject that is continuously unfolding and in flux: How do we keep up? How can we make the research current and definitive when there is no end point? But then, in the course of my research, I realized that discourse on TV anchors is as old as their existence, and it manifests itself in patterned ways around central themes. I also realized that the discursive patterns associated with community maintenance and change are relevant to the journalistic community in reference to a wide array of subjects beyond the negotiation of community boundaries. And after much thought and toil, it became clear that what I sought to accomplish in my project was not a running record of the day-to-day goings-on in television journalism but answers to much broader and enduring questions. Why do television news anchors cause such a stir? Perhaps they capture so much attention because they are vested with a special and powerful role in American democratic society—they keep us informed. But if this were the key reason, why wouldn't print and radio journalists command equal attention? Maybe the reason television news anchors receive so much coverage in the media is that they are easily accessible to the public. One does not have to be an expert or an insider to feel qualified to read, understand and talk about the goings-on of anchors. I discovered this as soon as I began to tell friends and acquaintances about my project. Ordinary viewers who simply *watch* a television newscast come to feel as though they *know* the people who tell them the news. So the press

writes about anchors for the public interest, and network TV anchors are among the few journalists who are known to the public on a national scale. But beyond piquing the public interest, the media have a second, at least as important, audience for whom they cover anchors. It is an audience of peers—fellow journalists and others within the field. This is where the real dialogue about television journalism takes place. It is in discussions with the audience of fellow journalists that the interesting "dirty laundry" of the community is revealed. It is through this dialogue that it is possible to search for answers to the question: Why and how has the journalistic community coped with the complexities that the advent of television brought to journalists' jobs over the past fifty years? This is what all of the talk about anchors is really about: the community of journalists trying to deal with a complicated partner.

The Subject of Study

Throughout the evolution of journalism, members of the American journalistic community have developed ways of dealing with changes in the work environment by discursively articulating and negotiating the boundaries, norms and values of the profession in the face of these changes. While many types of changes occur, the journalistic community's adaptation to technology is particularly important because it shapes the form that the news product takes and the routines and practices that journalists develop to create that product. New technology presents opportunities and challenges to journalists: they must find ways to transform their craft to accommodate the new medium but also incorporate and preserve the community's existing identity, values and function.

Journalism's adaptation to television fundamentally changed the nature and shape of journalistic work. Television changed the way that news is produced, received and regarded. It privileges visual imagery and marks a change in the relationships between journalists and their audiences, the media industries in which they work, and their fellow journalists. At the same time, the journalistic community has clung to principles and practices from earlier forms of journalism—print and radio. The journalistic community has never fully come to terms with the elements that television introduced into the journalist's job, and the community has haggled back and forth over the elements that constitute journalism in the fifty-odd years of the television era. This struggle between old and new has been compounded by

the added competition from new news organizations, other advances in technology, and a changing cultural and political landscape in the United States and the world.

This book is about the elements of the television journalist's job that are unsettled within the American journalistic community and with which the community continues to grapple. Although some aspects commonly associated with the TV journalist, such as fame and heightened emotionalism, were already present to a lesser extent in previous forms of journalism, their amplification by the television medium has made them more obvious, and in turn, has brought them to the forefront of journalistic debate. Other elements such as a journalist's appearance became central to the journalist's job through the visual imagery of television, marking a departure from the attributes commonly associated with journalists more generally. These attributes have had far-reaching effects on many aspects of journalistic practice, and this book traces their reception and evolution as part of journalism. Of all those practicing journalism in the television era, the struggle between the time-honored principles of print and radio journalism and these new elements introduced by television is experienced to the greatest degree by the TV news anchors themselves. The television news anchor embodies the effect of television technology on journalism through traits associated with his or her visual presence, qualities related to personalization, and other aspects of a particular kind of relay of news to audiences. The melding of television technology and journalism, as seen in the form of the anchor on TV news, has rendered the anchor a useful type of journalist for addressing the shape of journalism more broadly. This is an important moment to consider, for when it comes to anchors, the journalistic community is schizophrenic; externally, it uses anchors for community promotion and reaps the positive benefits of power, adulation and affirmation of authority that anchors afford. But internally, the community feels that anchors undermine many key journalistic values. This book uses the anchor as a lens through which to examine the journalistic community's struggle brought on by the wedding of journalism and television technology. The discussions surrounding the anchors are important because they both reflect internally on the practice itself as well as externally on the journalistic community at large, and in this way they signal the broader shape of professional and technological adaptation among journalists.

The Interpretive Community Framework

My approach to this study follows from a particular notion of how American journalists are tied together as a collective through which they discursively negotiate, articulate and reassert their identity and authority as tellers of news. Some scholars have looked at journalists through the prisms of formal organizations (Weber, 1947; Blau & Scott, 1962; Born, 2004; Epstein, 1973). Others have examined them as professions (Freidson, 1984; Becker et al., 1987; Henningham, 1985). Still others have used the lens of occupations to consider journalistic work (White, 1950; Breed, 1955; Tuchman, 1972; Gans, 1979; Fishman, 1980; Tunstall, 1971; Klaidman & Beauchamp, 1987; Weaver & Wilhoit, 1986; Underwood & Stamm, 2001).[1] In each case, scholars have used the various prisms to address how journalists maintain their collective autonomy and authority through self-evaluation, adaptation and self-control against changing external circumstances.

While the different conceptualizations of journalists as formal organizations, professions and occupations may partly capture the nature of the journalistic collective, each falls short on some account. While journalists do behave like formal organizations by developing and voluntarily obeying procedures of conduct, there are no official rules or designs of a formal organization from which these procedures are derived (that is, except for government regulation which is external to the organization). What is missing from the formal organizations framework is the fact that the journalistic collective establishes and follows norms and practices precisely because of its lack of a recognized governing, rule-making body, and its need for legitimacy. The characterization of journalism as a profession is similarly flawed. Journalism does not seem to fit the professional framework's emphases on training, education and credentialing. The professional framework also ignores the relevance of journalistic discourse in determining what members of the journalistic community do and restricts our understanding of journalistic practice to those aspects of journalism emphasized by its particular view. Journalism has been characterized as a service-oriented field with a certain amount of independence and a mission to serve its "clients" who are thought to be the American public (Gans, 2003; The Project for Excellence in Journalism, 2004), but these characteristics are

1. For a detailed account of how scholars have talked about journalism, see Zelizer, 2004: 32-42.

not sufficient to achieve professional status. While "professionalizing" journalism may serve to lend status to the journalistic community and give its members a sense of control over their work, offsetting "the dangers inherent in the subjectivity of reporting," the professional and occupational frameworks neglect to recognize the means by which reporters arrive at shared constructions of reality, informally network and depend on narrative and storytelling practices (Zelizer, 1993a: 220). This is especially important in the collective of broadcast journalists and other journalists using new technologies for whom the professional ideals and norms that were originally developed in terms of print journalism must be adapted.

Rather than conceptualizing a community as a profession, Zelizer (1993a) borrows from anthropology, folklore and literary studies in suggesting that a more fruitful way to conceptualize some groups may be as interpretive communities, "united through...shared discourse and collective interpretations of key public events" (19) that help members determine what is appropriate practice. Although these organizations may be bureaucratic or corporate by typology, their members still behave as folkloric communities that use their own talk about themselves to keep themselves in line.

This study follows Zelizer's lead in viewing journalists as interpretive communities. Viewing journalists as an interpretive community brings the lens closest to journalists' own conceptions of themselves in the examination of the journalistic collective and looks at journalists in terms of what they actually do and how they talk about it. Interpretive communities are characterized by common modes of interpretation of their social worlds. Interpretive communities act as cultural sites where meanings are constructed, shared, and reconstructed by members of social groups in the course of everyday life (Berkowitz & TerKuerst, 1999). Similar to other studies (Meyers, 2003; Berkowitz & TerKuerst, 1999; Berkowitz, 2000; Kitch, 2003; Cecil, 2002; Brewin, 1999; Lindlof, 1988; Fish, 1980)[2] that have employed the interpretive community framework, this study explores the ways in which journalists have understood and articulated their professional and social roles over the years through stories that they tell about their own work, its significance, and its relevance to larger cultural and social narratives. At the heart of such stories is an ongoing process of

2. Although the idea of interpretive communities was originally developed in reference to audience groups and consumers (Fish, 1980; Lindlof, 1988), it has since been applied to other types of groups including producers of cultural products such as news.

establishing and maintaining the collective.[3] As Schudson (1982: 111) wrote, the talk of journalists is a critical process of consensus formation. "The group becomes a brotherhood that influences and colors, beyond any individual resistance to prejudice or individual devotion to fact, all of what [journalists] write."

I found the interpretive community framework most useful in thinking about how notions of appropriate characteristics and behaviors of TV journalists are batted around through mediated journalistic discourse. Journalists are an example of an interpretive community formed in conjunction with, and continuously adapting to, communication technologies in the environments in which they work. TV news anchors in particular are a product of journalistic adaptation to the television medium. In that the modes of adaptation were not forced on the journalistic community by mandate, members of the community developed ways of dealing with new environments through informal discussions. In this way, journalists' discussions of changing practice help shape the format and content of journalistic output.

For this reason, this book tracks existing discussions about journalism, and specifically about anchors, to uncover what they reveal about the changing values, codes of behavior and boundaries of the journalistic community. This is accomplished primarily by examining written materials from the popular press and trade press, scholarly literature,[4] memoirs, network archives, organizational proceedings, and intermittent broadcasts

3. Other work has been done on the news media's self-criticism, but it is not talked about in the context or framework of interpretive community discussion that discursively maintains and reasserts norms and boundaries. Instead it is discussed as "self-reflexive news media reporting" (Haas, 2006: 351; Bishop, 2001: 23), "journalistic metacoverage" (Haas, 2006: 352), or "boundary work" and "self-coverage" (Bishop, 1999; 2001). Bishop (2001: 23) suggests that journalistic self-examination is a kind of ritual sacrifice, performed in the hope that it persuades the audience to regain its faith in journalism and to sustain ratings and readership. This supports Zelizer's (1997: 17) contention that journalistic self-reflection is also designed to deflect potential external criticism and distrust.

4. Scholarly accounts and critiques of television news, anchors, and journalism more generally, constitute another sort of meta-discourse about journalism. While some of these scholars themselves are not actual journalists, their meta-discourse is part of the larger discussion through which the journalistic community self-monitors. As such, it provides added context and critical and often historical perspectives that other journalistic accounts lack.

themselves from the 1950s onward. A sample of the discourse on anchors from each decade was examined until a "saturation" point was reached (Glaser & Strauss, 1967). Appendix 1 provides information on how the sample was constructed. All of this is tracked as well through interviews with journalists and other employees of media organizations. A listing of all personal interview information can also be found in Appendix 2. In total, over 900 articles, transcripts, books and broadcasts were examined.

It is important to note that in referring to the 55 years of ongoing discussions from which I sample, I widely construe the meaning of "internal conversations" among members of the journalistic community as the following: while one media columnist or reporter who covers the media beat, writing about anchors or TV news, may not be directing his written speech toward a particular person, a conversation can still be said to be taking place more broadly to which this individual media writer is contributing. The fact that this is a journalist him- or herself using a forum such as a newspaper or trade publication to critique, praise, or question a practice or event means that this media writer, as a member of the journalistic community himself, is engaging in a dialogue about the craft with other community members—the internal audience—and the public— the external audience. So while this may not be a conversation in the sense of speaking face to face, or one on one, it certainly is still a conversation. The archival research mostly from print publications is used to this end, to demonstrate that this type of community discussion through the venues I have delineated has been ongoing since the beginning of TV news in the 1950s. In this sense, this book directly engages in analyzing a "conversation" that has taken place among journalists.

The question of how to adapt to technology has been around since the inception of journalism, but its relevance to the evolution of television technology is commonly dated to 1941 (Barnouw, 1975). The fact that twenty years later, in the early sixties, the stature of television news was still being debated (Zelizer, 1992) and continues to be debated today more than sixty years after its advent, is evidence of how ongoing discussions about adaptation really are. According to Zelizer (1992), though print was still viewed as superior to television, by July 1964, the summer following Kennedy's assassination, "television journalism had emerged as a powerful force in American life and politics" (28), and "[b]y the late sixties, television had come of age as the preferred medium for news" (29). Journalistic discussions about technological advances and institutional changes worked to

bring about these changes. By most accounts, television journalism reached its pinnacle in the eighties, as measured by audience levels never before reached and unmatched ever since. Subsequently, a quickly changing technological and cultural landscape that outpaced the journalistic community's speed at which it could adjust, led up to its recent state of public unrest.

Carey (2000) argues for the importance of understanding journalism as "independent of, or at least orthogonal to, technology" (129), although he grants that the full development of journalism was technologically dependent. Journalism, he writes, is a historically situated social practice rather than a machine or a medium or a publisher or a business organization. It is an evolving practice and a cultural act. "Journalism is a peculiar way of using these technologies rather than the technologies themselves" (130). Technologies are means or instruments with which journalism is practiced. Although discussions within the interpretive community of journalists date more broadly than just to television, having originated in the days of print, fifty years ago, discussions within the interpretive community of journalists began to shape the ways in which journalists adapted their craft to the television medium and made use of the new technology Ever since then, the community has continued to debate, praise and critique the ways that television journalism works.

Some scholars have set out to investigate whether changes in technology influence changes in other journalistic practices, such as the reliance on, or inclusion of, official sources in event-driven news stories (Livingston & Bennett, 2003) or whether the application of technology in news organizations leads to a lowering of the quality of content (Ursell, 2001). In some cases, these studies find that even with new use of technology, other journalistic practices do not change. In other cases, while there may be consequences of the technology, these consequences are not due to technological innovation alone but rather innovation as mediated by the political-institutional role allocated to organizations, their economic and organizational characteristics, their corporate aims (Ursell, 2001), and discussions among journalists in the community.

So in the examination of journalism's adaptation to television technology, one must consider the mediating forces within a particular journalism organization as well as across television news organizations: "While it is true that a new technology can condition politics and society, a

new technology appears and comes into use only in certain political and social circumstances. The way the technology is used has a relation to, but is not fully determined by, the technology itself" (Schudson, 1982: 97). Viewing news organizations as cultures that are created and sustained and which socially construct and enact their own shared realities may be one effective way of trying to understand the role that technology has played and continues to play in those organizations (Morgan, 1986: 131). Jackaway (1995: 4) explains that beyond struggles of economic survival, the battles between media employing old and new technologies are about new media threatening an established medium's institutional identity, institutional structure and institutional function, all of which make up the organizational culture. Here, the question to ask is how communities adapt new technology to their cultures or are forced to change their cultures to accommodate the technology. This project uses the interpretive community framework of journalists to examine how journalistic adaptation to television technology was shaped and why that adaptation modified journalistic practices in some ways that have proved controversial to the community.

Organization of the Book

In the following five chapters, this book explores the impact that television has had on what is valued in journalism, how one becomes a journalist, who is counted as a journalist, and who is believed as a journalist.

Chapter 2 establishes the context against which television news anchors emerged. It also traces the discourse among journalists about the elements that television introduced into journalism.

In Chapter 3, I discuss three elements that became key dimensions of the television journalist's job (appearance, personality, and emotion) and the ways in which these elements have conflicted with preexisting journalistic values and norms. The discussion is accompanied by an analysis of the contradictory ways in which the interpretive community of journalists has struggled to reconcile these elements that are incompatible with tenets of their craft and the reasons behind the community's split sentiments.

Chapter 4 explores how the three dimensions of appearance, personality and emotion figure in the anchor's signature persona. An offshoot of this unique signature is the fame of TV journalists, which has proven controversial to tenets of the journalistic community. This chapter also traces the links between the unique characteristics of TV journalists' jobs and

journalism's cultural authority and their impact on TV journalists' salaries and their selection and promotion.

The occasions on which television journalists violate community mores and etiquette, and the ways in which the community has dealt with these violations, are the subject of Chapter 5. Using case studies and theories of paradigm repair to explicate this process, I analyze the reasons that certain actions by TV journalists have been seen as breaches of community norms, while others have been sanctioned. Additionally, I demonstrate how these reasons are offshoots of the conflictual ways in which the journalistic community regards the four elements I've delineated as unique to the TV journalist's job.

In Chapter 6, I extrapolate from the discussion and analysis of the data to address the role and impact of television for journalism, with specific address to anchors. I also provide a refined recapitulation of the study's movement through its core arguments.

Although the opinions expressed in community discussions about journalism are often in conflict with each other, journalists talk about journalism in patterned ways. Whereas previous surveys and studies have asked journalists about their values and roles (Ferri, 1989), this study analyzes how journalists talk, broadcast and write about anchors as a means to uncovering their perspectives on TV news. The news anchor game of musical chairs that has recently taken place is changing the familiar television news landscape of the past 30 years. These changes make a study of news anchors particularly timely by illuminating our understanding of the news anchor's role and positioning within the American journalistic community.

Chapter 2
The Emergence of Television Journalists and the Rise of the Anchor

The journalistic community's transition from one technology to the next has always been rife with challenges and opportunities. As difficult as the transition from print to radio was for journalists, so too has been the transition to television. For this project, it is important to understand how the interpretive community of journalists has responded to the innovations ushered in by the television era, for as Schudson (1982: 98) observes:

> the power of the media lies not only in its power to declare things to be true, but in its power to provide the forms in which the declarations appear. News…on a television has a relationship to the 'real world,' not only in content but in form; that is, in the way the world is incorporated into unquestioned and unnoticed conventions of narration, and then transfigured, no longer a subject for discussion but a premise of any conversation at all.

The principles, practices and challenges of journalism in previous forms of media were carried over into the new context created by television journalism. The most tangible embodiment of this new context was the television news anchor. Fifty-five years after TV journalism's advent, journalists continue to wrestle with the problems that surfaced with the television news anchor. In that their discussions about the evolution of television journalism and the rise of anchors were shaped by historical circumstances, this chapter will trace the context against which television anchors have emerged and show how community discourse about the new elements of TV journalism developed in tandem.

The Early Years

In the days of print that preceded the invention of broadcast technology, journalists employed and relied on a number of routines and practices to ensure that they filled their pages, met their deadlines, and maintained their credibility as designated and disciplined conveyors of the news (Gans, 1979;

Tuchman, 1972, 1978; Hackett, 1984; Fishman, 1980; Sigal, 1973; Geiber, 1964; Molotch & Lester, 1974). Under the objective model of journalism that has been in operation for the past 75 years or so (Schudson, 1978), these routines and practices became codified through informal socialization in newsrooms (Breed, 1955), through oral and written community discussions and through membership in associations such as the Society for Professional Journalists.[1] Other professional associations such as the American Society of Newspaper Editors and the American Newspaper Guild issued codes of standards and practices to serve as informal guidelines for the field of newsgathering[2] (Jackaway, 1995: 47).

Among the assumptions that this print tradition of journalism entailed are that journalists should remain in the background of the events they covered and report stories from a detached and value-free stance. Ideally, the journalist stood apart from the event he covered—a mere transmitter of the events he witnessed (Hackett, 1984). He rose to a place among his journalism peers through on-the-job training and only through experience could he earn his journalism stripes. As Fishman (1980a: 111) wrote, "Good news practices entail going out in the world to get stories. Anything else is seen as a matter of crass expediency or downright cheating."

Within print news organizations, a chain of command operated in which reporters delivered stories to section editors, who, in turn, filtered stories and passed them on to editors-in-chief and managing editors with whom the ultimate gatekeeping power to select stories for publication rested (White, 1950). Across this hierarchy, responsibility for the story rested with all parties through whose hands the story passed, but it was the individual reporter who was expected to gather all information on which the story was based, assemble the story, and give it its form.[3]

1. SPJ is America's most broad-based journalism organization, founded in 1909 as Sigma Delta Chi. See: http://www.spj.org/aboutspj.asp
2. According to Jackaway (1995), The American Society of Newspaper Editors adopted the "ASNE Canons of Journalism" in 1923, the Associated Press put forth its own guidelines in 1928, and the American Newspaper Guild set its guidelines in 1934.
3. Barnhurst and Nerone (2001) point out in *The Form of News* that the print style of objective observation developed in dialog with the rise of picture technologies, and then later broadcast news furthered a kind of division of labor: print journalists turned to expert observation as pictures took over the job of description and broadcast media took over breaking news and storytelling.

In the first thirty-five years of the 20th century, journalists worked to adapt their print routines and practices to radio broadcasting. At the time, the transition from print to radio was seen as a colossal shift that threatened the established media, and that forced print journalists of the 1930s to come to grips with their identity in a changing communication environment (Jackaway, 1995). The new radio journalists, on the other hand, had to figure out how to hold on to the journalistic values from the days of print while modifying their routines and practices for radio technology. The advent of radio introduced several elements into the journalist's job that were not previously present in print journalism (Jackaway, 1995). These included attention to the instantaneousness of news—the decreased time between an actual news occurrence and the reporting of it on air, the tone and quality of the journalist's voice, the cadence with which news items were read, the inflections of voice, and how the journalist would begin and end the broadcast or transition from one item to the next. Much as television would, "radio violated the established codes governing the shape and nature of the acceptable news message" (Jackaway, 1995: 63). This new focus on the characteristics of the radio journalist reporting the story marked a shift away from a focus that was purely on the news story itself. It was the beginning of the conflation of the person reporting the news with the person *doing* the news.

During this time, the Columbia Broadcasting System (CBS) was building its news service, making the voices of Edward R. Murrow, Eric Sevareid and others known through radio while the conflicts leading up to World War II escalated (Barnouw, 1975). As newspaper reporters, audiences had little by which to identify particular journalists. These early radio journalists who had been trained in newspaper journalism first and worked without much notoriety for the printed press developed individual and recognizable styles in applying their skills to radio. The journalist's personal delivery style became his signature. Listeners developed a familiarity with particular journalists' voices and manners of speaking over the air. But not all print journalists rejoiced in the ability of radio journalists to parlay these new elements of the technology into success with listeners. Some felt the focus on making the broadcasts sound good to listeners' ears inappropriately upstaged journalists' true missions. According to Jackaway (1995: 63), print journalists took issue with the medium of radio itself, an aural medium by which news is conveyed through the spoken, rather than printed, word. Print

journalists offered several reasons for why the printed word was a "superior means of transmitting news and information" (Jackaway, 1995: 64). One of their supporting arguments was that radio appealed more to emotions and less to intellect, linking emotions and subjectivity with hearing and cognition and objectivity with reading (Jackaway, 1995: 65). The human voice was thought to possess a "magical" quality that appeals to "lower nerve centers" and creates "emotions which the hearer mistakes for thoughts" (Irwin, in Jackaway, 1995: 65).

During WWII, Murrow and his CBS colleagues, a team of reporters known as "Murrow's Boys," created worldwide "eyewitness" radio reports of the war from correspondents although initially the correspondents broadcast from overseas studios rather than locations (Winston, 1993: 182). This was the most significant form of American radio network news broadcasting throughout WWII (Winston, 1993: 183).

Whereas in print journalism, newspaper editors were the official gatekeepers of the organization, selecting and editing stories for publication, in radio, as would also be the case in television, the official gatekeepers were the producers, who performed an array of tasks. The role of the producer in radio, and subsequently in television, followed the notion of radio news as a production that took place in a production studio with an assembly process. Although it varied from program to program, radio producers were responsible for controlling the overall output of the program (skillset.org, 2003). From generating ideas to editing, they were involved in the entire process of broadcasting content for radio. They also acted as managers of teams of broadcast assistants, studio engineers, and reporters, and scheduling, scriptwriting and researching could also be aspects of the role (skillset.org, 2003). As well as fulfilling a creative role, producers could also be in charge of budgets and other business matters.

The Emergence of Television Journalists

Although television was operating full swing on a commercial basis by 1941, with WWII in progress, television and FM radio were stunted by a halt in the manufacture of receivers and curtailed schedules while AM radio continued unimpeded (Barnouw, 1975). As the war came to a close in 1945, the manufacture of television sets was approved, and in 1946, television sets went on sale (Barnouw, 1975). Journalists hardly had to alter their radio methods in the first attempts to televise the radio news. The earliest programs

were little more than radio journalists reading the news in front of a camera, sometimes accompanied by still photographs (Winston, 1993).

In 1948, NBC began its own in-house nightly production, taking over *Camel Newsreel Theater*, which was produced by sponsor R.J. Reynolds and a 20th Century Fox newsreel company (Winston, 1993). These "newsreel" programs contained compilations of film clips of news items spliced together. According to Winston (1993: 183), the professional newsreel producers and technicians were largely film industry personnel who "did not see themselves as journalists nor their product as journalism. There was little or no shared culture." One year later, the show was expanded to 15 minutes and became *Camel News Caravan*, fronted by John Cameron Swayze, and it lasted until 1957 (Winston, 1993). Swayze provided the introductions to, explanations of and transitions between the film clips presented. In contrast to other news broadcasters of the era who delivered reports in an "earnest and sober *basso profundo* imitation of Edward R. Murrow," Swayze's voice had a "flat, Kansas accent" and was "higher and noticeably more excited" (Alan & Lane, 2003: 57). CBS contracted with Telenews, a subsidiary of Hearst-MGM newsreel, for film, and began a regular nightly bulletin, *CBS News with Douglas Edwards*, in 1948 sponsored by General Motors. A precursor to current practices, Edwards, the newscaster, was "a speaking subject against an abstract map" (Winston, 1993: 187).

Although some accounts such as Matusow's (1983: 1) characterize the program hosts in these early years as "relatively humble figures who read the news," Winston (1993: 199) says that this characterization must be rejected, for newscasters actually had personal power over the broadcasts and were required to perform duties such as live voicing-over for considerable stretches of film and hitting one's marks when the program switched between shots of the studio to film and back that are much smoother and easier to navigate today.

The Emergence of Visual and Performance Aspects in TV Journalists' Jobs

Just as newspaper reporters in the 1930s watched the transition to radio journalism with anxiety and skepticism, print and radio journalists in the late 1940s were concerned with the inherent dangers of the new television medium. Some disdained TV in the beginning for its inferiority to radio in live coverage and mobility (Barnouw, 1975). Mirroring print journalists'

reactions to radio (Jackaway, 1995), print journalists like the *New York Times'* radio and TV critic Jack Gould (1955) and radio journalists such as Eric Sevareid, were now chagrined by TV's "emphasis on pictures" over words (Gould, 1955) and on the "journalistic circuses" orchestrated to attract TV audiences (Schumach, 1955). According to Barnouw (1975: 169):

> A favorite pronouncement of the day was that television had added a "new dimension" to newscasting. The truth of this concealed a more serious fact: the camera, as arbiter of news value, had introduced a drastic curtailment of the scope of news. The notion that a picture was worth a thousand words meant, in practice, that footage of Atlantic City beauty winners, shot at some expense, was considered more valuable than a thousand words from Eric Sevareid on the mounting tensions of Southeast Asia. Analysis, a staple of radio news in its finest days, was being shunted aside as non-visual.

Those working in television news learned that powerful and emotional pictures could override the voice tracks that gave the real information and lent context to the images that were only supposed to serve as illustrations.[4] And just as radio had introduced a new dimension into the journalist's job with the aspect of sound, necessitating a focus on the reporter's voice and delivery, the adaptation to TV added the visual aspect of the journalist and necessitated attention to one's physical appearance and body language.

It has been said that John Cameron Swayze, whose ability to memorize fifteen-minute news broadcasts enabled him to keep his gaze on the audience in a pre-TelePrompter era, introduced a level of eye contact that would become the standard for anchors (Alan & Lane, 2003). According to one account, in efforts to compete with Swayze, it was suggested to Douglas Edwards that he learn Braille so that he could read the news with his fingers and not have to look down at his script (Alan & Lane, 2003). Journalists became aware that their looks, facial expressions, mannerisms and demeanor all came into play with audiences who could *see* them on the screen. Now, not only could their voices portray an opinion or emotion, but their face and body could as well.

For journalists who had been schooled in the practices of newspaper reporting and lived by the community mantras of objectivity and detachment,

4. Jamieson (1992) discusses this phenomenon as "evocative visuals."

improper displays of emotion were violations of the journalism code. As reporter Eric Sevareid told the *New York Times* in 1955:

> You get a sense of power in television. It's like hanging onto the throttle of a locomotive. Everybody's watching you like a hawk. You mustn't betray the slightest emotion that shouldn't be there. People must get the feeling you're trying to be fair (Schumach, 1955).

Even when television journalists strove to hide their emotions, viewers could read into a journalist's natural habit—something as small as a raised eyebrow[5]—and mistake it for evidence of certain predispositions toward the story being reported.

The adaptation to color TV beginning in 1953 added yet another dimension of adaptation, necessitating more careful attention to one's wardrobe, makeup and set decoration. Powerful studio lighting made it essential for on-camera journalists and guests to wear makeup, lest they appear washed-out. According to Barnouw (1975: 272), Richard Nixon refused CBS' Don Hewitt's offer to have makeup applied before the Kennedy-Nixon debate in 1960 since Kennedy, who "had been campaigning in California and looked tanned, incredibly vigorous and in full bloom," had also declined. Nixon's advisers, worried about his appearance, applied some Lazy-Shave, a product recommended for "five o'clock shadow" (Barnouw, 1975: 273). The result was that Nixon appeared on TV as "haggard; the lines on his face seemed like gashes and gave a fearful look. Toward the end, perspiration streaked the Lazy-Shave" (Barnouw, 1975: 274). If one's shirt was wrinkled, a button missing or hair mussed, the audience would notice.[6] As former CNN anchor Leon Harris said, "You've got to batten all the hatches. The day you wear the shirt with the iron stain will be the day you have to take your jacket off" ("Picture-Perfect from the Waist Up," 1995). Some strategies anchors adopted to appear pleasant onscreen included sitting on one's jacket so it would not ride up, staying camera-trim by holding one's elbows in and avoiding colored shirts in the heat: "You can sweat like a pig in white...but in a blue shirt, everyone can tell" (Leon Harris in "Picture-Perfect from the Waist Up," 1995). Television, and now color television, had

5. For example, Rather says this happened to himself and Walter Cronkite (Rather, 1977: 275).
6. According to Barnouw (1975: 273), during the same 1960 debate, the shirt collar of Nixon, who had been ill and lost a few pounds, looked loose around his neck.

introduced aspects of appearance and performance into the journalist's job. Getting the story right and delivering it to audiences in a digestible way, which had previously been the journalist's sole task and focus, was now only one part of the job's demands. The television journalist had to come across as credible and likable to viewers at home, lest he be called too "business-like," "clinical," or "folksy" by critics such as Jack Gould at the *New York Times* in 1953. To some newspaper journalists, one of the most striking aspects of a television news broadcast was the fact that any single item could turn off a viewer, sending him or her to another channel. Whereas newspaper readers could browse through the newspaper looking for items that appealed to them and skipping those that bored them, viewers had no such freedom with television "so every item on a broadcast carries the weight of the entire program. One false step and you've lost a viewer, or a million of them" (Downie & Kaiser, 2002: 118).

As they adjusted to the television medium, news anchors began to constitute a particular kind of complication between what journalists ought to do and what they in fact do: "The skills of presentation are different than the skills of reporting...but the two come together during live events, and this is where you need someone with journalistic skills" (Peter Herford, who wrote scripts for Cronkite, in Paige, 1998: 9). Other members of the journalistic community clung to their belief that the television journalist should be permitted to "come to grips directly with the news" for he "at heart is a journalist, not a performer" (Gould, 1953). Despite these protests from print journalists such as Jack Gould of the *New York Times*, in their adaptation of their craft to television, journalists came to rely on and take advantage of the parasocial relationships that viewers form with television anchors (Reeves & Nass, 1996). Journalists quickly learned what research would eventually show—that the face-to-face appearance of television offers viewers an illusion of intimacy with on-screen performers (Horton & Wohl, 1956; Goffman, 1981; Mancini, 1988), and in particular, with viewers of newscasts (Levy, 1979; Rubin, Perse & Powell, 1985; Goodman, 1990). Over time, viewers become more familiar with media figures, and as this illusory intimacy grows, viewers willfully engage in pseudo-conversational exchanges with those figures, responding to them as they would in a typical social relationship.

The Emergence of TV Journalists and the Rise of the Anchor 21

TV journalists developed on-screen personas to connect with viewers that were sometimes markedly different from their off-screen characters.[7] They learned to use "discoursive strategies" to mimic face-to-face interaction. As Mancini (1988: 155) observed, the anchor looks into the camera, into the eyes of the viewer, speaking "directly and personally to each individual viewer, establishing a rapport with him which is falsely based on the myth of a real, interactive presence." Through these discursive strategies, anchors talk to an implied public through direct address. From their posts behind the anchor desk in the TV studio, they address the camera as though they were making eye contact with actual viewers in their homes.

Television provided the illusion that a real-time dialogue could take place between anchors on television and viewers at home, unmediated. As opposed to the newspaper where print journalists had to translate their observations and information into text that would be printed on the page, physically delivered to customers, and read by viewers at a delayed point in time, with television, there was no time delay, no mediating text or transfer of information and human contact from one medium to another.[8] It simply all happened in front of viewers' eyes instantly. This had been made possible to a lesser degree with the telephone and radio, but the important visual component that completed the illusion was missing. With TV, anchors, producers, directors and other TV news staff learned to manipulate the television medium in such a way as to make viewers feel as though they were peering in on the action, a party to a conversation taking place between the anchor, the viewer, and other reporters on location.[9] Aiding this illusion is the customary "throw" or segue to reporters on location. This whole process of creating the illusion of direct physical real-time address was foreign to print journalists who were used to their physical presence being hidden from readers behind the barrier of the page and the reader's own voice interpreting their words on the page. This shift toward the performance aspect of the journalist's job was problematic for the journalistic community as performance was not part of the original norms and practices ascribed to journalism. Again, it posed the risk of distracting

7. For example, see Dan Rather's discussion of Mike Wallace (Rather, 1977: 284).
8. Jackaway (1995: 5) observed this difference to be true of radio in contrast to newspaper journalism.
9. As suggested by Zelizer (1990).

journalists and audiences from their chief role, gathering and reporting the news. But they could not be ignored if television journalism was to succeed.

The political conventions in Philadelphia in 1948 were the first major event to be televised on a national scale (Matusow, 1983; Frank, 1991). By this time, between 14 and 17 eastern television stations were hooked up to coaxial cable, and as many as ten million people watched the conventions. However, until the mid-fifties, the evening news, which was only fifteen minutes long at this time, was treated as unimportant by the networks and the television journalists were regarded similarly. Television held little appeal for the newsmen themselves—"the action, the glory, and the money were still in radio" (Matusow, 1983: 43).

The dimensions of appearance and performance that television introduced brought a disjuncture in the standards that Murrow and his followers had set for admission into the broadcast news club. Although experience as a foreign correspondent and intellectual qualities had been prized, these were "not a passport to success in television, no matter how desirable they were in radio" (Matusow, 1983: 54). If one could not connect with the television audience, his journalistic training and smarts would not carry him in this medium; showmanship had become an essential trait for the TV journalist. Murrow was never comfortable on television; his television series *See It Now*, adapted in 1951 from its former radio version *Hear It Now*, was tightly scripted for him in advance (Matusow, 1983; Barnouw, 1975). Thus, even for previously successful journalists, in the new age of television, those who were unwilling or unable to adapt would be left at the wayside. For Murrow, as with other TV journalists, the TV producer became a central figure in the broadcast. As the producer of CBS' *See It Now*, Fred Friendly became as synonymous with the broadcast as Murrow himself (Epstein, M., n.d.). However, Friendly's public notoriety would not be the norm for television producers. Although the anchor and producer act as a team in the case of many TV news programs and are sometimes seen as equally responsible for the success or failure of the broadcast, it is the on-camera personnel who become publicly recognized, not the producers.

Changes in Journalistic Conventions

In order to assert their cultural authority and legitimacy, reporters learned to exploit the technology of the television medium through several techniques. Broadcast journalists developed formal qualities and conventions of news

reporting to follow when crafting and delivering stories. In doing so, they realized that the visual component of TV necessitated a different type of information relay. They discovered that the "language" of television consisted of a complex and transparent relationship between experience and narrative structure: "The raw historical event cannot, in that form, be transmitted by... a television newscast....To put it paradoxically, the event must become a 'story' before it can become a communicative event" (Campbell, 1991: 28).

The technology of television brought new restrictions and new opportunities to news coverage. Due to the difficulty in moving expensive and awkward television equipment, film crews tended to be centered in just a few locations, with certain places, such as Washington, gaining great emphasis in the news (Barnouw, 1975; Diamond, 1991; Epstein, 1973). This meant a reallocation of journalists and beats concentrated in these geographic areas as well as an increased focus on developing and maintaining source relationships in the seat of government and other places where crews were located. Additionally, the shift required a redistribution of news resources such as money, equipment and supplies to these select locales.

TV news brought other new forms as well—chronological accounts of the day's events and the spectacle and ritual surrounding an event (Campbell, 1991). With TV news, the inverted pyramid structure of storytelling was replaced by storytelling through narratives that helped to legitimate journalists' authority as credible tellers of events (Zelizer, 1993b). Other conventional strategies embedded in the television news process include presenting experience in terms of two conflicting points of view, eliminating overt value judgments, citing expert testimony through sound bites, and reporting the news through detached, invisible voice-over narration (Campbell, 1991). Because the simultaneous transmission of an event became possible with television, reporters began to vie with their TV audiences' own interpretations of events. In response to the changes in the nature of their jobs that television wrought, journalists established these conventions in order to continue to lay claim to professional virtues such as credibility, fairness and neutrality (Campbell, 1991). As Hallin (1986: 339) wrote, "television has always been torn between a desire to belong to the inner circle of serious journalism and its other identity as storyteller-moralist."

To bolster their authority, broadcast journalists also learned to employ presentation practices in constructing an illusion of proximity to the event about which they report. Just as print and radio journalists had developed their own techniques for accomplishing this, such as the use of a dateline, television journalists developed their own methods: each news story begins with a sense of place, and the journalist must align him- or herself in some way with the sense of place that is being communicated (Zelizer, 1990). This is accomplished in a variety of ways, such as through visual keyings ("slugs") that appear on the TV screen, or verbal keyings which establish the place of the event and the place of the reporter (Zelizer, 1990). As stories are retold on the news, video from an event is used to illustrate it, and the broadcast journalist performs the accompanying narration and contextualization. Because only a sliver of the total footage of an event is broadcast, the images selected are used to synecdochically symbolize the entire event (Epstein, 1973). The journalist's version of the story *becomes* the story and begins to displace the chronicle itself. With broadcast news, the journalist plays a larger role, to the extent that journalists become well known themselves rather than just the stories that they report. The story format becomes based on a single host capable of holding viewers' attention and dependent on images and dramatic narrative elements. The broadcast journalist projects a familiarity with interviewees and audiences, and a broader knowledge about the instances that are shown in the broadcast (Zelizer, 1990). In these ways, television journalists adapted and sometimes abandoned conventions that were unquestioned and generally unstated in print and radio journalism to become *storytellers* of news events.

The Role of the Anchor in the News Program's Production

In addition to the TV journalist who appeared on camera, many actors worked to create the news broadcast and assemble all of its components. Whereas individual journalists in the era of print were the primary constructors and overseers of the news product from beginning to end, in the new TV age, their role became much more specialized.[10] Although TV

10. Merton (1957) first discussed individuals' positions within a social structure as "role sets" in his larger discussion of role theory. He argued that there are a set of different expectations for any status within the structure (the "role set") and these expectations could come into conflict. Since then, others have referred to these role expectations in field theory as field effects (Martin, 2003).

broadened the journalist's role in terms of public visibility and the necessity to connect with viewers, it narrowed it in terms of relative control of news stories. For example, in 1949, Douglas Edwards "who wrote his own scripts, was supported by a full-time staff of sixteen and fourteen part-timers" (Winston, 1993: 186). As a 1949 *Editor and Publisher* headline put it, "148 Man-hours Produce 15 Minutes of TV News" (Walker, 1949: 50).

In television news, the program is a collective product involving many talents and decision makers, but "in American television it is the producer who frequently serves as the decisive figure in shaping a program. Producers assume direct responsibility for a show's overall quality and continued viability" (Saen, n.d.). However, producers' roles vary dramatically from show to show or organization to organization. According to the Museum of Broadcast Communications (Saen, n.d.), in some cases, producers are primarily business executives presiding over several programs, likely to concentrate on budgets, contracts, and troubleshooting, handing over day-to-day production to their staffs, and exercising control only in a final review of the newscast. Other producers are more intimately involved in the details of each newscast, participating actively in writing, set designs, and hiring. Still others serve as enabling mid-managers who delegate crucial activities to directors, writers, other staffers and on-camera personnel, enforce critical standards, and work to insulate the creative staff from outside pressures (Saen, n.d.). But rather than mere orchestrators of TV newscasts, some scholars consider the producer television's auteur, suggesting that shows should be considered above all extensions of the producer's individual, creative sensibility (Marc, 1989; Marc and Thompson, 1992, in Saen, n.d.).[11]

11. According to the Museum of Broadcast Communications (Saen, n.d.): "one sign that the producer is not an individual auteur is the multiplication of producer credits seen on American shows since the mid 1980s. Programs may identify an 'executive producer'" (sometimes the conceiver of the show's premise), "an associate producer, a supervising producer (who usually serves as head writer), a line producer (who oversees day-to-day production), or list any combination of these titles," all in addition to the regular "producer." "Such credits may reflect a complex division of labor established by the organization or packagers producing a show. They can also reflect the growing negotiating power of participants in a highly successful show, who, no longer content simply to write or act, wish to have contractual control over the assembly of entire episodes." "In any case, the proliferating credits suggest that 'producerly' authority is

However, a news program's anchor sometimes rivals the producer's or executive producer's control over the newscast. Since the beginning of the use of the term "anchorman" in regard to Walter Cronkite, the network anchor has also assumed the title of "managing editor" of the broadcast (Auster, n.d.). As anchorman of the *CBS Evening News* from 1962 to 1981, "Cronkite viewed himself as a working journalist, epitomized by his title of 'managing editor'" (Auster, n.d.). The co-title of managing editor was a way of linking the TV anchor to his roots in print journalism, where the managing editor of the newspaper used his news judgment and the principles of the craft to select, hone, and place news stories on the page. It was a way of signaling to the news staff and viewers that the anchor was more than a face on the screen; he was the brain behind the operation. All solo network evening news anchors to follow would also hold the dual titles of anchor and managing editor. When Katie Couric assumed the roles of anchor and managing editor of the *CBS Evening News* in 2006, Andrew Lack, former president of NBC News and NBC, pointed out on *The NewsHour with Jim Lehrer* that:

> Katie comes over with the managing editor's title, which to some people may not seem important on the face of it…in fact, the managing editor, along with the executive producer, sets what stories go in that broadcast; how much time each of those stories gets; the balance and sensibility of the program; how many stories; how long on each story. Yes, the lead is often obvious, but the rest of the program is discretionary, and Katie will influence that agenda. And that's key in that role. So it isn't just a presenter who links the stories together. It's an editor who decides on a nightly basis what is important in the day's news and what do we want to spend as much time as we can on that informs the American public on a nightly basis ("Katie Couric Moves to CBS," 2006).

In vying with producers and others for control of the newscast, anchors absolutely have authority and influence in the selection and lineup of assignments and stories. In some situations, anchors can make or break the careers of other news employees, including executive producers and

divisible and negotiable, not individual and singular—a construction emerging from institutional pressures and politics (though individual talents and preferences of course affect how a given person executes any institutionally-defined role)."

employees lower down in the pecking order (Matusow, 1983). It is also a mutual relationship between anchors and other news employees who are part of the decisions to assign stories. Often, an anchor will hear of a story and want it, or if an assignment editor or producer hears of a good story, they will want a particular anchor or correspondent for it. The degree to which the anchor is involved in the preparation for the news segment (which includes research, sometimes booking interviews with guests, and writing the news script) changes according to individual anchors and individual stories. An anchor may have little to no involvement in the story or program other than reading and performing the materials that have been prepared for him or her by others:

> Most Americans think that the anchors write their scripts. I remember for years people were surprised to know they just sit there and read...let's face it we've both worked with anchors before who can't handle unscripted stuff and I'm not gonna name names, but there are plenty of them that could never spontaneously deal with breaking news and couldn't write their own stuff (personal interview with G.B., veteran news booker).

Or the opposite may be true in which the anchor has a hand in a story from beginning to end: "Some of them do [their own legwork, write their own scripts]. Some [anchors] change it around" (personal interview with G.B., veteran news booker). It really depends on the level of anchor's interest, and the routines that all employees of the news program are accustomed to. Almost always, the anchor will have little to do with the technical, rather than content and style, aspects of the broadcast.

Even though anchors also hold the title of managing editor of a program, their level of involvement in a nightly newscast's production can vary. A very powerful anchor can exert enough pressure on a network's executives to have an executive producer hired or fired[12] (Traister, 2004; McClellan, 2004). The decision to hire an anchor is ultimately up to the network's head of the news division, the head of talent negotiations and other executives at the top of the organization's structure, all the way up to the president or

12. Several articles including Traister's (2004) suggested that Katie Couric was responsible for orchestrating the 2002 dismissal of former *Today* show executive producer Jonathan Wald. In 2004, *Broadcasting & Cable* reported that "some inside the network say Katie Couric is leading the charge" to have *Today* executive producer Tom Touchet canned (McClellan, 2004).

CEO.[13] When it comes to disagreements between executive producers, news heads and anchors, the one who is perceived as in the position of greatest power is the one who is contributing the most to the welfare of the network in terms of audience ratings, ad revenue and positive reviews.[14] So it is possible that an anchor in the midst of a bad PR scandal can be ousted (Dan Rather at CBS). On the other hand, an executive producer can also be credited with the success of a news program.[15]

As Goodman (1982) illustrates, anchors can also be just the packaging on the news story and have very little involvement otherwise. Of course, this has implications for respect of the anchor by other journalists, but one of the chief goals of the anchor in the eyes of the network is to attract viewers.

Whereas in print journalism, the individual reporter was largely responsible for the life of a news story from beginning to end, up until the point at which it reached the editor's desk, in television journalism, a nightly network newscast gets organized throughout the news day in an assembly line fashion. Its components pass daily through many hands through which the broadcast is gradually cobbled together (Ericson et al., 1987).[16]

Throughout the day, the various staff members of the news program review wire stories from the Associated Press, Reuters, UPI and other services, and watch and edit news feeds. There is a continuous back-and-forth exchange between these staffers and the show's executive producer (EP) and anchor, all of whom may "pitch" stories to be included in the broadcast (Ericson et al., 1987). Several production meetings will usually be scheduled throughout the day in-person or by conference call to staff members who may be located in other bureaus. During these meetings at which the show's team (including the EP, anchor, producers, production assistants and writers) is present, a program rundown is progressively formulated. A rundown is the second-by-second outline of the show's lineup

13. For example, Les Moonves, the CEO of CBS, courted Katie Couric for CBS (Johnson, 2005a).
14. Although it is assumed "that an anchor's popularity has a major influence on the ratings of the program he or she is attached to...it should be noted that during their time competing with each other, Rather, Jennings and Brokaw...each held every spot in the ratings competition, first, second and third" (The Project for Excellence in Journalism, 2005).
15. As was Jeff Zucker, formerly Executive Producer of the *Today* show on NBC (Bauder, 2007).
16. I also personally observed this process at NBC and CNN from 1999–2001.

and content. In tandem with its development throughout the news day, the writers, sometimes jointly with the EP, producers, or anchor, work to create the accompanying script. Sometimes hours in advance of the broadcast, and sometimes just minutes before, the rundown is finalized, and the scripts are prepared. When it is time for the broadcast to air, the show's director, EP or other producer, anchor, technical staff, and assistants take their places in the news studio. The producer, through a live connection to the anchor's ear, cues him or her to start, end, and transition through the different components of the broadcast. Although the anchor remains the central feature and face of the broadcast, numerous other people facilitate the program's production (Golding & Elliott, 1979).

Although anchors or correspondents themselves are most often thought of as TV journalists, in actuality, all of the news staffers take part in the televised journalistic process, each with very limited but interconnected roles.[17] As such, they are all part of the larger television journalism community and, more broadly, the American journalistic community. Again, the television news production process itself altered who was constituted as a member of the journalistic community. With print, journalistic identities seemed more straightforward; with television, they became more broadly construed. The recognition of these other members of the TV news production process as members of the journalistic community was another gradual and contested transition since TV's advent.

Marking this recognition, in 1952, what had formerly been the National Association of Radio News Directors (NARND) (and prior to that, National Association of Radio News Editors[18]), became the Radio-Television News Directors Association, dropping national from its title to include international members, primarily from Canada (Shelley, 1966). Other professional associations such as the National Association of Broadcasters that were first

17. Golding & Elliott (1979: 112) categorize those involved in the news production process as planners, gatherers, selectors and producers.
18. According to Shelley (1966), the change from news editors to news directors was made because from its start the organization was dedicated to the belief that professional news departments should report directly to station management; that the role of the news director is a key one; and "for many years full voting rights were reserved to persons who directed news operations with their stations, in a deliberate attempt to emphasize the status of such persons."

formed around radio also gradually evolved to include television members as well[19] (Harris, n.d.).

The Rise of the Anchor

Matusow (1983) writes that the year 1952 marked the first time television became an important force in the nation's political life.[20] President Eisenhower embraced the new medium, and Richard Nixon saved his own political life on TV with his "Checkers" speech. It was also in 1952 that NBC's morning news and talk program, the *Today* show with newly minted "anchor" Dave Garroway debuted. *Today* would not have a morning news competitor until the launch over twenty years later of ABC's *Good Morning America* in 1975. The softer and more eclectic morning news format would provide a different type of forum for showcasing the on-screen talents and versatility of Jane Pauley, Barbara Walters, Tom Brokaw and other hosts in succeeding years, but the evening news would remain the premier news broadcast through the turn of the century.

One journalistic star who emerged from the 1952 political conventions was Walter Cronkite, a seasoned wire service reporter who had been anchoring the local news for the CBS-owned Washington station since 1950. The introduction into the language of the new term "anchorman" took place at the 1952 conventions in regard to Walter Cronkite. In one of their pre-convention meetings, Sig Mickelson, then head of CBS television news, and producer Don Hewitt "discussed the need to have their strongest person in the booth, holding together the coverage from the floor. Hewitt compared the arrangement to a relay team, where the strongest runner, who runs the final leg of the race, is called the 'anchorman'" (Matusow, 1983: 65; Diamond, 1991). Thus, Cronkite, and not Murrow, became sealed in history as the first and quintessential television anchor. Despite what he lacked in

19. The National Association of Broadcasters (NAB) was formed in 1922 initially to work for rational rules related to spectrum allocation related to U.S. radio broadcasting. The Association was crucial in bringing about the Radio Act of 1927 which created legislation for station licensing and frequency allotment while avoiding government control of station's business operations and programming (Harris, n.d.). The NAB is now the chief governmental lobbying group for licensed, free, over-the-air broadcasters in radio and television (nab.org).
20. While the 1951 convention of the NARND "couldn't quite bring itself to approve a name-change that would get television into the title," by 1952 it had (Shelley, 1966).

showmanship, Murrow had established a journalistic tradition—that of the crusading reporter—with his 1954 attack on Senator Joseph McCarthy and in reporting on the injustices committed against those accused of communist sympathies (Barnouw, 1975: 175). He also introduced techniques into broadcasting, such as the multipoint radio roundup and the split screen interview, that are still used today (Edwards, 2004). But the era of the radio news star was on the decline; the era of the television anchor had begun.

Chet Huntley and David Brinkley emerged as stars from the 1956 convention, but 1963 was the pivotal year for television. Cronkite was first to deliver the news on TV of Kennedy's assassination in November 1963. For the first time, more people said they got their news from TV than from newspapers, and the nightly newscasts grew from fifteen minutes to a half hour (Matusow, 1983). This critical moment marked a shift in the distribution of recognition, popularity and authority of different types of journalism and journalists within the larger journalistic community.[21] Whereas print, and then radio, had reigned supreme, television now surpassed these others as the preferred news medium, with the anchors as its conduits. Diamond (1991: 40) divided television news into two historic periods—the years before Cronkite, and the modern era. From the late sixties until his ousting in 1981, Cronkite presided over the top-rated network news program. He first vied for popularity with NBC's Huntley and Brinkley who owned the early and mid-sixties, and in 1965, ABC put Peter Jennings on the air as its evening news anchor, adding to the competition, but it was Cronkite who prevailed throughout the Vietnam War era. The anchors became the face, the identifying signature of the news broadcast, and signified that television had changed the expectations of what it meant to be a journalist; new burdens were added to the job description.

While not all anchors have a moment that defined their careers and cemented their names in public memory, many of the most well-known ones became known through their reporting of particular events. The sixties in America provided a colorful and troubled backdrop against which journalists conducted their work and etched their names in public memory. Andrea Mitchell and Dan Rather are among the journalists who cite the tumultuous

21. Zelizer (1992a) and others including Levi-Strauss (1966) and Gerbner (1973) have discussed critical moments as "critical incidents." These moments or incidents are those by which people air, challenge, assess and negotiate their own significance and boundaries of practice (Zelizer, 1992a: 341).

period of the sixties that encompassed the civil rights movement, the assassinations of President Kennedy and Martin Luther King, Jr., and Vietnam as the time during which they learned the basic lessons of journalism (Mitchell, 2005; Rather, 1977). In addition to being the reporter responsible for making Cronkite and CBS first on the air with news of Kennedy's death, one of the early groundbreaking moments for Rather was his publicly televised exchange with President Nixon during the "fevers of Watergate" at a press conference in which Nixon taunted, "Are you running for something?" and Rather replied, "No, Mr. President, are you?" (Rather, 1977:17). This would be the beginning of a protracted grudge conservatives would hold toward Rather, and the first of many media tornadoes in which Rather would find himself the center. In addition to the confrontation with Nixon, Rather would become "as newsworthy as his stories" due to a string of incidents he was involved in that made news: his admission to an interviewer that he had tried heroin as a cub reporter in Texas; an argument with a Chicago cab driver that was reported in the papers; an attack on Rather by thugs in Manhattan in 1986, after which he appeared on-screen with a swollen, bruised face; his staging of a six-minute walk-out in Miami in protest that the U.S. Open Tennis tournament had cut into the *Evening News* in 1987; and in 1988, Rather engaged Vice-President George Bush in what *Newsweek* called "the great TV shout-out" (Zelizer, 1989: 78).

Unlike Rather, about whom audiences came to know partly for his outrageous behavior, Cronkite, through his JFK assassination coverage, came to be known as the epitome of the consummate broadcast journalism professional and the most aspired to model of the TV news anchor. However, the actions during his assassination coverage that catapulted Cronkite to the highest echelons of journalism and became the template that future TV journalists would emulate deviated markedly from traditional codes of journalistic practice. His visibly emotional relay of the news of Kennedy's death included "removing his eyeglasses in a distracted fashion and forgetting to put on his suit jacket" (Zelizer, 1992: 146). Cronkite also did something certainly not ascribed to traditional journalistic norms; he cried—on television. In the end, the emotional display combined with his ability to transcend his own personal distress to guide the public throughout the ordeal "showed how it was possible to define professionalism through improvisational and instinctual behavior" (Zelizer, 1992: 146). However, this redefinition of journalistic professionalism would never sit quite right with

the greater journalistic community. For the next forty-plus years, future anchors would try to replicate Cronkite's combination of humanity and strength, steadfastness and feeling, in reporting monumental and tragic events in the nation's life. Some would accomplish the feat authentically, while others would feign emotion by purposefully re-enacting Cronkite's signs of distress, although distinguishing between real and put-upon displays of emotion would be an area of contestation itself within journalism.

For anchors who are normally thought of as steady and assured, the breakdown of their cool façades would come to be known as the signifiers of the extraordinariness and magnitude of events; they would become markers of the "what-a-story" (Tuchman in Zelizer, 1992: 50). The Cronkite JFK assassination episode also assigned a new paternal role to anchors in times of crisis—as one who empathetically mourns on behalf of the nation, consoles, reassures and holds the nation together. Interestingly, although the "what-a-story" category was initially created for stories that sidestepped routinized journalistic expectations and lacked steadfast rules of coverage (Zelizer, 1992: 50), Cronkite's behavior in reporting the JFK assassination—which at the time was improvisational and redefinitional—became, through emulation by future anchors, a routine in itself for reporting during crises. This routine which would be adopted widely by broadcast journalists would become another way in which TV journalists connected with audiences at home.

During this period, journalism in general experienced growth and greater legitimacy (Halberstam, 1979). Television journalism in particular improved its status by excelling at coverage of the era's events and expanding its offerings. This included the launch of PBS in 1969, and the teaming up of Robert MacNeil and Jim Lehrer in 1973 to cover the United States Senate Watergate hearings for PBS (weta.org). Additionally, Don Hewitt and Arthur Bloom at CBS launched the first "magazine" program to grace the television screen, *60 Minutes*, in 1968 (Sullivan, 2006). Capitalizing on the spirit of investigative reporting that Watergate brought, the long-form feature and in-depth pieces on the program could take months to assemble and represented a very different sort of journalism from the fast-paced nightly news with daily deadlines. Although comparable programs at the other networks would be slow coming onto the TV scene, the news magazine template that *60*

Minutes provided would become among the most popular throughout the eighties and nineties.[22]

Before the Kennedy assassination, print journalists still believed their medium was superior, but a "clear change was brought about by coverage of Kennedy's assassination," in part due to recognition and acceptance of television's technological capabilities that made it a powerful form of journalism (Zelizer, 1992: 29). Consequently, television journalism's rise in status created an unforeseen and, to some, an unwelcome by-product. This era of change during which television journalists had unprecedented amounts of face time with the American public and became associated with, as well as helped to define, major events also resulted in the creation of a cadre of TV journalism stars. In media retellings of historic events, individual journalists became synonymous with the stories they covered. One example is Cronkite's trip to Vietnam: upon his return he gave his opinion on national television that the war would never be won on military grounds and that the only end was negotiation. The result of his action that has made it into popular lore is that his pronouncement was the catalyst for President Johnson's decision to not run for re-election and the shift in strategy to get troops out:

> When Cronkite returned from his visit to Vietnam in 1968 and expressed doubt about President Johnson's war, Johnson concluded that having lost Cronkite, he had lost the country. The President therefore decided not to run for re-election (Diamond, 1991: 41).[23]

TV journalists' fame was a direct offshoot of their increased appearances on-screen during key news moments and during a time when a greater value was being assigned to television as a news medium. By and large, these stars were male.

However, as the sixties progressed, "a handful of female newscasters achieved short bursts of prominence," but it wasn't until the women's movement of the early seventies that the networks put more women on the

22. Based on the success of *60 Minutes*, ABC's *20/20* would begin ten years later in 1978. ABC would also launch *Nightline* in November 1979 as a series of special reports during the Iranian hostage crisis. The program became a regular late-night newscast four months later. NBC's *Dateline* would not be launched until 1992.
23. Cronkite, himself, did not believe that President Johnson decided not to run for re-election because he came out against continuing the Vietnam War (Yoakam, 1993: 994).

air (Matusow, 1983: 181). By 1972, the Equal Opportunity Act had passed and the FCC had recently included women in affirmative action programs for TV broadcasting (Stahl, 1999).[24] Lesley Stahl, Connie Chung, and Bernard Shaw were among the "affirmative action babies" who were hired during this time by CBS (Stahl, 1999: 13). These issues of identity in television journalism were directly tied to the visual dimensions of the journalists themselves. The link between a television journalist's appearance and character and his success on a TV news program had become explicit within the walls of news organizations. This link was spurred and reinforced by news consultants hired by the networks to conduct audience research about aspects of their broadcasts, chiefly the anchors (Allen, 2003). By the late sixties, newscasts had grown to hour-long blocks. By 1974, the three networks had added about a dozen women reporters and were recruiting more.

The Focus on Ratings and Celebrity

The move by the networks to hire news consultants and the elevated pursuit and promotion of celebrity journalists in the late sixties and seventies occurred against the backdrop of a changing economic environment at the networks. Increasing attention was being paid to the bottom line which depended on audience ratings and advertising dollars. Powers (1978: 6) called this the time of "the tyranny of advertisers," and in the seventies, American television entered the era of "cybernetic news" that played to what gratified instead of what was thought useful or necessary. According to many accounts, newscasts became focused less on serving the public and surrendered their allegiance to advertisers. Thus, the criterion for judging the news became the size of the audience it could attract to the main event, the commercial. Powers (1978) wrote that in the 1970s, the three major networks looked to news anchors to become their identifying signatures, to symbolize each network's collective persona, and to fill the void left by the fading star system that formerly distinguished them by their entertainment offerings. Some believe the era of celebrity journalism may have officially begun in 1976 when Barbara Walters left NBC's *Today* show to become the first female co-anchor of a network evening newscast, ABC's evening news with

24. It was not until 1969 that the Society of Professional Journalists (SPJ) decided to admit women to its organization (spj.org).

Harry Reasoner, thereby becoming the first million-dollar anchor on ABC (Robert Lichter in Shepard, 1997). Her "auction" brought into question the entire issue of the newsman as celebrity. Considering that journalism had been slow in promoting minorities and women, the fact that the first million-dollar anchor would be a woman made the announcement all the more sensational.

The pressure to attract audiences was compounded by changes that the move from film to video wrought on the broadcast community. The switch from film to videotape in the late 1970s, called ENG for electronic news gathering, eliminated the amount of time needed to process film, but many opportunities for glitches resulted at first, and the equipment was heavy to carry. While three men were required for film, only two were needed with video (Stahl, 1999). When minicameras (video) worked, television news reports could be live and up to the minute. The video system compressed the time it took to get pictures on the network, but it also meant less time for news judgment. Time to reflect on events that were covered, to put them in context, and to figure out what was important or not was disappearing (Stahl, 1999).

Technology presented new dilemmas for broadcast journalism, including speed above accuracy and sourcing difficulties (Mitchell, 2005: 402). Another change brought about by the switch from film to video was that with videotape, which was less expensive than film, the camera crews rolled on everything political candidates did or said. In the past, TV news programs waited to go on the air until they had the story. With the trend toward speed and with new technology such as satellites, TV journalists were under such competitive pressure that sometimes they began to go on the air before they had the story and invited viewers to come along as they tried to figure out what the story was. "There's a great difference in 'live' and in 'news,' and sometimes we put too much emphasis on the 'live,'" said Bob Schieffer (Millage, 2003).

Additionally, the advent of the TelePrompter in the 1970s posed different challenges to television journalists. In 1977, the prompter consisted of a roll of paper that scrolled several inches above the eye of the camera. Eventually a machine was developed that reflected words right across the lens of the camera, making it possible to read and look directly at the viewer at the same time. Although some journalists considered mastery of the prompter a mark of professional expertise and described the ability to read

and seem to make eye contact with the audience as an important skill (Stahl,1999), others felt the prompter was another technological trick and crutch that detracted from journalism's essence. It reduced the necessity for television journalists to think quickly on their feet and express themselves well. For example, a 1984 *New York Times* editorial article by Motion Picture Association of America President Jack Valenti criticized the over-reliance of TV reporters and anchors on Teleprompters:

> Television viewers in the United States have become so accustomed to flawless newscasters...that they forget how much make-believe is required to create these carefully sculpted images of spontaneity. The indispensable tool in this world of make-believe is the Teleprompter. Almost everything said in any morning or evening news show springs from the omnipresent Teleprompter, so that no newscaster is ever at a loss for an articulate and seamless reading of world events...if the Teleprompter were to break down...you would see the starkest transformation...from a seamless orator to a shambling fumbler...it provides a pathway to eloquence otherwise unattainable by most speakers (Valenti, 1984).

In these instances, members of the journalistic community felt that the use of and reliance on the prompter was one more ingredient in TV news presentation that brought the journalist's job farther away still from the traditional roles and practices assigned in the days of print. Further illustrating the rift in the journalistic community toward the use of the prompter, Rather explains in his 1977 book *The Camera Never Blinks* that although Walter Cronkite was criticized by some for "reading" too much on air, this was a misunderstanding of Cronkite's dedication to the news—he refused to adorn a story and his objective was to deliver as much news as time would allow (Rather, 1977: 247). In this respect, to be seen as reading was actually a positive attribute as it showed that the anchor was not engaging in tactics to camouflage or dilute his task at hand. The fact that the use of the prompter divided the journalistic community is evidence that even at the inception of new technologies for creating TV news, the community struggled with, on one hand, welcoming the audience-pleasing improved presence and showmanship of TV journalists that the technology enabled, and on the other hand, trying to reconcile the new value of a performance contrary to the original aims of their craft.

As the technological trappings of television became institutionalized and the race for ratings and big names escalated, in 1980 CBS announced that

Dan Rather would succeed Walter Cronkite as anchor of the evening news. For most of the mid-1980s, Rather and the *CBS Evening News* were number one among evening newscasts, with Peter Jennings at ABC and Tom Brokaw at NBC running behind (Diamond, 1991). The entry of agents into television news intensified the trend toward anchor control, and increasingly, through the 1980s, the anchors of the evening news were in a position of control: "From its helter-skelter origins three decades ago, when it was a clumsy stepchild scorned by its betters in radio, television news at the dawn of the 1980s had evolved into a national institution of awesome resources and power.... Through a combination of circumstances that no one had really intended or controlled, the anchors had come to be seen as the single most crucial individuals in determining the success or failure of entire networks" (Matusow, 1983: 251). The broadcast journalist had come to be so heavily relied upon, in fact, that assignment editors made an effort to choose stories that could be covered by star correspondents and routinely rejected or selected stories on the basis of which correspondent reported them (Epstein, 1973).

As the position of the anchor rose in the hierarchy and journalism shifted toward showbiz in the early 1980s, network television news was being squeezed by rising production and satellite costs and competition from cable. Network news saw its profits level off, and news shows were covering tabloid topics and personalities more and more, and tabloid programs (such as *Hard Copy*) were looking more and more like news broadcasts (Stahl, 1999). The networks' overall share of the audience was down to 67 percent. In homes with cable it was down to 56 percent (Stahl, 1999). The fledgling cable news channel CNN which came on to the scene in 1980 was on the air almost constantly with a story. With each technological advance, the time for making news judgments, fact-checking and thinking through coverage was shrinking (Stahl, 1999: 358). The decline of network news was brought about in part by technological change but also by deregulation (Stahl, 1999). No longer could news programs succeed on television unless they were profiting financially. In addition to the trend toward tabloid news and coverage of personalities, TV news was drifting toward "hostility journalism" with more conflict in reports (Stahl, 1999: 405).

The Past 25 Years

Since their appointments to the anchor desks in the early eighties, Dan Rather, Peter Jennings and Tom Brokaw reigned as broadcast news royalty at their respective networks for the greater part of the next two decades.[25] Many other network TV correspondents would also gain national attention and respect for their network reporting throughout the eighties and into the nineties.[26] But amidst the constancy of the network evening news trio, changes were brewing in the broader news environment. As has been the pattern with the introduction of new players into the journalism arena, CNN's entry into the TV news realm in 1980 was at first met with little fanfare and doubt that a cable news startup could pose a bona fide challenge to network television news. It was not long, though, before those who initially brushed the new contender aside soon began to see CNN as formidable competition.

From its beginning, CNN relied on the recognizability of its correspondents to attract viewers. Network head Ted Turner engaged in a one-year recruiting blitz that was seen as unrivaled in intensity in the business, raiding seasoned professionals from the other networks (Hall, 1980). Some in the industry saw CNN's hiring practices as an imitation of practices employed by other networks, while others defended the raid on the other networks as the only places CNN could go to find professionals (Hall, 1980). It was apparent early on that CNN would flourish during breaking news. CNN showed that it could move quickly on breaking stories and stay with them as they developed (Schwartz, 1980) More than any other network, CNN set the standard for Gulf War television reporting in 1991 (Schmitt, 1996). For many ambitious young correspondents, the Gulf War represented a big break. Bernard Shaw, Christiane Amanpour, Peter Arnett and Wolf Blitzer were among the CNN correspondents who benefited from lots of Gulf War air time. In addition to earning their journalistic stripes, they would be respected for having done their time in the field even after arriving at safer

25. Tom Brokaw's temporary pairing with Roger Mudd in 1981 did not last. Neither did Connie Chung's pairing with Dan Rather from 1993 to 1995 although she would remain one of a handful of women who had broken into the highest tiers of TV journalism's ranks. Jennings was originally one of three co-anchors at ABC since 1978 along with Max Robinson and Frank Reynolds until he was named solo anchor in 1983.
26. For example, Bob Schieffer, Lesley Stahl, Diane Sawyer, Hugh Downs, Cokie Roberts, Judy Woodruff, Sam Donaldson, Andrea Mitchell and Ed Bradley.

posts. The recognition and prestige gained by these young correspondents through war coverage would serve as a link to traditional journalistic routes to promotion and help to perpetuate the precedent for future rising reporters.

Other cable news networks were founded and rose in the nineties, including CNBC in 1989, MSNBC in 1996, and the Fox News Channel also in 1996. In calling themselves news networks, these cable channels have been able to take liberties that the big three networks could not. In situations of breaking news, they have ever-ready formats and the staff to be able to interrupt their programming at a moment's notice. In continuing coverage of events of national interest, such as the O.J. Simpson trial, the 2000 presidential election vote recount, or the American presence in Afghanistan or Iraq, these cable news channels were able to develop new programs or alter their entire programming schedules in a single day. However, in non-crisis times, ratings fall and the cable news channels don't pose quite the same threat to the traditional broadcast networks with diversified programming.

In addition to increased competition for stories and talent, the advent of cable outlets that broadcast instantaneous coverage of live events around the clock has also enabled journalists to do their reporting from their desks, which some see as a negative change:

> Journalists in the seventies and eighties assigned to cover events had to be physically present in order to get the footage, interview sources and understand how the event was unfolding. With the advent of C-SPAN, that all changed. They spent more time in their offices watching live coverage, but losing the immediacy of contact with the participants. Now, the internet has made it even less necessary to be physically present. There are obvious advantages, but you lose a lot of direct contact with policymakers and other sources (personal interview with Andrea Mitchell, NBC News correspondent, 2006).

The advantage of being able to view events remotely is that the TV journalist then multi-tasks, and is available on the computer writing notes, briefing people, going on air, or doing updates.

Among other changes to TV journalism in the most recent two decades, those inside and outside the field lament the continued and growing focus on infotainment and the "Hollywoodization" of television news and its anchors (Auletta, 2003; Fallows, 1997). In 1997, *60 Minutes* creator Don Hewitt told *Variety* he felt that broadcasters "got out of the news business and went into

the entertainment business.... It's spawning a generation of personalities, not newspeople" (Levin, 1997). Although network television news, in the face of competition, could have chosen to go another route and make its news programs conform more strictly to the ideals of hard news, it seemed to do the opposite. One of the ways in which the networks seemed to undermine the seriousness of journalism's mission was by hiring personnel who lacked traditional journalistic backgrounds to become the new faces of their programs. Some of these cross-over *talents*,[27] as they came to be called, were former actors and models—evidence that networks were prioritizing attractiveness over hard-earned experience and news values and that good-looking people lacking a substantive track record in journalism could still see these jobs as obtainable. These additions, as well as the transformations in the appearance of anchors already working on TV and a shift in promotional strategies of the networks to emphasize the attractiveness and star power of their rosters of anchors and reporters, perpetuated the glamorization of TV journalists.

Although individual journalists were complicit in these strategies, the general trend did not sit well with the broader journalistic community. For example, the repeated camera shots of Katie Couric's toned and tanned bare legs crossed in front of her while she interviewed guests on the *Today* show and her trendy and sexy new wardrobe were the subjects of contentious discussion in both the mainstream and trade press (Stanley, 2005; Moraes, 2006; Kurtz, 2005; Clark-Flory, 2006).

Beyond the differences in the people who fronted the news stories, the content of news programs changed as well as seemingly softer stories and more sensationalistic and gratuitous coverage appeared in news programs. As some journalists and scholars have noted, it is difficult to decipher what came first—audience consumption habits that favored more entertaining programming or moves by the networks to adopt such changes in programming (Goodman, 1994; Barsamian, 1999). Regardless of which one preceded the other, journalists say the trivialization of news is not entirely their fault but has become a cycle by which audiences consume lighter fare and networks continue to produce it. By 2005, most industry analysts agreed

27. This is a term used to describe all on-air personnel as well as creative employees of programs such as writers and producers. For example, NBC has a vice president for talent negotiations who is involved in hiring and contract negotiations for all creative and on-air personnel for news programs.

that the networks' morning news programs, such as the *Today* show which had begun in 1952 and typified the hybridization of news and entertainment, were eclipsing the evening news programs in terms of popularity with audiences and value within their news organizations (Learmonth, 2006; personal interview with G.B., veteran news booker, 2006). Although late night talk show hosts were satirizing news reports as early as the sixties (Gould, 1968), networks and scholars began taking note more recently of the huge bite programs such as the *Daily Show* with Jon Stewart and *The Colbert Report* on Comedy Central have taken out of the younger viewing audience. These networks and scholars are looking into the mechanisms of these types of alternative formats that attract and potentially inform people about news and current events (Goldthwaite & Tisinger, 2006; Delli Carpini & Williams, 2004).

The growth of the internet and online news has also complicated the news picture. The internet redefined journalism by engendering the development of "citizens' media" which doesn't require an intermediary such as an anchor or correspondent (personal interview with P.K., former veteran television news producer, 2006). Users are able to post their own versions of events. The internet also made possible the continual and immediate updating of information that can simultaneously be made available to users. No longer would television and radio be the most current. The internet has also opened up new avenues for the ways that people can consume news with increased portability. No longer must viewers be fixed in front of a television screen at a particular time to receive the latest information. While they may still need or desire a trusted, experienced filter to help them decide what's important, with features like video on demand, users can access an online news website and watch news footage on their own schedule from anywhere in the world. The development of news aggregators enables users to register and have news from all of their favorite sites—from AP to CNN.com to the *New York Times*—delivered to their desktops.

Perhaps in part a result of the changes to television news in particular and more generally changes in the overall news landscape, a decline in public interest and confidence in the news media has been documented by many over the last two decades (Gans, 2003; Project for Excellence in Journalism, 2005). Between 1985 and 2002, the number of Americans who thought news organizations were highly professional declined from 72% to

49%. The number who thought they were ethical fell from 54% to 39%, and the number who thought the press got the facts straight fell from 55% to 35% (The Project for Excellence in Journalism, 2005). For the network nightly newscasts in particular, between their peak in November 1969 and 2003, ratings fell by 59% (The Project for Excellence in Journalism, 2005). However, in the last year or so, although the three broadcast nightly newscasts overall lost viewers for the year, the declines were about half of those of recent years, and CNN, Fox News and MSNBC all gained viewers in 2008 (Pew Project for Excellence in Journalism, 2009).

This suggests that people still want the kind of product they find on the nightly news—traditionally an anchor-centered format. There is an array of factors driving the network news decline, many that have little to do with the actual job journalists are doing. Programs are on at a time when a decreasing number of Americans are at home (5:30 pm and 7:00 pm). There is also evidence that audiences are not so much giving up entirely on nightly news as catching it less often. Although there was a sharp drop between 1993 and 2000 in the number who said they regularly watched nightly network newscasts, since then the data show a gradual increase in regular viewing (The Pew Research Center for the People & the Press, 2004). What people consider "regular" viewing has also likely changed. There are a variety of reasons people watch network evening news less often today, including an increasing number of alternative news sources and altered commuting times. The number of network evening news viewers has not fallen in a straight line but in cycles. The mid-1990s saw rapid drops—8.5% between 1994 and 1995, then 3.4% in 1996, and after a flat year in 1997, another 7.5% in 1998. Audiences actually grew by 3% in 2001, but then fell 8.5% in 2002, and lost another 2.7% in 2003. While the declines in 2004 continued, they fell on the low end of annual declines, as they also did in 2008 (The Project for Excellence in Journalism, 2005; 2009). It is important to note that these declines in nightly news viewership have occurred amid declines in viewership of network television generally. News viewership has actually tended to suffer less erosion than viewership at other times of the day (The Project for Excellence in Journalism, 2005).

In trying to ameliorate, if not reverse, the trend in decreased viewership, the network news broadcasts continue to shuffle anchors and correspondents and experiment with new features and formats despite the belief by some that over the past 25 years, news programs have already exhausted the

possibilities and have left "nothing new under the sun" to be discovered (personal interview with Alan Wurtzel, NBC research president, 2006). Although it is not the first time that a journalist made the transition to the evening news chair from a softer format (in 1983, Tom Brokaw was plucked from the *Today* show to anchor the *Nightly News* and in 1976, Barbara Walters went from the *Today* show to anchoring the evening news on ABC), the zest with which news anchors and hosts of one program genre are being traded and plugged into slots in another demonstrates the increasing fluidity of traditional journalistic boundaries. An example is the anchor-host game of hop-scotch played out on network television in 2006 when Katie Couric moved to the *CBS Evening News*, Charles Gibson from ABC's *Good Morning America* moved to *World News Tonight*, and Meredith Vieira from ABC's *The View* moved to the *Today* show. Also illustrating the blurring of genres and the tendency toward "infotainment," some members of the journalistic community believe that Oprah Winfrey is subsuming the role once occupied by the anchors. As one journalist remarked:

> There's actually a replacement for all of them [the anchors]. Oprah...Oprah has replaced them. Oprah fulfills the role that Walter Cronkite used to. Absolutely.... She is the person—not universally, not for everybody in America, but she has a huge audience. She's the, if you look at the TV medium, the only person who has the kind of audience, clout and trust and credibility that Walter Cronkite had in his heyday, it's Oprah Winfrey (personal interview with Chris Satullo, Executive Director for News and Civic Dialogue at WHYY and former *Philadelphia Inquirer* editorial board editor, 2006).

In regard to format changes, some of the ideas that have been tossed around in recent years include returning to a multi-anchor format, although not by repeating the placement of one male and one female anchor side by side at a desk but rather a tag-team format whereby one anchor reports from the desk in New York and one from assignment in the field (Steinberg, 2006b). Networks have also initiated webcasts entirely separate from their evening news broadcasts and publish their anchors' web logs (blogs) on their websites in attempts to reach internet users. Although they do not yet know if their efforts in these new venues are successful, they believe at least that they are not detrimental and continue them in order to remain contenders in a new age of connectivity (personal interview with Alan Wurtzel, NBC research president, 2006). In addition, they continue to brainstorm ways to reach

potential audience members through their mobile devices such as cell phones and PDAs. In the future, networks may also provide their newscasts at different times or provide a pay-per-view option. By March 2009, according to Wurtzel, the use of blogs by anchors had increased and "become a part of what anchors do and now with Twitter it's accelerated...we still have no measurement of what the positive impact is on ratings but I think it's clear that in an increasingly 'social networking' world they have begun to play a legitimate role."

Over the past twenty-five years, viewers' eyes have become trained on the anchor as focal point of the TV newscast, and networks have built their broadcasts around the regard for and notoriety of individual anchors. The anchors have become the models of appropriate practice for television journalists. These are the reasons why the changes in on-screen personnel automatically trigger tensions about the role of the anchor within the journalistic community. During the initial rise of the anchor, the assigning of such an extraordinary role to a single journalist was interrogated by the journalistic community. Then, for the greater part of three decades during which particular anchors rose to fame and became fixtures of TV journalism, above the surface, the status quo was largely unquestioned although under the surface the bubbling of community discourse about anchors never ceased.

As they have in the past, changes in the on-camera lineup of news programs provide junctures at which the journalistic community again faces uncertainty and turns back to questioning the role of the anchor. One of the ways they cope with the uncertainty is by tinkering with and suggesting changes to the traditional single anchor format. Another way is to try to alter the characteristics of the person chosen for the anchor job. A third way the community deals with uncertainty at the juncture between anchors is by questioning the existence of the anchor altogether. At these times, the community asks whether the success of a newscast really depends on audience identification with a particular anchor and if an alternative format without anchors is feasible. This occurred in 1982 when anchors Dan Rather, Roger Mudd and Tom Brokaw were all new on the scene:

> The secret is out. All suspicions are confirmed...the part played by the network anchors in determining the makeup of a given evening's news show is measurably less than that of the show's producers, directors, writers, editors, camera crew and technicians, not to mention the correspondents in the field. The anchor's contribution lies somewhere

between the girl with the clipboard and the boy who goes for coffee. Why then so much attention to whether Dan Rather wears a sweater or whether Roger Mudd respects Tom Brokaw? It's packaging, of course.... Since on any given evening, the news is the news, viewer loyalty is determined in large part by whether one is attracted to or put off by the master of the revels (Goodman, 1982).

As illustrated by this excerpt from a review of ABC News executive producer Av Westin's book *Newswatch*, when the community examined the necessity of the anchor in 1982, it echoed acknowledgments it had made before in the fifties during the emergence of anchors and reaffirmed that the anchor was essential, if for no other reason, than to establish and maintain a connection with the audience. The same questions have been raised and the imminent demise of the anchor predicted almost continuously throughout the eighties and nineties (Vanacore, 2006).[28]

A new wave of community re-examination of the anchor's role was sparked again by the departures of anchors at all three broadcast networks in addition to changes at the cable news networks in the 2005–2006 year. This most recent time around, the community has yet again decided that the anchor is a necessity, although it expresses doubt that in this environment of lifestyles in flux and increased competition from alternative news sources, the new anchors will have the same status as their predecessors. Whereas anchor transitions in the past occurred one at a time, the fact that several anchors chose to, or were forced to, "disappear from that screen at the same time" might also make it tougher for their successors (Millage, 2002). However, the steadiness of audience ratings before and after the latest anchor transitions suggests that the effects of these transitions on audiences may not be so different from transitions of the past (personal interview with Alan Wurtzel, NBC research president, 2006; "Dan Rather Signs Off with 'Courage': Anchor Leaves Post as Colleagues Fire Salvos," 2005).

While in many ways, the community's discussions about the most recent anchor transitions follow the pattern of discussions surrounding past anchor changes, there are a few striking differences in the more recent conversations. Of major significance is the prediction by several members of the community that in the near future, at least one of the major broadcast

28. This article in *American Journalism Review* reprinted quotes from eight different years during which the obituaries of the nightly news were forecast. They stretch from 1986 to 2005.

networks that have been producing news for over fifty years will go out of the news business (personal interview with Alan Wurtzel, NBC research president, 2006; Koppel, 2000).

Others predict that in the future, with many veteran news employees reaching retirement age, and therefore a loss in the institutional structure and memory that groomed and supported anchors of the past, networks will scale down on the time and resources devoted to grooming and supporting individual anchors (personal interview with G.B., veteran news booker, 2006). As a result of the decreased attention paid to anchors by their own organizations as well as an overall decline in the power and prestige of individual anchors, some also believe that in the future fewer people will aspire to the anchor post. As one news booker put it:

> Whenever you have anything that's going to be high profile, that's hopefully going to be highly remunerated—I mean people who are anchors make more money than anybody else in television...you're going to have people who want to do those jobs. The question is how many of those jobs are going to exist with that level of payoff because the field is shrinking and you're seeing it now in terms of the numbers of producers and support staff who are being laid off at various media enterprises. Those jobs are not being recreated to support the big system of old. So you still have the anchors but you have fewer people supporting them and as a result, the systems themselves are changing (personal interview with G.B., veteran news booker, 2006).

Despite some gloomy predictions about the survival of the anchor tradition and the 30 percent drop in the 6:30 pm newscast ratings since 1991, the three original broadcast networks still command an average of 25 million viewers, compared to upwards of five million for CNN, Fox News Channel, MSNBC and *Headline News*' ratings combined (according to Nielsen Media Research in O'Brien, 2006). In an increasingly cluttered information marketplace, the network newscasts are trying to hold on to one of the remaining features that sets them apart from other news providers—"an immediately recognizable brand" (Foege, 2005).

At this latest juncture of uncertainty sparked by anchor switches, the journalistic community has once again resorted to the same forms of questioning and examination of the roles and characteristics of the TV journalist that it has employed since the initial wedding of journalism and television. Journalists have weathered a myriad of changes in the television

news landscape since the initiation of anchors in the fifties. Building on the context this chapter has established for the emergence of television anchors, the following chapter will explore journalists' response to three elements that TV introduced into journalism—appearance, personality, and emotion.

Chapter 3
Appearance, Personality, and Emotion of Newsroom Anchors

Across the more than five decades of television news in the United States, the journalistic community has incessantly contested the boundaries between traditional values and practices from the days of print and the new dimensions that were introduced into the journalist's job by television. Some of these new dimensions are not unique to TV journalism. Emotion existed to a lesser degree in previous forms of journalism. It was certainly possible to convey emotion and personality through one's writing and speech. But the visibility of these dimensions increased through television, heightening existing tensions about their place in journalism. These key dimensions of the television journalist's work—appearance, personality, and emotion—are not mutually exclusive but rather build off of each other.

Throughout the history of TV journalism, the journalistic community has defined appropriate parameters for the appearance, personality and emotion of its members, but these parameters have been largely exclusionary, limiting those parameters only to certain individuals. And yet, over the decades, these parameters have been loosened and have become increasingly less formal. This overall de-formalization of the anchor that manifests itself across the typical attributes of TV journalists is part of a strategy of creating an alternative journalistic persona that appeals to viewers.[1]

This chapter will delve into how journalists have discursively responded to the changes and emphases introduced by television into their work. Overall, the elements of appearance, emotion, and personality have enhanced journalism's cultural authority in some ways while undermining it in other ways. In an effort to maintain standards and boundaries, the journalistic

1. In 2002, Pew's news survey found that all segments of the public have little trouble with a news-delivery practice tested by Pew: news anchors who deliver the news in a "more friendly and informal way." Three-quarters (76 percent) of respondents approved of this trend, while 16 percent saw it as a bad thing (Kohut, 2002).

community has thereby simultaneously viewed the focus on these elements as a departure from, and threat to, traditional journalistic values and practices while recognizing that these elements can also bolster journalistic power.

Cultural Shifts that Paralleled TV's Increasing Emphasis on Appearance

The increased emphasis on the appearance of television journalists drew from larger societal trends that involved a scrutiny of appearance and beautification of oneself and others and increased materialism and consumerism (Langer, 1998; Hartley, 1996; Epstein, 1973). There is little question that beauty and appearance are central to American culture. On the covers of magazines, on TV and in movies, in our interactions with others in day-to-day life, we are immersed in the notions of what is attractive. The relationship between our cultural norms and preoccupations with beauty and the media's emphasis on and depiction of beauty is a symbiotic one.

Cosmetics and lifestyle make it possible to alter one's appearance. But with the inventions of modern medicine and science, it has become possible to alter one's appearance more radically. In 2002, nearly seven million surgical and nonsurgical cosmetic procedures were performed in the United States, with women having 88 percent of them (American Society for Aesthetic Plastic Surgery, in Melani, 2003). Aided by the media, the combination of institutional forces and changes in cultural attitudes toward cosmetic surgery has led to the increase in the popularity and visibility of the process (Haiken, 1997). Technical and programming developments in the last decade, including the development of the reality television makeover show genre, have culminated in this appearance-altering process being shown on television for the entire viewing audience to see (Kilborn, 1994). This fascination with appearance, beauty and makeovers reached a fever pitch in the 1990s and beginning of the twenty-first century. By 2006, more than ten different makeover or plastic surgery programs had appeared on television. These cultural shifts, combined with an increased national and international obsession with celebrities, have formed the stage upon which television journalists' appearances are increasingly placed under the microscope.

Appearance

As the previous chapter outlined, the technology of television made journalists' physical appearance visible to viewers at home. This necessitated a more conscientious managing of the journalist's attire, grooming, and manner which were not concerns ascribed to journalists in the days of radio and print. As former CNN anchor Donna Kelley said, she was nostalgic for her radio days: "don't you know we wore our casual clothes then!" ("Picture-Perfect from the Waist Up, 1995). According to the 1995 *People Weekly* article, Kelley had to trade in her casual wardrobe for the "two closetfuls of classic suits" she now owns for her TV appearances. Although the present-day assumptions about the anchor's desired appearance include that he or she be well groomed with a neat, stylish haircut, a healthy physique (Conconi, 1996), and flattering makeup for women and be professionally, yet fashionably, dressed (Nee, 2004; "Picture-Perfect from the Waist Up," 1995), so that they may be found friendly and likable, pleasant to watch, yet still able to be taken seriously, it was not always so. In the early years of television, journalists already recognized that appearing credible and likable were important in cultivating relationships with audiences. However, the measures by which these traits of credibility and likeability were judged were open to interpretation, and the physical attractiveness of the television journalist had not yet become an essential part of the equation. Although some post facto accounts say that good looks and manners added to Edward R. Murrow's legend (Edwards, 2004), he was considered "dashing" even as a radio correspondent through his dramatic and groundbreaking wartime reporting from around the globe. There was "no pattern to the success of the most visible faces in the industry"—Walter Cronkite, David Brinkley, John Chancellor, Harry Reasoner, Mike Wallace and Eric Sevareid—other than that they were all white males of a certain age and reasonably polished (Rather, 1977: 281). The common denominator among these journalists was that they were believable, although it is hard to say precisely what this quality consisted of. It has been widely remarked that Cronkite's integrity made him so highly regarded, not his physical appearance. Similarly, Edwin Newman found favor with audiences by coming through as someone people could trust and not by being a "matinee idol" (Rather, 1977: 284).

However, it is the physical manifestation of these inner qualities that makes them discernable to others. Although Burriss (1987) found that viewers do distinguish between the story elements that are directly related to

the informational content of a newscast and those related more to the anchor, the influence of an anchor's personal characteristics onscreen cannot be denied. The anchor uses his physicality in particular ways to embody desired characteristics, and parasocial relationships between viewers and anchors grow out of a viewer's attraction to and bonding with media figures who are perceived to be real and similar to the viewer (Rubin, Perse & Powell, 1985). So, while viewers are not consciously focused on the anchor's physical appearance, the anchor projects certain traits through his physicality, similar to Goffman's (1959) concept of the "front stage" in the theory of impression management. In this way, the anchor presents a socially attractive persona, which is central to the creation and maintenance of viewers' parasocial relationships (Rubin & McHugh, 1987). These parasocial relationships then influence viewers' loyalty to and selection of media content (Horton & Wohl, 1956; Zillmann & Bryant, 1985).

Although it is difficult to disentangle appearance from intangible qualities such as likability and integrity, it seems that the trustworthiness and conviviality that TV journalists exuded in the early days of television was what has been most noted and remembered in community recollections. These characteristics were regarded in themselves, apart from any mention of handsomeness. This was a sign that the interpretive community of journalists still had control of the core traits it wanted attributed to journalists. Aside from one's credibility as manifested through his physical presence onscreen, other capabilities were prized among TV journalists, such as Reasoner's and Charles Kuralt's writing talent, Chancellor's range, Wallace's gift for interviewing, and Newman's precision of language (Rather, 1977). Again, by championing these abilities, the community maintained its grasp on journalism's intellectual focus.

However the journalist's physical appearance and his success did not stay separate for long. As the sixties came to a close, public acknowledgment of and attachment to individual journalists peaked. This regard for TV journalists was cultivated through spikes in the amount of time journalists appeared on camera during coverage of major events in the nation's life. These television journalists along with the stories they covered became imprinted on Americans' psyches. In an attempt to raise its newscast from the depths of third place against Cronkite, Rather, Huntley and Brinkley, who had emerged as trailblazers from their coverage of the decade's assassinations and scandals, ABC made 26-year-old former Canadian

television anchor Peter Jennings the anchor of its evening news broadcast in 1965 (Steinberg, 2005a). Although the network thought his "fresh-faced and handsome" looks would appeal to younger viewers, his inexperience and the strength of his competition led Jennings to seek other assignments, and ABC replaced him in 1968 ("Obituary: Peter Jennings," 2005). Jennings would later gain recognition as the first network correspondent on the scene when Palestinian terrorists murdered Israeli athletes at the 1972 Munich Olympics and return, substantially more seasoned, to the anchor chair in 1978 ("Obituary: Peter Jennings," 2005; Steinberg, 2005a). While ABC's hiring of Jennings in 1965 partly for his looks provides evidence that the networks had seized upon the importance of the TV journalist's appearance in making their hiring choices, Jennings' failure at that time was actually a triumph of traditional values of the journalistic community. In the contest between attractiveness and substance, substance won out.

Unfortunately for those who wished to preserve traditional journalistic values, the same would not be true in other cases. Appearance as an attribute was evolving, and what started out as "appearance"-as-likability became "appearance"-as-good looks. Encouraged by the results of audience research conducted by news consultants in the sixties and seventies,[2] the networks embarked on strategies of hiring on-camera personnel that incorporated the journalist's physical attributes as a prime factor. This was part of larger attempts to achieve high audience ratings, which determined the amount of advertising money paid for commercials.

Not only were critics such as newspaper columnists and members of academia questioning these practices, but TV journalists themselves such as Cronkite and Wallace were criticizing the use of consultants and the trends toward prefabricated newscasts, the use of photogenic anchorpeople and the softening substance of TV journalism (Powers, 1978). The journalistic community rallied against the use of consultants and this newfound emphasis on the cosmetic elements of the newscast. The *New York Times*, *Columbia Journalism Review*, the *National Observer*, and the Alfred I. DuPont-Columbia University *Survey of Broadcast Journalism* published unflattering accounts of consultants' methods (Powers, 1978: 91, 99; Sklar, 1975; Barrett, 1975). The networks defended their use of consultants, maintaining

2. Nielsen was then, and continues to be, the largest provider of audience ratings. Frank N. Magid Associates and McHugh & Hoffman Inc. were among the first and largest consulting agencies to enter into the TV news business (Powers, 1978: 79).

that control over actual news content would remain with the journalists (Steinmetz, 1975). These two groups—station managers and network executives versus journalists—would come to stand on opposing sides of a growing chasm that had formed between those who served the bottom line and sought to make the newscast profitable at any cost and those who held fast to the traditional values of journalism. The use of consultants and audience research represented a "reversal of the very journalistic process itself" (Powers, 1978: 2). Instead of striving to impart information to viewers, networks now extracted information from the viewers.[3] The focus on the appearance of the anchor also represented a "radical discontinuity with journalistic tradition" (Powers, 1978: 2). The selection of these journalists was made according to a standard unique in TV journalism—the anchor's "presumed ability to personify a shared viewer fantasy" (Powers, 1978: 2). Over the decades, some of these fantasies began to include the presence of women and minorities on the news.

The Impact of Gender, Race and Ethnicity on Appearance

As a category of evaluation, appearance has long been a category of exclusion, not inclusion. Appearance as a category has moved from one of ineffable personal attributes to physical attributes, first of white males and then broadly to others. Even for white men, the specific characteristics that have been thought to make one's appearance attractive have been ill defined and subject to change. It is as if the quality of attractiveness is such that "you know it when you see it," but it cannot be specified in advance. The original white male construction of appearance made it more challenging for female journalists and journalists of other races and ethnicities to break into the TV journalism ranks. Equal opportunity and affirmative action provisions in the early seventies combined with the use of audience research did lead, however, to the hiring of new faces on news broadcasts. Discrimination against women and minorities in TV news up to this point had in part been directly tied to their physical appearance.

Although the hiring of women and minorities in TV news was a step forward in social progress, some of the reasons they were hired and their treatment in on-camera positions were not. TV stations in the 1970s and

3. As early as 1955, networks were commissioning surveys of viewer opinions and preferences (Shuster, 1955), but the funneling of audience research data into format, content and anchor alterations did not really begin until the late sixties and seventies.

1980s clearly hired female journalists for their looks which worked to effectively decrease the stature and credibility of these women reporters. Jessica Savitch once recounted how her Houston television station received sixty calls from viewers who were afraid that she might be ill, having seen Savitch cover a storm without her makeup on (Chambers et al., 2004). In response, Savitch said:

> Looks should neither attract nor distract. Ideally, a reporter's appearance should be pleasant enough to be disregarded.... I have decided to quit apologizing for my looks, which have played both a positive and negative role in my career. I have my own theory that attractive people in the industry are considered bad journalists; average looking reporters are automatically given more credence (Savitch, 1982: 72).

Many journalists have speculated about the inverse relationship between the journalist's attractiveness and the degree to which he or she is taken seriously.[4] On "being knocked" for making it on her looks instead of her ability, Catherine Crier, a former prosecutor, judge, and Court TV anchor said "it made the explanation [for my success] easier and more palatable for some to accept" (Swartz, 1995: 110). However, women still succumb to pressure to fit the ideals stations and consultants set for them. In a 1995 *People Weekly* article ("Picture-Perfect from the Waist Up," 1995) about the appearance of television anchors, several female anchors commented on the constraints on their appearance:

> "I look for something that's classy with a little snap. I want people to pay more attention to what I'm saying than what I'm wearing." (former CNN anchor Donna Kelley)

> ... Stahl feels she must "suppress my inner self." [Stahl] says she likes "red, yellow, curlicues and bows," but she knows that on-camera, less is more. And if she forgets, producer Don Hewitt will remind her. "Don likes

4. A common misconception about the intelligence of NBC *Dateline* anchor Stone Phillips has stemmed from his chiseled model-like good looks (and his name—several internet websites contain critiques of Phillips such as jumptheshark.com which asks, "How can you take a story seriously when the anchor/reporter's name is Stone Phillips?"). As a *Radar* magazine article said, "It may come as a shock, but pretty boy Phillips...graduated with honors from Yale...sources insist he's 'very smart'...despite his robotic on-air persona" ("My Big Dumb TV Anchor," 2005).

browns and beiges," she says. "Once I wore a black-and-royal suit with epaulets, and he asked me to go home and change." (CBS *60 Minutes* anchor Lesley Stahl)

In 1981 *Life* magazine commissioned a story on the blonde women of television news. In addition to Savitch who by then had become an NBC network anchor, the piece pictured Lesley Stahl, Jane Pauly, Lynn Scherr, Sylvia Chase, Judy Woodruff, Betsy Aaron and Diane Sawyer (Chambers et al., 2004: 58). A posthumous biography of Savitch describes 'Savitch clones' sending tapes to talent scouts and the stations instructing younger women how to look like Savitch (Blair, 1988). Diane Allen, who replaced Savitch in Philadelphia, dyed her hair the same color and was sent to the same speech coach (Chambers et al., 2004). In some cases, women were told never to smile during stand-ups and were rigorously trained to come across as authoritative in a male-dominated news environment (Stahl, 1999:14). In other cases, female anchors were expected to appear "warmer" on the air and smiling was encouraged. As Chambers et al. (2004: 7) observed, a "dilemma facing women journalists from the start was that the very notions of 'objectivity' and 'impartiality' were anchored within a partial, male-oriented construction of knowledge, reportage and 'news.'"

Because the desired appearance of TV journalists was first constructed in regard to white males and has been measured against that construction ever since, historically women have had a more difficult time breaking into journalism and being promoted to the anchor desk. Except for a few "glamorous" women, the big anchor jobs have always been reserved for men (Mitchell, 2005: 136). Female journalists' careers have been plagued by salaries unequal to men's, by glass ceilings, and by being forced to retire earlier than men because they no longer looked young enough. Christine Craft and Janet Peckinpaugh were two well-known cases of female local anchors who filed suits against their stations for discrimination because of age and appearance. In 1983, Craft sued her employer, ABC affiliate KMBC in Kansas City, after the station demoted the 37-year-old anchor to street reporter upon receiving the results of a viewer survey that found her too old, unattractive, and not deferential enough to men even though Nielsen ratings showed a slight increase just before her departure and a decline after it (Chase, 1983). Craft claimed that during her entire tenure at KMBC, the emphasis was on her appearance and not on the substance of journalism. Additionally, she said that although she had been forced to undergo a

makeover upon arriving at the station, her male co-anchor was never subjected to a makeover and was paid considerably more for the same work. Craft was initially awarded $500,000, but that award was thrown out by a federal judge who found that Craft had not been discriminated against on the basis of her sex ("Craft Retrial Starts Today," 1984). In a retrial, a jury awarded Craft $325,000 (Kerr, 1984). The case brought into public view several issues in the industry, among them, whether women who appear on camera in news programs are judged more on their appearance than their male colleagues, that TV executives value a pleasing persona over journalistic ability among reporters and anchors, and the pervasive influence of market research on decision-making in television news (Smith, 1983; 1983a).

In the realm of female TV anchors in the over-40 or over-50 age group, only Barbara Walters, then age 51 in 1980, held a highly visible position, in comparison with a large group of men in their 50s and 60s including Dan Rather, Walter Cronkite, Harry Reasoner, Mike Wallace and David Brinkley (Smith, 1983). Jane Pauley, at age 39 in 1989, was edged out of the *Today* show by younger (31) and more glamorous Deborah Norville. Sixteen years after Craft's suit, Janet Peckinpaugh was awarded $8.3 million by a Connecticut jury after she was fired by WFSB-TV in Hartford. Peckinpaugh claimed her age and gender cost her the job (Waters, 1999). However, in the early 1990s, CBS news president Eric Ober told Lesley Stahl that "people want their news from older-looking people" (Stahl, 1999: 377). While age and appearance had become criteria by which to judge the value of an anchor, they were also used in ways convenient to their employers to justify decisions in hiring, promotion and compensation. Although the legality of these criteria had been tested in court and gave networks pause about overtly using age and appearance in decision-making, they continued to do so in more discreet, but no less effective, ways. Through media coverage of suits brought by anchors and by the portrayals of age and appearance discrimination in popular movies such as *Up Close & Personal* (1996) and accounts in journalistic memoirs, the public became aware of the use of these criteria by the networks.

The emphasis of physical appearance was a double-edged sword for some in the television news business. For women in particular, the type of attractiveness to which one aspired and which was desired by the networks was a complex formula nearly impossible to achieve. Although many female

television reporters may not have been hired in the first place had they been considered unattractive, "being beautiful, had the effect of making people think [they] were brainless" (Stahl, 1999: 15). This dilemma led some female television journalists to adopt such strategies as wearing glasses (Stahl, 1999). Of course the public knowledge that many well-known female television news stars had participated in activities and competitions that played off of their looks perpetuated this stereotype. An article ABC published on its website about the troubled times that have befallen the Miss America Pageant included a listing of celebrity pageant contestants from years past that included Diane Sawyer, a former Miss Junior America pageant winner at age 16, Oprah Winfrey, winner of Nashville's Miss Fire Prevention pageant at age 16, Paula Zahn, a finalist in 1973's Miss Teenage America Pageant, and "Entertainment Tonight" anchor Mary Hart, who represented South Dakota at the 1971 Miss America Pageant before losing to another TV host, Phyllis George (Wolf, 2005). More than one magazine has published photos of Katie Couric in her high school cheerleader's uniform. *Access Hollywood* anchor Nancy O'Dell hosts the Miss USA pageant that she once competed in, and several articles in the mainstream press mentioned that ABC's Lara Logan was a former swimsuit model (Meadows, 2006; Steinberg, 2005c). CNN also injured the credibility of female journalists when it hired Andrea Thompson, a former *NYPD Blue* actress with little journalism experience whose nude photos turned up on the internet, for an anchor job on *Headline News*. Thompson's resignation provoked a series of articles (Bone, 2001; Kempner, 2002). Knowledge of these women's career paths may stoke the aspirations of present and future pageant contestants and other attractive young women who aspire to parlay their beauty into jobs as TV reporters or personalities like their role models.

The timing of some female anchors' rises to fame put them in no-win situations. At first they were told "You can't have the job because you're a woman" and then they got hit with "You only got the job because you're a woman" (Haller, 1983: 49). According to one account, Jessica Savitch was once told by a TV executive that "you couldn't put a woman on the 11 o'clock news because that's when wives look their worst, so they will be jealous" (Haller, 1983: 49). Women had to be pretty and feminine, but their sexiness could not be too obvious; it had to remain subtle. They were "either…too sexy or…not sexy enough" (Stahl, 1999: 224). This dilemma was evident when, in 2002, CNN briefly aired and then pulled a promotional

spot for Paula Zahn's program that touted the anchor as "sexy" over the sound effect of a zipper unzipping. Zahn reportedly had no knowledge of the spot before it aired and was "livid" upon learning of it (Grossberg, 2002). The ad caught much flak from media watchdogs who thought the ad degraded journalism, and CNN executives said it was a blunder by their promotions department (Grossberg, 2002). A similar publicity snafu occurred in 2006 when CBS responded to accusations that it had substantially altered a photograph of its new anchor, Katie Couric, to make her appear thinner in the CBS magazine *Watch* by admitting to the doctored photo and placing the blame on an overzealous employee in the photo department ("CBS Says Photo Tech Altered Couric Image," 2006).

The exploitation of the attractiveness and sexiness of female anchors has historically stirred contempt in the journalistic community. A six-page spread in the premiere issue of *Radar Magazine* (2005) was titled "My Big Dumb TV Anchor," and offered an "exclusive industry poll" of TV's "dumbest, meanest, laziest, and vainest news personalities" (101). This portrayal of anchors as beautiful and vacuous, disconnected and docile, is one of several. The *Radar* article outlines fatal flaws of prominent anchors that span the gamut, from not being able to read a teleprompter to being a diva, to being stiff as an "automaton," to being perceived as a lightweight, to being overly outspoken and opinionated, to rising to the anchor chair through nepotism instead of merit. A multi-media slideshow essay entitled "TV's Aryan Sisterhood: They Know Only One Hair Color: Blonder!" appeared on Slate.com in February 2006. Citing research from a scholar of "blond studies," the feature explains in a sardonic fashion that blond is associated with youthfulness and softens facial lines and is flattering to mature faces but also that "to be blonded is to be sweetened for consumption" (Shafer, 2006). The piece also points out that the blond phenomenon is not limited to female anchors; a few male "outliers" have gone the same route. The feature goes on to say that "soon, network executives will concede that they cast anchors the way Hollywood used to cast stars: Find a beauty and make her blonder." The author also asks if he is the only "TV pervert" to notice the rising number of sweater-clad newscasters. The piece concludes with more photos of blond anchors accompanied by a passage that reads:

> Blond hair may have already passed as a sexual signifier on news networks. The new blond is lips, specifically what people inside the industry call "Fox

lips"... achieved in the makeup room in a procedure that sounds one step this side of cosmetic surgery... (Shafer, 2006).

The Slate feature is clearly not meant to elevate the status of female anchors or flatter them.

Some of the actions of the network TV machinery do nothing to assuage these opinions. ABC proudly publicized the fact that viewers emailed inquiries about Diane Sawyer's shade of lipstick and Robin Roberts' necklaces ("What Color Is Diane Sawyer's Lipstick: Inquiring GMA Viewers Get Sneak Peek into Hosts' Dressing Rooms," 2006). NBC created and aired a video entitled "The Many Looks of Katie Couric" during the *Today* show's three-hour Couric sendoff in May 2006. The piece, narrated by fashion critics Joan Rivers and Jonathan Antin, features a chronology of Couric's hairstyles and wardrobe choices in a kind of fashion *This Is Your Life*. ABC featured an article on its website about the wardrobe stylist for *Good Morning America* and interviewed her and the cast about how they pick out their outfits daily ("Backstage Confessions from 'GMA's' Wardrobe Supervisor," 2006). Through these types of promotional devices, television news organizations attempt to capitalize on the physical attributes of their female news personnel. The fact that ABC publicizes behind-the-scenes information from *GMA*'s wardrobe person on its own website also represents an acknowledgment that they are in the business of smoke and mirrors and now they are making that transparent to viewers—they are not trying to hide it. Perhaps this is a strategy to familiarize viewers with the cast and crew of the program and make them feel as if the figures they watch are regular people who just look better because they receive special services and attention. In this way, ABC tries to demystify the anchors for viewers.

However, the greater journalistic community finds this type of promotion highly problematic. Female news reporters and anchors gain attention and notoriety through network promotion of this kind, which in turn adds to the attention paid to on-camera TV people in general, but it causes these women to become known for the wrong reasons. Appearance is a "catch 22"; journalists are not supposed to become known for their looks, but their success with audiences is partly based on their appearance, so their news organizations exploit it amidst protests about community values. In this way, the back and forth between the exploitation of the anchor's appearance and the community's criticism of this exploitation seals the practice of capitalizing on anchors' appearances into an unspoken, yet understood,

ritual. Unlike other fields such as modeling, in which the whole reason for success is the way one looks, in journalism, the community holds on to the fantasy that appearance does not or should not matter in the news. The reality is that where ratings and audiences are concerned, it matters very much. Anchors become style icons for the American public. Katie Couric's $555 hairstyles have spawned a demand for copycat color and cuts at salons (Silverman, 2000). MSNBC anchor Ashleigh Banfield was featured in *People* magazine's "Style Watch" wearing her trendy glasses (Cojocaru, 2004).

The ideal anchor is good looking but not *too* good looking, so that others cannot claim that she is trading on her looks or that her attractiveness is the sole reason for her success. For former beauty queens turned anchors, some of them have made good by achieving serious journalistic accolades that now outshine their more shallow beginnings. Not being attractive enough, as has been noted, is also a barrier in career success. Fox News anchor Greta Van Susteren is a prime example. Before Van Susteren moved from CNN to Fox News in 2001, she prided herself on not fitting the cookie cutter mold of the perfectly profiled anchor: "I'm not glamorous.... I spill my lunch on my blouse" (Van Susteren in "Picture-Perfect from the Waist Up, 1995). As her former colleagues have recalled, she was "totally low maintenance: 'No, don't do my hair.' She would just run her hands through it. She flamboyantly did not care" (Tucker Carlson, in Silverman, 2002).

A former criminal defense attorney and adjunct Georgetown law professor, Van Susteren had broken into TV news with her legal commentary for a local CBS affiliate in 1991, and then for Court TV and CNN during William Kennedy Smith's rape trial. She shot to prominence on CNN during her analysis of the O.J. Simpson trial (Kramer, 2002). But the reality of her job was that it did matter what she looked like, and reality got to her. When Van Susteren appeared on Fox News air for the first time, she had been visibly lifted. She had had her eyes done. Beyond just having the surgery, the fact that Van Susteren gave an interview in February 2002 to *People* magazine about the procedure (Silverman, 2002) and discussed it in her 2003 book caused even more controversy.[5] To admit to one's vanity and publicize it are even worse offenses in the eyes of the community than having the surgery in the first place. Van Susteren has also been talked about for another undesirable feature—that she is known to talk out of the side of her mouth

5. Van Susteren's book *My Turn at the Bully Pulpit* was published by Crown in 2003.

(Simpson, 2002). While this feature has brought her attention, it detracts from her reporting and is not the kind of attention a TV journalist wants.

Former news anchor Bree Walker also faced challenges professionally and personally because of a genetic deformity she was born with called ectrodactyly that gave her fused fingers and toes. Although her stunning face and figure and drive and determination enabled her to succeed as a television anchor despite her deformity, Walker has discussed how she tried wearing prosthetic hands and was turned away by many TV stations, including one executive who told her he "couldn't hire someone like that to work during the dinner hour, because it would put people off their food" ("Encore Presentation: Interview with Bree Walker, Jim Lampley," 2004) before encountering a station manager who was willing to hire her and support her. Walker has been outspoken about the American popular culture that "has become pretty toxic for young women and for aging women." She believes that "as the bar continues to be raised on what is physical perfection and a narrower definition is given us, what's acceptable, we have an impossible standard. And we're forced to focus on superficial values...diversity isn't celebrated when you're living in a culture that worships only the pursuit of physical perfection" ("Encore Presentation: Interview with Bree Walker, Jim Lampley," 2004).

Although age and appearance discrimination in the anchor business have been more rampant and received more attention with regard to women, they are not exclusive to them. One CBS insider has written that Walter Cronkite beat out Charles Collingswood for the anchor post because executives viewed Collingswood as "too elegant" and "too handsome" for the post (Gates, 1978). Instead, he was relegated to correspondent assignments. In 1982, when Dan Rather's ratings had precipitously declined, the network tried to make him "friendlier" by asking him to smile more and soften his tone (Stahl, 1999). When this didn't work, Rather tried wearing a V-neck sweater on the broadcast, which resulted in an immediate perception and ratings boost (Stahl, 1999). Forty-nine-year-old Steve Alvarez of WPLG in Miami sued his station on the grounds of age discrimination but lost in 2001 (Kiernan, 2001). After Peter Jennings's departure from *ABC World News Tonight* and subsequent death, ABC aired a two-hour televised tribute to Jennings (Yellin & McGrady, 2005). The piece featured a smattering of quotes from his colleagues alluding to his "James Bond" and "movie star handsome" good looks. Others recalled how he resembled actor Errol Flynn

and that he was sexy, tall, well-built, athletic, and "devastating to a lot of women" (Yellin & McGrady, 2005).

These examples make it clear that although female anchors and reporters are more often thought of as the targets of appearance-driven pressure, the emphasis is placed on men as well, albeit to a lesser degree. Certain qualities associated with anchoring are employed to discriminate against men as well as women: "Many talented male reporters who are lacking a perfect profile are also dismissed out of hand as candidates for front-and-center assignments..." (Lowry, 2004: 48). The importance placed on appearance has increased dramatically and become much more overt since the early days of television news, even for men. As one article noted, "Like many of his generation, [David] Brinkley did not look or sound like today's polished, blow-dried news anchors... ." Brinkley himself conceded: "If I was to start today, I couldn't get a job because I don't look like what people think an anchorperson should look like" ("Pioneer Newsman David Brinkley Dies at 82," 2003). Not being conventionally attractive is still not a career breaker for men; the *Today* show's Al Roker was part of the morning team for years before dieting and undergoing gastric bypass surgery in 2002 although his longevity may in part have been due to the ensemble character of the *Today* cast. Roker may not have fared as well in a news anchor slot. In addition, whereas as women age, the less attractive and desirable they are seen as being, as men age, they are considered stately, distinguished and seasoned. Thus, historically, men's careers on TV news have been easier to sustain.[6]

Chambers et al. (2004) note that one area in which women are surpassing men's success is among Asian American anchors. Citing one study by USC/Annenberg (2002), they recount that the top twenty-five television markets had eighty-five Asian women on air and only nineteen Asian men. This interest in Asian anchorwomen has become known as the "Connie Chung phenomenon" (Sengupta, 1997). The theory that an 'exotic' woman will attract white male audiences without threatening white male management has led to other Asian American women being hired as anchors and then being asked to look as much like Connie Chung as possible (Chambers et al., 2004: 87).

6. This is one finding from an unpublished study "Women and Minorities on Television," prepared in 1993 for the Screen Actors Guild and the American Federation of Radio and Television Artists by George Gerbner at the University of Pennsylvania's Annenberg School for Communication (Walsh, 1996).

Historically, television news has been difficult terrain for minority journalists. Mal Goode was the first minority reporter on network news. ABC hired Goode in 1962 and sent him straight to the United Nations (Papper & Gerhard, 2000). Throughout the 1970s, African American journalists were required to mimic whites not only in their behavior on the air but also in appearance. African Americans on television "spoke in the same clipped diction as their white counterparts and bore no traces of African American culture in their mannerisms or appearance" (Newkirk, 2000: 81). Some black TV journalists resisted the requirements. Melba Tolliver disobeyed a WABC-TV news director who had ordered her to straighten her hair when she sported an Afro to cover the 1971 White House Rose Garden wedding of Tricia Nixon (Newkirk, 2000 in Chambers et al., 2004). After suspending her from on-camera work, ABC relented and put her back on the air after a *New York Post* article reported her story. In 1981, Dorothy Reed was suspended by her ABC station in San Francisco for wearing her hair in cornrows. With the support of the NAACP, she filed a grievance and won and returned to her job, but her contract was not renewed. In 1981, Max Robinson was the only black anchor man on network television as the Chicago-based co-anchor of ABC's *World News Tonight* with Peter Jennings and Frank Reynolds. Robinson caused a stir when the press reported that he had made remarks about the TV networks discriminating against black reporters and that "unconscious racism" existed at the decision-making levels in news media at a speech he gave at Smith College (Overbea, 1981). Network officials indicated that ABC included four blacks among its 65 correspondents, while the rival networks, CBS and NBC, employed 8 blacks each at the time of the 1981 incident. Robinson said that his own appearance at Smith and the Janet Cooke debacle—she was the *Washington Post* reporter who admitted writing a fictitious story that almost won her a Pulitzer Prize—"raised eyebrows" in assessments of black journalists (Overbea, 1981).

By 1989, although they expressed hope and optimism, the National Association of Black Journalists was still frustrated over the level of minority representation in news organizations (Jones, 1989). But even as minorities were increasingly appearing on the air, they were making fewer inroads in management positions:

> I didn't see very many people of color in management positions in my newsroom, or frankly in any of the others that I had visited. And I said, you

know I think what's really needed here—I see faces of color, I see women on the air, but I'm not seeing them in decision-making positions in management. So that was really what I was interested in pursuing. And I said if I change my mind, you can always be a good correspondent or anchor. It's a lot harder to do it the other way around. So that's what I decided was most important (personal interview with P.K., former veteran television news producer, 2006).

Although the number of minorities working on network television news and behind the scenes has increased overall, for the first time in five years, no black reporter was among the top 25 on the network evening news programs in 2001, as measured by the amount of stories they reported, according to a study by the Center for Media and Public Affairs released in February 2001 ("Report: Blacks Get Less Air Time," 2002). Like most groups, historically marginalized and underrepresented ethnic groups are eager to claim a star who is one of their own. The Hispanic community was able to do this with Elizabeth Vargas. As an ABC anchor and correspondent in 2004, Vargas was featured in *Hispanic Magazine*'s cover story on "Latinas of Excellence." In 2006, she would briefly become the first woman of Hispanic descent to achieve the network evening news anchor post. Although not part of network television news in the United States, Unavision's nightly newscast for Hispanic Americans with Maria Elena Salinas and Jorge Ramos often surpasses or rivals the English-speaking networks in ratings in certain markets such as Miami, New York and Los Angeles (Ojito, 2006). No English-language network has had a male-female team as successful, or for as long, as that of Salinas and Ramos. Overall, the Center for Media and Public Affairs study found that the number of stories reported by all minorities and women in 2001 was up slightly over 2000. Eighty-eight percent of the stories were reported by whites and 75 percent by men. Another study found that black television journalists were more likely than Hispanics to see their minority status as a career barrier and to say that racial discrimination may drive them from the field (Stone, 2001 in Chambers et al., 2004).

De-formalization of Appearance

Within increasing focus placed on the TV journalist's physical form, there has also been a trend toward a less formal appearance, more noticeably for female journalists. Although some softening of male anchors' appearances

has subtly occurred, the effect is due more to a change in comportment of these male TV journalists than to actual wardrobe changes. With reporting from the field aside and with the exception of Dan Rather's sweater experiment in 1982 (Stahl, 1999), there has been little deviation from the dress shirt and tie and often full-suit uniform that men in news have worn through the decades.

In contrast, the move toward a more casual style is visible in female anchors' wardrobes—there has been a shift from conservative power suits to sweater sets. Whereas some women anchors in the seventies tried to downplay their femininity and took on more masculine personas to make others perceive them as authoritative, by the nineties, women were dressing more like women. By the end of the twentieth century, women in network television news were embracing and displaying their womanhood through more formfitting and casual choices in apparel. This was part of a larger strategy by the networks to strengthen the feelings of camaraderie between anchors and audiences and make anchors seem like regular people whom audience members might encounter in their daily lives. To some, it was another way of turning up the female anchor's sex appeal.

In comparison with their wardrobes in previous decades, some of the anchors' new choices in clothing could be considered daring and did not go unnoticed by audiences and the journalistic community. While viewers had empathized with Katie Couric after her husband's death, by 1999, her period of mourning was ending and her public image was changing: "She even looked different. She closeted her conservative suits and replaced them with leather skirts and summer dresses that showed off her legs and arms, which had been buffed by a personal trainer. She streaked her hair blond...she appeared in fashion spreads for *Vogue*" (Auletta, 2005). Couric's new style did not receive praise from some critics in the community: "Before viewers' eyes, Couric has morphed from girl next door to fashionista, trading in tailored suits for leather jackets, donning what seems like a different pair of glasses every week, and switching hairstyles with Hillary Clinton-like zeal" (Lang, 2005).

Couric herself has said that female anchors shouldn't "be too glamorous or make people feel uncomfortable" and that she's "never tried to be über-sexy" but that at age forty-eight [at the time] she wanted to age gracefully and look nice and feel attractive, and "that doesn't mean [her] core values have changed" (Auletta, 2005). Some disagreed and called Couric's new

style "age inappropriate," and others said her new wardrobe personified her new "diva" attitude (Stanley, 2005). Couric believes that the portrayal of her as a diva was tinged by an element of sexism: "What's a male name for diva? *Divo*?" (Auletta, 2005). According to one account, as *Today* fought in the spring of 2005 to hold its top position which many believed had been jeopardized by Couric's new style that turned viewers off, Couric began asking colleagues for advice. She was often told to tone down her appearance, and by May of that year, her clothes were less flamboyant (Auletta, 2005).

Another example of the transition female anchors have made in wardrobe choices over the past decades is reflected in the discrepancy between the way Diane Sawyer's outfits have been discussed in the nineties and more recently. In 1995, one *New York Times* critic described Sawyer's clothes in the following way: "She wears a discreetly handsome black pants suit, black hose and high black heels with pointed toes and ankle straps. The ensemble conveys manly authority along with curvilinear femininity" (Jefferson, 1995). Then, in 2004, a *TV Guide* article joked that Sawyer had hired Couric's wardrobe person after she appeared in a TV interview in a skirt with knee-high boots (Peterson, 2004). The stark contrast between the styles of these female anchors over time illustrates the shift toward feminine and casual styles of dress. The negative attention these shifts prompted show that if not executed in precisely the right way, even an anchor's manner of dress can alienate viewers and members of the journalistic community who hold very definite ideas about how TV journalists should present and adorn themselves. While some may argue that even negative publicity is good publicity, these female anchors' expressions of power through femininity disregarded the community's and audience's ideas about what the anchor should look like, and the anchors paid the price for their transgressions. The anchors' clothes are not supposed to be the main event, and the community's quiet yet coercive efforts through its dialogue served as a check for these women and led them to return to styles that better satisfied community norms.

Keeping pace with an increasing cultural focus on appearance, the appearance of TV journalists has progressively garnered more attention since the union of television and journalism in the fifties. In more recent years, anchors—female more than male—have chosen to adorn themselves in less formal fashions. Even as the focus on anchors' appearances has

tremendously impacted notions of journalism and actual journalistic practice, so too have other features introduced by television.

Cultural Shifts that Paralleled TV's Increasing Emphasis on Personality

The cult of personality that accompanied television in the nation's daily life has drawn from the rising interest in personality in American culture more generally (Snyder, 2003). It has long been presumed that personality is a key ingredient in the success of many types of public figures. For instance, studies that discuss the role of personality in politics date to the fifties (Lang & Lang, 1956), and evidence continues to establish that it plays a deciding factor in voting decisions and popularity ratings (Johnston et al., 2004). In TV news in particular, there has been an increasing tribalism built around personalities—something seen in the culture as a whole. Increasingly, programming is built less around original reporting and more around personalities. Some researchers believe the change is due to differences between viewers born before 1945 and those born later in their attitudes toward tribalism and the national culture. The first generations of the 20^{th} century rejected regionalism and embraced a national culture like no generation before them. What replaced them is the generation of Woodstock—a generation raised on a diet of Vietnam and Watergate. That generation has a far darker, more conspiratorial suspicious attitude when it comes to the news (Alan & Lane, 2003: 363).

To combat increasingly suspicious attitudes toward news and increasing cynicism in media and politics more generally (Cappella & Jamieson, 1997; Project for Excellence in Journalism, 2005), producers of all kinds of content have increasingly come to rely on personality. Within the category of content producers, TV journalists and their networks have learned how to create effective on-screen personas that facilitate positive parasocial interactions with audience members. The belief that TV anchors need to be perceived by viewers as real people with whom they could imagine interacting, and not just as faceless reporters, comes from experience and research in this arena.

It makes sense, then, that advertisers and marketing firms as well are on the never-ending quest for the perfect personality with whom their target consumers can identify to represent their products. Athletes and musical artists have become known as much for their personalities as for their professional talents. For decades, motion pictures and TV sitcoms have played on audience's connections with characters. Television programs such

as MTV's *The Real World* and Fox's *American Idol* have taken these viewer attitudes and connections with characters one step further, featuring real people in their real lives. This newer breed of programming capitalizes on the love or hate relationships that TV viewers form with contestants on their shows, primarily in response to the personalities these people exhibit on camera. Viewers are compelled to root for or against the most sympathetic or most despised participants. In other business sectors, personality assessments have become a significant part of the hiring process (Johnson, 2006). Amidst this cultural scenery, it is no surprise that since the advent of television news, personality has occupied a growing space in TV journalism.

Personality

Creating a "shared viewer fantasy" (Powers, 1978: 2) that the networks hoped to establish via their anchors has depended in large part upon the projected persona of the anchor. Although there is no official consensus about the ideal personality of the TV news anchor, there have been many occasions in which the anchor's failure has been attributed to a flawed public persona. The increasing importance of anchors' appearances in the seventies was interconnected with the importance of anchors' personalities. Ever since then, performance and persona have been entangled. Whereas the main priority for print and radio journalists was to get the story right and to deliver it in a timely fashion, TV made it necessary for journalists to be much more than mere messengers of the news. Audiences have come to expect from anchors the personality and qualities that they seek in an idealized friend or mate. In addition to being slightly better looking than the average person, the idealized anchor is trustworthy, polished and worldly. He can draw from wide experience, is quick on his feet, "prepared to ad-lib and talk intelligently about almost any topic" (Chet Collier, former VP for programming at the Fox News Channel, in Paige, 1998: 9), well-spoken, affable, respectable and dignified. He is perceptive and sensitive, yet tough when need be. In sum, the idealized anchor fits a description that hearkens back to the days of Murrow and his colleagues who were thought of as "a special kind of philosopher-king-intellectual-statesman-journalist," (Halberstam, in Powers, 1978: 56) only the TV anchor is expected to exude warmth and charisma in addition. If this sounds like a tall order, it is, and the exact amounts of these traits remain an enigma.

Even in the early years of TV news, the anchors had identifying personas that the networks tried to control and use to their advantage. Although he predated the coining of the term "anchor," Edward R. Murrow's personal reputation (achieved in concert with his producer Fred Friendly on *See It Now*) was as courageous, "simple, lucid, intelligent," and his presentation was "personable and well-modulated" (Stengren, 1955). Friendly has remarked that what made Murrow so memorable was his "intensity of conscience"; viewers could "feel his emotions" (Stengren, 1955). As early as 1958, Dave Garroway's style on the *Today* show was seen as "serene" and "low pressure," which at the time was "preferred infinitely, on an early morning show, to excessive cheerfulness and energy" (Shanley, 1958).[7] Exemplifying just how nuanced the perceptions of program and anchor personalities really were, one 1964 *New York Times* article compared NBC's reporters' personalities with those at CBS, remarking that humorless CBS frowned on "journalism with passion" in contrast to NBC's "breezier informality" (Gould, 1964). The anchors had come to represent the personalities of entire networks, and each network achieved a particular characterization through its on-air personnel. In addition to selecting individual anchors to watch based on their perceived demeanors, viewers could feel a match with an entire network on that same basis.

The anchors' personas were in part perpetuated through the dissemination of information about anchors' backgrounds and personal details to the public. The public knew that Walter Cronkite "came from St. Joseph, Missouri, the son of a dentist. His circumstances were neither North nor South, East nor West, rich nor poor" (Diamond, 1991: 39). Diamond speculates that the Huntley-Brinkley duo that dominated the news in the early and mid-sixties was put together to appeal to viewers in all parts of the country, as Chet Huntley was from the west and David Brinkley hailed from the east. Of all of the major network anchors up until the turn of the 21st century, only six have come from outside the "heartland," and they were calculated choices.[8] It was thought that being from that region, they brought

7. Ironically, cheerful energy is what would come to describe the successful *Today* show in succeeding decades. Its host from 1991–2006, Katie Couric would universally become known for her "perkiness."
8. According to Alan and Lane (2003), John Daly, David Brinkley, Barbara Walters, Max Robinson, Peter Jennings and Connie Chung were the "calculated choices" who hailed from outside the "heartland."

with them a certain demeanor—"a certain solidity of character and gentility of spirit" (Alan & Lane, 2003: 179).

But the networks were not always able to effectively manage their anchors' public faces, and NBC "must have been less than pleased when Huntley pushed a piano into a pool and made the local news" (Diamond, 1991: 92). At one point in 1964, NBC expressed concern that "journalistic joshing about David Brinkley's dry humor might detract from his image as a serious news reporter" (Adams, 1964). According to accounts in *Time* magazine, *Newsweek* and the *New York Times,* CBS used audience Q scores in their decision to pick Dan Rather as successor to Walter Cronkite over Roger Mudd. Q scores are ratings that market researchers use to measure the degree of a viewer's positive response to a television personality. According to the reports, surveys showed that Rather projected "almost as much warmth, compassion and honesty" as Cronkite whereas Mudd was perceived as "somewhat cold" (Diamond, 1980).

Network executives have been hard pressed to state explicitly just what qualities they look for in an anchor; there is no clear model for predicting an anchor's success. Instead, one past CBS news president has said that "in fact, an individual just naturally emerges. His performance adds up" (William Leonard, former CBS news president, in Diamond, 1980). Others have observed that the anchorman's job cannot be approached as science but rather as a "magical, mystical art" (Diamond, 1980). Although the specific qualities that led to anchor assessments could not be pinpointed, it was said that Cronkite conjured up the "sense of your favorite uncle with a world statesman demeanor" while John Chancellor developed a "calm, professorial" style (Fred Friendly and Reuven Frank in Diamond, 1980).

Three anchors whose performances "added up" were Dan Rather, Peter Jennings and Tom Brokaw. The three men attracted viewers through their distinct on-air personae and personal aspects of their broadcasts. Demographic and ratings data show that viewers "aligned themselves in accordance with their understanding of the subtext of each man and his program.... Dan...country and western, appealing to an older, idealized American of the imagination. Peter...urban, projecting an image with which a more youthful market can identify. Tom positions himself somewhere in between, in the middle, as an avatar of suburban values" (Diamond, 1991: 38).

The market research firms and then news consultants—who were sometimes one and the same[9]—brought in by TV stations to achieve anchor popularity among audiences also engineered techniques used to perpetuate feelings of familiarity, such as "Happy Talk" (the seemingly informal banter on-camera between anchors). These techniques trickled upwards from local stations to the network newscast. Additionally, anchors, with instruction from consultants, learned how to create particular "faces" for the viewing public. Face refers to someone's public self-image. It is the presentation of the self which he or she would like to project for others. In Goffman's (1959) dramaturgical model, in which social interaction is analyzed as if it were part of a theatrical performance, people are actors who must convey who they are and what they intend to others through performances. As on the stage, people in their everyday lives manage settings, clothing, words, and nonverbal actions to give a particular impression to others. Through this type of "impression management," there is a distinction between "front stage" and "back stage" behavior. Front stage actions are visible to the audience and are part of the performance. People engage in back stage behaviors when no audience is present.

In creating and maintaining a public face, anchors learned to manage their front stage. This management may be conscious or unconscious, but it attempts to influence others' perceptions by regulating and controlling information in social interaction. The interactional styles of anchors vary from one newscaster to the next. Dan Rather rarely tried to interact with his audience: "He is detached and his authority derives from this detachment, from knowing the stories...as well as from the power to decide when, and if, to let other journalists appear" (Mancini, 1988: 163). Conversely, Bill Moyers was often directed by his audience, involving them and introducing them in discourse (Mancini, 1988: 163). These metadiscursive indicators used in the presentation of news place the anchor in a position of power based on the trust of viewers. What is absent, of course, from this interactional rapport is the negotiable dimension of a real interaction—in simulated interaction, any possibility of negotiation is absent. The TV anchor establishes (within technical and programmatic limits) the modalities, the rules, and the characteristics of the interaction. The only feedback from the audience is a posteriori, not immediate, through audience research, studio

9. For example, Frank N. Magid Associates was both a market research firm and a news consultancy.

rehearsals and newspaper criticism. It is only through these ways that the anchor receives criticism to "verify or adjust the communicative situation he or she has established" (Mancini, 1988: 156).

Over the past fifty years of television journalism, Dan Rather has been one of the most talked-about personalities in network television news. Other journalists writing about Rather have recounted how his "climb to prominence at CBS was based on his energy and his work ethic, but also his huge personality" (Kushman, 2005). And while his antics won him favor with some fans, observers note that "journalism, driven by personality, can be a tightrope," and Rather's strong personality not only made him an easy target, it sometimes overshadowed the news (Kushman, 2005). Succinctly summing up the Rather persona, an article published in the *Sacramento Bee* (Kushman, 2005) accurately described Rather and his career as a "tangle of contradictions":

> He's a serious journalist who says things like, 'This race is shakier than cafeteria Jell-O' and, 'They beat him like a rented mule.' He stood up to CBS' owners, arguing against commercializing and trivializing the news, but then goes gaga over weather stories. He's patriotic to the point of reverence, yet some conservatives hate him.

Rather's own network, CBS, has struggled to manage and withstand the fallout from Rather's behavior over the years. The network stuck by him through his controversial exchanges with President Nixon and President George Bush, Sr., kept him on after his walkout in 1987 and seemed to have embraced his "Ratherisms" or funny sayings and his zany personality. As part of the tribute to Rather upon his stepping down as anchor in 2006, CBS hosted a feature on its website proudly cataloguing the "Ratherisms" from CBS' 2004 election coverage ("Ratherisms," 2004). Perhaps because the idiosyncracies that turned some viewers off were endearing to others, Rather cultivated a critical mass of loyal viewers during the quarter century of his tenure. Many thought the Rather personality too "hot" for the essentially "cool" medium of television (Shaw, 2005), but others felt that his "oddly folksy 'Rather blather'" and his post-9/11 tears on *Letterman*, made him "a bit more human than your average venerable anchor" (Katz, 2004).

In addition to making adjustments in physical appearance to make the anchor more appealing and familiar to TV audiences, being perceived as human (just a regular person) adds to an anchor's appeal. But in contrast to

Rather who had many outward devices through which he conveyed his everyman status, Tom Brokaw was able to achieve this persona much more effortlessly:

> Tom Brokaw never anchored in a snowmobile suit, never reported with a piece of straw dangling from his mouth, never wrapped up the broadcast with "you betcha." He didn't have to. We already knew he was one of us. Brokaw never forgot those roots...His specialty was talking to and about the common man: simply, directly, honestly (former CNN anchor Aaron Brown in Justin, 2004).

Other observers feel that Rather's problem, as well as for all anchors, was phoniness and artifice. So much of an anchor's appeal was and continues to be a perceived personal and truthful relationship devoid of artifice or manipulation. Rather's aphorisms that were designed to reflect a more folksy, accessible Rather to some extent backfired, often seeming scripted and forced (Alan & Lane, 2003: 283).

An anchor's personality that connects with the audience can become his or her ticket to promotion; however, the failure to do so can be an obstacle to advancement. In spring 2006, when the *Today* show was contemplating which of three women should replace Katie Couric, Ann Curry was considered out of the running by most analysts because of her stiff demeanor on the air:

> Outside her isolation booth at the news desk, Ms. Curry is downright unwatchable, and none of the network's other aspirants seem personable and down-to-earth enough to win over the show's mostly female, middle-aged audience. Ms. Vieira, 52, is an engaging, good-humored and experienced newscaster who may not always enthrall viewers, but is unlikely to bore or repel them (Stanley, 2006).

Previously, in 1991, when Couric's possible successors were being discussed, Steve Friedman, senior executive producer of CBS' *Early Show,* said that although Ashleigh Banfield "earned raves for her breezy delivery and sharp observations..." and is "a very dynamic TV personality," it was also true that "a personality that dynamic could alienate morning viewers who like to ease into their day" (Rice & Weiner, 2001).

Rivaling Dan Rather in the attention it has drawn, Katie Couric's personality has been dissected at great length and in great detail. Couric's cute, saucy, and perky (the adjective the newswoman shuns most)

everywoman persona, in addition to the way she wields her toothy grin, turns a silly comeback phrase, and still manages to ask tough questions, has made her one of the most powerful figures in TV news to date.[10] However, like Rather, her strong personality lures some viewers and repels others who feel her glee and pleasantries are artificial. Couric has achieved a rare feat in TV journalism. She has become a personality type against which all other anchor personalities are compared and contrasted. In comparison with Couric Diane Sawyer seems refined, mature, sexy and aloof. Geraldo Rivera is said to have Dan Rather's "hot" personality while Peter Jennings was seen as a "cool" opposite. It is in comparison with Mike Wallace's dogged personality that other anchors are called softies. Paula Zahn's glamour and cosmopolitanism has caused Greta Van Susteren to be viewed as plain, no-nonsense and down-to-earth. In this way, anchor personalities become positioned relative to other famous templates.

These anchor personality archetypes are deeply embedded. As her predecessor had years earlier, Meredith Vieira, who took over Couric's slot on *Today,* appeared on the September 2006 cover of *Good Housekeeping* magazine and was the subject of that issue's cover story (Allen, 2006). The timing of the cover story was perfect for priming Vieira's new audience and signaling to them that she would carry on the Couric tradition. The article relates that rather than being the glamour-puss that Couric was said to have become in recent years, Vieira resembles the earlier Couric and is a tomboy who hates to go shopping, does not care what she looks like, and is not a material person. Even though others in the on-camera TV news business have implied that vanity or ego is a requisite of the job, to appear vain is to be instantly disliked, just as to be seen as coveting an enormous paycheck is also taboo. In this magazine article, Vieira guards against this perception. Additionally, the article portrays Vieira as compassionate (we read that on her way from the lunch interview, Vieira stopped and checked on a dejected woman on the street), a supportive and dutiful spouse (her husband suffers from multiple sclerosis and has twice battled colon cancer—the same disease that killed Couric's husband and for which she became a crusading activist), and a doting mother, who also, like Couric, loved working on *The View* because it enabled her to see her kids off to school in the mornings and be home in time to drive them to activities after school. Almost a verbatim copy

10. Couric, Diane Sawyer and Christiane Amanpour made *Fortune* magazine's 100 most powerful women list in 2005 (August 2005 issue).

of what Couric told the press about her decision to accept the CBS news position, Vieira tells *Good Housekeeping* that she asked her children and husband if she should take the *Today* job, and only with their blessing did she accept. Although her aura is slightly older and more stately than Couric's, this article sets her up to fit the Couric archetype—it might have been engineered and stamped with the NBC seal of approval. Very little, if any, of the information in the article has to do with actual news and the nitty-gritty of journalism.

Again, the focus on the TV journalist's personality runs contrary to traditional community values. The more a journalist's personality is allowed to shine through in the newscast and the more one's opinions are publicly expressed, the more the community takes these as signs of a slide toward entertainment and away from pure news. This was true even as early as 1968 when the *New York Times* published a piece by Jack Gould entitled "Should Huntley and Brinkley Don Leotards?" that decried the "intermarriage of theatrical and journalistic concerns" (Gould, 1968). But what is interesting is that once again, the schizophrenic community cannot completely reject or lambaste this slide when it leads to increased viewership. The community would like to hold onto its strict principles that dictate a narrow interpretation of what it means to be a journalist, but practicality tells it otherwise. Among TV journalists, a survival and self-preservation mechanism is built in. They know their success and survival depend on the audience. The audience is key because it determines the ratings, which, in turn, determine ad revenue, which determines the networks' budgets for news resources. It is through this relationship between journalistic values and audience-pleasing tactics that the personae of the anchors are tenuously formed and managed.

De-formalization of Personality

The trend toward a more informal appearance and style of anchors and broadcasts over the past five decades of television news has included a more personal approach by reporters: "We had traveled from 'Don't smile' to 'Get into the story'" (Stahl, 1999: 326). In 2006, Bob Schieffer's less formal style was praised by analysts:

> Less than three weeks after Dan Rather's departure from the anchor chair, Schieffer has already markedly revamped the job description, showcasing a

more inquisitive, interactive style than his predecessor or his competitors.... This anchor approaches his role more as a viewer's representative than as a reporter's leader.... He uses vernacular, even blunt language, to ask for more... (Tyndall, 2005).

It is notable that Schieffer is known to viewers as "Bob," not Robert. The names by which anchors become known are also key in creating a casual persona. It has been widely recounted in the press how Katie Couric, and NBC made the deliberate choice to call her "Katie" from the onset of her *Today* show career even though she had been "Katherine" as a local TV reporter and as a reporter for CNN (Gough, 2006; Kurtz, 2006). Audiences also came to know Dan Rather as "Dan," not Daniel, and Tom Brokaw as "Tom," not Thomas. Former anchor Bree Walker has explained that although she was raised Patricia Lynn Nelson in Austin, Minnesota, she created the name "Bree" as a play on her father's "Breeze Automobile Service Station" when the radio program director who first hired her in Kansas City ordered her to come up with an unusual and catchy on-air name (Cooper, n.d.). Nicknames or alternative names are deployed to familiarize the audience with the anchors and make them feel as if these are people they know.

This de-formalization of TV news is also visible in the way television anchors and reporters speak. As one writing coach advises, supposedly off-the-cuff dialogue that sounds as if it's being read and speech jammed with journalese are turning viewers off (LaRocque, 2006). And so television journalists are being advised to speak naturally on the air. The same advice is given to radio journalists. According to Brad Linder, a former public radio news reporter for WHYY in Philadelphia, there's been a major push especially in public broadcasting, probably over the past 10 or 15 years, to get people to sound more and more natural:

> Whereas as much as you have to respect a man like Edward R. Murrow, in the earlier days of broadcasting, they sounded relatively stiff. If you look at somebody more like Ira Glass of *This American Life*, they really started this revolution of getting people to sound like people talking, and you respond more as a listener I think, because the sound of a human voice, it sounds human (personal interview with Brad Linder, 2006).

Perhaps one of the most significant changes to the network evening news landscape is the transition Katie Couric made from her post she held for 15 years as co-anchor of NBC's *Today* show to CBS where she anchors the *CBS*

Evening News with Katie Couric (cbscorporation.com, 2006) Aside from the fact that she was the first solo female anchor in the history of network television evening news, critics from inside and outside the industry wondered in 2006 if her talents in the morning would translate to a successful evening news program. Some also asked why CBS News and Les Moonves were dead-set on Couric as Rather's permanent replacement when its newscast under interim replacement anchor Bob Schieffer was achieving higher ratings than it did under Rather and positive feedback from viewers (Kurtz, 2006b). The decision to hire Couric for the anchor slot marked a shift in the desired persona of the evening news broadcast. Brian Williams' succession of Tom Brokaw at NBC generally followed in the staid anchor tradition, and ABC's flailing attempts to achieve a younger and slightly more relaxed feel ultimately resulted in the choice of *Good Morning America* anchor Charles Gibson, but the Couric move was the most dramatic change. Beginning in 2005, heads of news divisions such as Les Moonves at CBS talked about getting away from the "voice of god" model (Steinberg, 2005). Finally, preceded by months of speculation, Couric announced in early April 2006 that she would move to the *CBS Evening News* as Dan Rather's permanent replacement (Carter, 2006). Spearheading the trend of de-formalization of news anchors and newscasts, some said the selection of Couric marked a departure from the rigidity of the persona and format audiences have come to expect on the evening news. Additionally, the replacement of Aaron Brown by Anderson Cooper on CNN was an attempt by that network to be younger and hipper (Holloway, 2005). However, three years after Couric assumed the *CBS Evening News* position, she had yet to raise the broadcast from third place in the ratings behind NBC's and ABC's evening news broadcasts (Friedman, 2009).

NBC selected Meredith Vieira to replace Couric in the *Today* chair. Vieira has had experience reporting for *CBS News* and *ABC News*, although her most recent position had been as moderator and co-host of ABC's late morning talk show *The View*. While Vieira had to cease her duties as co-host of *The View*, she will likely fulfill the remainder of her contract to host the game show *Who Wants to Be a Millionaire*. NBC secured another three years for Matt Lauer to remain as her co-host, and Rosie O'Donnell temporarily replaced Vieira at *The View* (Steinberg, 2006a). All of these trades illustrated the ever-more malleable boundaries of traditional news formats. The increasing appearance of anchors in other venues further points to strategies

to make audiences see them as amiable and approachable. Stone Phillips and Anderson Cooper have been among the journalists featured as guests on the *Colbert Report* on Comedy Central. Again, this mixes up the traditional genres as Colbert (a fake journalist) hosts real journalists to poke fun at journalism, and everyone benefits. As long as they act within the parameters of decorum delineated by the community, the behavior of these journalists, who are able to display a sense of humor and go along with the joke, even if they are at the center of it, creates a perception of them for audience members that is desirable. In addition, their presence on programs that ordinarily command a different audience demographic from their own news programs expands their visibility and notoriety to greater segments of the population. Provided that they do not overstep the boundaries of community-dictated codes of behavior, their displays of personality in other venues are permitted by both their own news networks and the journalistic community in the hopes that it may lead to cross-over viewing by audiences and more favorable impressions of the journalists themselves. In an increasingly competitive media environment, TV networks and the journalistic community realize that TV journalists must avail themselves of all strategies at their disposal for holding onto and attracting more viewers.

The anchor's public face or public personality is achieved through a complex process of conscious and subconscious self-management, in addition to external pressure from networks, audience research and audiences themselves. The ability to project a positive and pleasing persona, although inconsistent with original journalistic tenets, is an undisputed necessity for success in television news broadcasting. Although both personality and appearance are major factors of TV's entry into journalism, they are only part of what makes an anchor work.

The Cultural Background to Displays of Emotion on TV

Norms of emotional display on television news have been established and maintained in reference to broader societal norms that govern displays of emotion in interpersonal interaction. Emotional display, like other elements of social interaction, is culturally specific, and emotions are supposed to fit the circumstances, so people regulate themselves to display emotions that are warranted and culturally and socially appropriate. In this respect, emotions, with their obvious physiological counterparts, can be normative (Heise & Calhan, 1995). Certain kinds of relationships may require that people display

no emotion at all. People might be obligated to suppress emotions in work and professional encounters, to present a neutral demeanor and maintain the conditions for enhanced rationality. This type of prescribed non-emotionality occurs in medical relationships between doctors and patients, legal relationships between judges and those who come before the court, and in the normal relationships of other institutions based on rational objectivity, such as journalism.

However, some workers can be required to emote as part of their jobs as is also the case in particular circumstances of journalism. Societal expectations govern prescriptive norms about women and men: women are expected to emote more intensely in some interactions than men. Research has found that human beings' emotions can be of two types: reactive and prescriptive (Heise & Calhan, 1995). Prescriptive emotion means that people's demonstrated feelings are socially controlled. Reactive emotion means that emotional responses to social situations might depend on idiosyncratic self-processes; we cannot predict what people may naturally feel in social situations. However, a given happening might evoke largely uniform feelings for most people who participate in it (Heise & Calhan, 1995).

These societal norms governing emotional display have been asserted and maintained in a variety of ways. Beginning with the earliest oral narratives, stories and histories have related how people emotionally reacted to events and whether their emotional behavior was rewarded or punished. Examples have also been provided through the centuries by the printed word, through radio and eventually through film and television. Aside from what is available in the media to model one's behavior after, everyday person-to-person interaction also provides cues as to what is socially appropriate in terms of emotion.

Some scholars believe that American culture is generally becoming increasingly emotional: "We air our feelings and dirty laundry on television talk shows. Many Americans rely on advice from a therapist to get them through daily crises and boost self-esteem. The news media constantly relays stories of people 'at risk'" (Furedi, 2004). According to this belief, there has been a recent turn toward a therapy culture and the realm of the emotions, in which problems of everyday life are framed through the prism of emotions.

Through a combination of general social norms about emotion and community-specific dictates for journalism, guidelines for the particular

emotional displays of journalists in varying situations, to some extent, follow the broader cultural turn toward increased emotionality. Journalists employ a variety of strategies, with varying degrees of success, to display appropriate emotional behavior on television.

Emotion

Situations arise in the work of television journalists in which the words they speak in delivering the news or in interviewing a newsmaker conflict with feelings or thoughts they have about the subject of which they are speaking. For example, the reports by some journalists on the U.S. presence in Iraq and the reasons given by President Bush for military decisions may have conflicted with the journalist's personal opposition to the "war on terror." In such situations, the journalist must hide his personal feelings so as not to appear biased to the viewing audience and so as not to influence their opinions—a difficult task. Trimboli and Walker (1987) refer to this phenomenon as the "absence of camouflage" ("camouflage" here is defined as naturally occurring consistent messages). TV journalists must act to make their nonverbal behavior consistent with the words they are speaking by controlling bodily or facial movement in order to not appear deceptive or contradictory. Each of these dimensions—verbal and non-verbal emotive displays, appearance and personality—builds off the others in relaying a certain simplicity and unidimensionality, and each supports the others in creating what we know as the "TV journalist."

The ability to contain and mask one's emotions and the ability to reveal appropriate amounts of emotion, as evaluated by the journalistic community and audiences, have been discussed as important abilities for a television journalist. There are two modes of emotional display allowed: none or a predefined proportion of emotion in predefined situations. According to journalists themselves, although it may be an unwritten code that many believe should be discarded, objectivity and detachment from the story are the cornerstones of good professional practice. Inherent in the ideas of objectivity and detachment is the masking of the journalist's emotion. The journalist is idealized as the receptor by which the reality of an event is relayed to the public who cannot experience the event for itself (Lippmann, 1922). The public, armed with pure information, may then form its own opinions. So, the journalist is to be unbiased, fair, and, in other words, free from human feelings.

It is within this construction of the journalist that television journalists must operate. Emoting equals a complication of objectivity in which the face betrays one's perspective. As an example, a 1974 article written after Chet Huntley's retirement explained that throughout the fifteen years during which Huntley reported, "if he smiled, the world was alright temporarily; if he grimaced, one could always hope for a brighter touch by his partner" ("Anchorman," 1974). The visual dimension of television forces the journalist to be aware of his or her body and voice and necessitates the deliberate management of nonverbal and verbal behavior, especially in regard to manifestations of emotion. So, in effect, the television journalist must hide the visible and audible human responses to emotion he or she experiences in order to appear objective and, thus, professional.

Mitchell (2005) writes that a basic lesson of journalism is to keep one's emotions in check when reporting on a tragic event. In especially difficult events, being part of the press pool helps create an artificial barrier, enabling reporters to distance themselves from their emotions no matter what they're witnessing. The scene becomes a backdrop for a television story, and the reporter is able to concentrate in a "kind of robotic, instinctively journalistic fashion" (Mitchell, 2005: 33). Similarly, in his autobiography, Ted Koppel (2000: viii) writes that although viewers presume to know him and his politics and "draw their inferences from a raised eyebrow or tone of voice," it does not occur to them that as a TV news anchor, Koppel is "principally concerned with extracting information from a guest, and that my tone or apparent facial expression has little or nothing to do with what I really think." According to Koppel, "the stylized role of a television anchor" is designed to reveal as few opinions and as little passion and intimacy as humanly possible.

Verbal and Nonverbal Cues in Emotional Displays

Established principles of nonverbal communication have long been applied to people's perceptions of interpersonal interaction on television, and findings from studies of nonverbal behavior have been found to be valid and generalizable to viewers of television news broadcasts. Several studies have claimed that nonverbal behavior communicates affect more powerfully than verbal signals (Burns & Beier, 1973; Mehrabian & Wiener, 1967). Walker and Trimboli (1989) found that in the absence of camouflage, nonverbal behavior is dominant, so that as the level of camouflage is increased,

nonverbal dominance is decreased. In other words, when people are receiving mixed messages, they will be inclined to turn to nonverbal cues. Conversely, when the verbal and nonverbal channels are relatively consistent, verbal information is more readily accepted. Walker and Trimboli (1989) also talk about verbal and nonverbal behavior in terms of "channels" that convey affective tones. They analyzed verbal and nonverbal channels that conveyed opposed affective tones for channel dominance and found that the majority of the time, the nonverbal channels carried the affective tone, but sometimes, the affective messages were "complex combinations of cues in which the roles of the verbal and nonverbal channels were interwoven to communicate several messages simultaneously" (Walker & Trimboli, 1989: 229).

This suggests that television journalists with an absence of camouflage will likely be given away by their nonverbal behavior unless they have truly mastered the art of controlling it. Therefore, a successful journalist must give the appearance of camouflage even when it may not really exist. Journalists who are unable to do this will not be able to deceive the public. The detection of incongruence between verbal and nonverbal behavior is commonly referred to as "leakage." The term was coined by Ekman and Freisen (1969) who offered a leakage hypothesis of behavior: Deceivers attempt to control their nonverbal presentations to avoid giving the receivers any behavioral clues that deception is occurring or any clues to the nature of their true feelings.

One of two techniques may be employed by TV journalists to control facial expression. Either the journalist attempts to neutralize or deintensify a felt emotion, or, more likely, he or she attempts to mask the emotion with a non-partisan expression. However, "efforts to disguise a facial expression by overriding a felt emotion with the appearance of a presumably more acceptable facial expression may result in a blend" (Ekman, 1971: 223). This means that trying to conceal anger with a smile may result in an anger-happiness blend, with the resulting expression possibly looking smug. It is often apparent that this is what may be taking place in television journalists. Failure to manage the nonverbal display of emotion results in leakage, a cue to deception.

Such cues may be manifest in adaptors, such as fidgeting or hesitating, to compensate for anxiety caused by absence of camouflage. Body segmentation (which refers to the number of movements—high segmentation

implies less-controlled reactions), pupil dilation and frequent blinking are also linked to deception. Among nonverbal behavior, facial cues are thought to be least likely to leak information about deception because encoders are highly aware that they are very visible and receivers are likely to notice them. Bodily cues are more likely to tip off receivers because they are harder to control. Vocalic cues are less likely to leak information because senders can control the larynx.

Although vocalic characteristics are not the most likely indicators of deception, there are vocal properties associated with deception. Mehrabian and Wiener (1967) found that attitude was communicated through tone rather than through the actual words articulated. Fluency, voice quality, pitch, tempo and amplitude are some voice properties that have been identified (Burgoon et al., 1990). Violations of vocalic norms involving speech that may indicate deception are speech errors or speech hesitation (Buller & Burgoon, 1986). These indicators are apparent when television journalists are presumably struggling to hide inconsistent messages that have incongruent verbal and nonverbal channels.

Finally, in trying to mask their real feelings about an issue, journalists may incur leakage in their actual verbal behavior. Inadvertently, journalists who are internally wrestling with having to say things they do not agree with may add irrelevancies to or engage in leveling in their speech.

The technical aspects of television may permit the television journalist to be framed only from the shoulders up, only from the neck up, or the entire body may be visible onscreen. How much of the journalist's body is visible will in part determine what kinds of leakage cues will be available and what kinds of nonverbal control the journalist will need to engage in. As has been established, when receivers have access to all forms of cues, their perception of deceptive cues will be more accurate than when they only have access to facial and vocalic cues.

It should be noted that there is no consistent profile of nonverbal behaviors that signal deception. Nonverbal behaviors identified as cues to deception vary across studies. Behaviors that depend on the context, situation and sender interact in ways that are sometimes detectable as deception and sometimes not.

When Displaying Emotion Is Allowed

As has been stated, the rules of journalism mandate that the journalist be objective and detached, with minimal emotion expressed in conveying the news, so that the focus may remain on the actual content, enabling viewers to form their own impressions. However, there are times when these rules can be bent or even broken. Cronkite's display of emotion in the reporting of Kennedy's assassination was the first by a television anchor. As was noted in Chapter 2, Cronkite's visual cues to his distress were mimicked by later TV reporters. For example, ABC anchor Frank Reynolds had a breakdown on camera in 1981 when he stammered, "Damn it, somebody get me some correct information" and pounded the desk with his hand (Alan & Lane, 2003: 160) while reporting on the attempt on President Reagan's life. Again on September 11, 2001, those journalists reporting on the terrorist strikes on U.S. landmarks had real visceral reactions that came across on screen. In professional, trade, and mainstream publications, the community consensus was that this behavior during such a terrible event was understandable and allowed (Cali, 2002; Schudson, 2002; Rosensteil & Kovach, 2005).

In the case of an event such as this, television journalists are unable to sufficiently mask their feelings and to do so would seem false to the audience who is simultaneously experiencing the trauma and grief. An occurrence of this magnitude provoked emotion too strong to be hidden. Viewers did see instances during this coverage of reporters who attempted to deliver information in a calculated fashion but failed to do so, resulting in trembling voices, gestures of fear and despair, and even breaking down and crying on camera.[11]

In this case, an attempt to report the news while masking nonverbal signals of being emotionally aroused may have been to the journalist's detriment. The viewing audience might have resented this absence of camouflage and seen it as cold, inhuman or unsympathetic. As Stahl (1999: 97) observed, "for some mysterious reason, the TV camera is particularly sensitive to the bottling up of emotion. It doesn't like it; it registers as inauthentic." The audience was willing to make an exception for the expression of emotion by TV journalists in this case, as were their

11. Three examples from television news coverage of September 11, 2001 are CBS' Dan Rather on *Late Show with David Letterman*, September 17, 2001; CNN's Elizabeth Cohen, September 13, 2001; NBC's Tom Brokaw reporting about his assistant contracting anthrax on October 12, 2001.

colleagues, even when professional standards espoused the contrary. Although they claim it may have been a random occurrence, Trimboli and Walker's research indicated that "subjects relied more heavily on nonverbal signals when the encoder was making a sad statement in a happy style than when the encoder was making a happy statement in a sad style" (Trimboli & Walker, 1987: 187). In the case of September 11, 2001, journalists were clearly making sad statements, and incongruence with nonverbal behavior could have led audiences to misinterpret the information if Trimboli and Walker's finding turns out not to be random but a general principle of behavior.

Nonverbal behavior, being ambiguous and subtle, may be especially well suited for expressing sensitive and risky interpersonal information. Nonverbal codes can express what is not situationally acceptable as verbal expression. So while professional code dictates that TV journalists are not supposed to talk about feelings or emotion or use language connotative of their sentiments, their nonverbal behavior in the case of such coverage as was required on September 11 performs this function and allows them to get away with some sort of emotional expression that the crisis warrants.

Michael Schudson is one scholar who has tried to systematize the instances in which it is acceptable for journalists to display emotion. Schudson (2002: 42) explains that three occasions when U.S. journalists instinctively and willingly abandon the effort to report from a neutral stance are moments of tragedy, public danger, and threats to national security. We have seen examples of these times when network news anchors have adopted patriotic (the 9/11 tragedy or fallen soldiers), parental (stories on public dangers or threats, including consumer or health warnings), or collegial (anchors who talk to audiences as if they are buddies) personae (Campbell, 1991). Echoing the words of Schudson (2002), other journalists have said that in times of exceptional crisis, such as September 11, 2001, on-screen journalists cannot be expected to repress their humanity, and in these extraordinary situations, the TV journalist's visible emotional alarm or distress is a marker to all of the significance of such an event:

> I remember I think I was watching Jennings that day [September 11, 2001] and he was losing it. And when Peter Jennings is losing it, you're saying my god this is really bad. When the coolest of the cool doesn't know what to say next and is that necessarily a bad thing? 'Cause that's almost one of the things that ratifies this is a day like no other—Peter Jennings has lost it

on camera (personal interview with Chris Satullo, WHYY, and former *Philadelphia Inquirer* editorial board editor, 2006).

In these instances, the TV anchor's role becomes extended. He becomes the vessel through which the nation's feelings are expressed and displayed in a cathartic kind of ritual:

> ...in this society we don't have poets. So there are moments that are just so pregnant with emotion that one of the roles people want played for them is to have what they're feeling expressed in a coherent and even an eloquent way. That's one of the roles a TV anchor plays...the anchors are the people you're sort of counting on, and it is deeply affecting but also deeply, I think distressing to people when they're watching (personal interview with Chris Satullo, 2006).

Although members of the journalistic community felt that the emotional outpouring by journalists in the coverage of September 11, 2001 "was appropriate to that circumstance," they still expressed concerns about the larger trend of journalists emoting on-screen:

> I do have some concerns that despite the advantages of blogging and cable talk programs, the extraordinary variety of additional information that we can bring to people, we risk losing a sense of remove and appropriate distance from the issues we cover. Once you're out there sounding off, you really risk becoming part of the story too much... (personal interview with Andrea Mitchell, NBC News correspondent, 2006).

By and large, in covering September 11, the viewing audience saw that journalists were humans with emotions, but this did not stop them from watching the news on TV. The audiences did not lose respect for the journalists because of their frailty. If anything, the audience feels a stronger rapport than ever with television journalists since they've seen them as people like themselves who are doing a job rather than automatons. During these times of emergency or crisis, open expression of emotions by television journalists reporting news is accepted and arguably needed. These are times in which there is overwhelming consensus of public or national sentiment about an event as well. So the journalist is not putting himself in jeopardy by expressing an opinion.

Limits on Emotive Allowance

With the surge of emotion among journalists who covered the devastation of Hurricane Katrina and to a lesser degree Hurricane Rita, many lauded the news media's newfound passion and some even wondered whether it might be a welcome sign of a new aggressiveness on their part, but the praise was by no means unanimous (Rosenstiel & Kovach, 2005). Some members of the journalistic community felt that there were times when TV anchors' televised emotional displays were inauthentic and over the top. In particular, Anderson Cooper's ascension to the anchor chair after his emotional reportage from New Orleans in the aftermath of Hurricane Katrina stirred the ire of other journalists:

> Anderson Cooper rises while Aaron Brown declines largely because of Katrina, New Orleans. So what's the heart of what Anderson Cooper did in New Orleans? He lost his cool on television. He substituted his emotion in what he was covering for actually presenting facts...Cooper ends up getting his own show out of that. So as a print journalist...it bugs me that Anderson Cooper becomes a star because he lost his cool and started openly emoting when he should have been reporting...when you're just kind of thinking your job is to do a stand-up outside of the convention center and narrate over some film and then to come back and stare in the camera and say well this is the most shocking thing I've ever seen, and you're standing there just relaying, then you're basically feeding a paranoid frenzy that's sweeping through a city instead of doing something to report it and correct it...if you're reporting from your emotion and your viscera, you might get some things wrong. You've gotta—keep the visceral connection because that's going to be part of your connection with your audience but it's got to drive up through your brain before it comes out (personal interview with Chris Satullo, 2006).

According to Satullo (2006), part of the disdain for Cooper's behavior was caused by the comparison of his attachment to the story to those of journalists who actually lived and worked in New Orleans:

> I understand how difficult it was, but basically at the *Times Picayune*, that's what they were doing. It was their houses and their families and their lives devastated by flood. They weren't parachuting in to a network trailer and they were trying to do the best they could.

In some critics' minds, native journalists were the only ones entitled to real emotional displays provoked by the conditions of their hometown surroundings. Cooper was not the only network reporter to get emotional while covering Katrina. Fox's Shepard Smith "raged against government incompetence with such intensity that he freaked out his colleague, Neal Cavuto…back in the Fox studios. Geraldo Rivera held up a baby and cried. CNN's Jeanne Meserve just cried, and ABC's Robin Roberts almost broke down. For TV journalists, choking up had become the new Blackberry" (Bradley, 2005).

According to Rosenstiel and Kovach, the issue cuts to the heart of what it means to be a journalist. Summing up the sentiments of journalists as expressed above, Rosenstiel and Kovach explain that emotional isolationism in times of human suffering would appear a loss of humanity for journalists. Yet, in the absence of genuine human emotion, it can quickly descend into "emotional gimmickry." Their solution comes in the form of two rules: 1) that emotion ought to come at those moments when any other reaction would seem forced or out of place—when it's the only organic response, and 2) that once journalists have reacted in a human way to what they've seen, they must compose themselves to sort out responsibility for how and why things happened.

Outside of the circumstances delineated by Schudson (2002) and Rosenstiel and Kovach (2005) that warrant exceptions to the emotional reserve and detachment rules, other anchors have caused controversy by displaying emotion in their broadcasts. In 2004, Court TV's Nancy Grace was criticized by other journalists for her outspokenness in favor of a guilty verdict for Scott Peterson, accused (and later found guilty) of the murder of his wife, Laci, and their unborn child, from the outset of his trial (Zengerle, 2005). Grace has often been a passionate advocate for victims and their families, having experienced tragedy in her own life. Over 25 years ago, Grace's former fiancé was murdered during a mugging. In the eyes of her critics, Grace makes her reporting on criminal cases personal:

> [Grace] could hardly hide her satisfaction with the decisions…. After the jury recommended death for Peterson—a decision that was greeted with cheers and high-fives by the throngs of people who had gathered on the courthouse plaza—Grace seemed to join in the revelry (Zengerle, 2005).

In addition to the Peterson case, Grace has displayed similar emotional behavior in discussing the Andrea Yates trial, suspicions that California Representative Gary Condit played a role in the disappearance and murder of Chandra Levy, and speculation about the handyman formerly accused of kidnapping Elizabeth Smart. But Grace's unabashed emotional pronouncements about the parties to the court cases she discusses connect with some members of the audience, perhaps because they have the air of sincerity and empathy to human suffering in their calls for justice. In this respect, although Grace is not reflecting national sentiments at times of mass tragedy or danger as Schudson (2002) and Rosenstiel and Kovach (2005) specify, she is reflecting the sentiments of victims on a smaller scale. It is also possible that the combination of Grace's outward femininity and inward fire make her journalistic breaches of the emotion rule tolerable:

> For such a firebrand, Nancy Grace cuts a surprisingly diminutive figure. She is a petite woman with frosted blonde bangs that point down toward brown eyes and a pert nose. In moments of repose, her face has a tranquil, almost delicate quality. But, when she gets agitated, as she often does when debating defense lawyers on television, her eyes widen and her nostrils flare, so that she takes on the look of a heavily made-up cartoon bull (Zengerle, 2005).

Although Grace developed a loyal enough following and commanded enough attention to receive her own *CNN Headline News* show in 2005, she likely has fewer fans among journalists who hold fast to the traditional tenets of their craft that mandate professional stoicism.

In contrast to the critical reactions to Grace, Dan Abrams, also a former Court TV reporter who, after hosting "The Abrams Report" on MSNBC, was named general manager of the network, was lauded by fellow journalists for his compassionate style and for letting his feelings show (Garfinkel, 2006). When California attorney Daniel Horowitz went on Abrams' show for his first live interview after the murder of his wife, Pam Vitale, Abrams began the interview by expressing his sorrow that the interview had to be under such circumstances and that he knew it was a hard topic for Horowitz to talk about (Garfinkel, 2006). Abrams ended the interview by saying:

> Good luck. And as I say this to you, I say this on behalf of so many of my viewers who have written in to offer support to you, and my staff as well. They say that they are wishing you the best. That their thoughts and prayers

are with you and we will do what we can to help catch Pamela's killer. I promise you that.

Some journalists viewed Abrams' manner as "refreshing for viewers to observe so that they realize reporters are human and do have emotions. They are not robots who regurgitate facts without a hint of emotion in order to remain completely neutral" (Garfinkel, 2006). Like Grace, Abrams was not expressing emotions in the face of national tragedy; however, he was expressing appropriate emotions in relation to his interviewee's personal one. Abrams' expression of emotion in this case was less controversial than Grace's as he was not advocating for someone else's prosecution.[12]

In spite of differences in the scale of the tragedy, the common thread that runs through journalists' displays of emotion in tragic events on a mass scale such as the death of a president, a natural disaster or a terrorist attack and their displays of emotion in individual tragic events such as the murder of a wife or daughter is the sense of humanity conveyed in an appropriate response to these events.

Although journalistic displays of emotion are most often noted and remembered when they are in response to tragedy or danger, throughout the decades, journalists have also displayed emotion in regard to happy events. For example, while Walter Cronkite "could report with disgust the Chicago police attacks on anti-war demonstrators at the 1968 Democratic convention," he could also report "with unalloyed delight the landing of a man on the moon" (Clark, 2006). Just as journalists' emotional responses to tragic events have been acceptable when they have been consistent with and reflected national sentiment and have therefore been seen as appropriate human responses, journalists' positive emotional responses to celebratory events in the nation's life have similarly been seen as acceptable human responses.

However, unchecked positive emotion has proven disastrous as well. In January 2005, newspapers and TV newscasts exalted with the news that the 12 miners who had been trapped in the Sago mines in West Virginia had been found alive. The next day, those news outlets had to correct their

12. In August 2008, Abrams' show *The Verdict* was replaced by Rachel Maddow's new program on MSNBC. Abrams also ceased being general manager. As of spring 2009, he remains an outside legal analyst for NBC and runs his own media strategy firm, Abrams Research.

unfortunate error; only one miner had survived. NBC News anchor Brian Williams wrote in his blog: "The coverage was joyous, breathless and few cautions were ever voiced.... What an awful night for the news media" (Williams, 2006). While some analysts called the coverage "one of the most disturbing and disgraceful media performances of this type in recent years" (Greg Mitchell, editor of *Editor & Publisher* in Eichel, 2006), others were "measured in their criticism, with some wondering how reporters could maintain skepticism in the face of ringing church bells and celebrating relatives" (Eichel, 2006).

Although the judgment is never foolproof, the skilled anchor can deftly maneuver between repressing personal feelings and emotion and delivering news in an objective tone, and displaying the proper level of emotion when appropriate. Again, much like appearance, there is a kind of "catch 22" about this as well; one is supposed to find exactly the right amount of emotion when it is not clear how much is enough until he or she is in it.

Appearance, Personality, Emotion and Program Formats

Of course, the extent to which emotion and personality are allowed to shine through on camera and how wide or narrow the parameters of appearance may be are in part determined by the format of the news program itself. Television news formats vary widely, and there are forms of television journalism in which the journalist is permitted to express his or her views and corresponding emotions on a subject. In this form of journalism, the television journalist has camouflage—the nonverbal and verbal channels match without effort on the journalist's part—because he is not pressured to appear unbiased. However, because this form of journalism deviates from standard practice and does not pretend to be objective, it is categorized as something else—such as commentary or opinion—and is hardly considered journalism at all.

This format exists at the extreme end of the TV journalism continuum. Between objective hard news and open expression of opinion, many formats exist in the continuum that, while not completely permitting the open expression of opinion, enable the journalist to occasionally insert personal commentary. Morning news shows are an example. An appropriate display for an anchor on the *Today* show is quite different from that of an anchor on *60 Minutes* or the *Nightly News*. Even within one particular program such as the *Today* show, appropriate levels of emotional display range from very

little during the news segments to high during a fashion segment. In between these poles, a moderate amount of emotion is allowably displayed during a guest interview with a politician and slightly more is acceptable during a celebrity interview.

The normative appearance of journalists is also tied to program format. Evening news anchors are not "cutesy" or "perky," like their morning show colleagues can be. For this reason, some observers publicly wondered whether Katie Couric would trade her new wardrobe in for more serious power suits when she began on the *CBS Evening News* (O'Connell, 2006). Couric has said that the evening news does not allow for the same latitude in dress—both colors and styles—as her previous job on *Today* (Romano, 2006). Within the medium, the program format and tone dictate the amount of personality and emotion that are acceptably displayed, and the type of appearance that is allowed. Baym (2005) employs Bakhtin's concept of hybridization in his discussion of what counts as news and who counts as an anchor. Hybridized formats and personas like the hosts of ABC's *The View* illustrate the artificial categorical divide that is constructed between TV news and entertainment. Baym calls these categorizations conceptual abstracts that don't withstand lived experience. For Baym (2005a), these hybrid formats represent a move beyond "infotainment." They are markers of the phenomenon of "discursive integration," a way of "speaking about, understanding and acting within the world defined by the permeability of form and fluidity of content" (262).

Despite all of the distinctions that are made between hard news and everything else, TV news genres are far from being mutually exclusive. Although critics were quick to point out the large differences between Katie Couric's *Today* show role and the one she assumed on the *CBS Evening News*, they were also slow to remember that she is not the first to make such a transition. Tom Brokaw also transitioned directly from the *Today* show to anchoring NBC's *Nightly News*. Even in the early years of TV news, John Daly, who served as ABC News anchor between 1953 and 1960, made forays into game show hosting, and in 1954, Walter Cronkite—the most revered anchor of all time—served as a CBS *Morning Show* host with two puppets as sidekicks (Alan & Lane, 2003). It is also not as though Couric stepped into the shoes of TV's most conventional anchor; Dan Rather was frequently colorful on the broadcasts. Thus, although format sets the rules as to how strictly a journalist must adhere to the masking of sentiments rule,

such rules are loosely followed, and the distinction between reporting and commentary has long been perceived by many in the journalistic community as too weak.[13]

All of this discussion about the journalist's ability and necessity to mask or display emotion is illustrative of the clash between a technology that plays off of emotion and a community with norms that mandate its containment. Emotion and personality are what connect the television journalist to the audience, but this is problematic according to professional codes.

This chapter has described three indices of community maintenance—appearance, personality and emotion—and how they are situated within journalism, and Chapter 4 will explore how these indices of community maintenance actually work. Specifically, this next chapter will discuss how these dimensions figure in the anchor's signature, which is so antithetical to journalism. The attention anchors' signatures command produces a class of famous journalists, perhaps a natural offshoot of the visible positioning of the anchor on television. Journalistic fame is another source of community tension that will be dealt with as well as practices of selection and promotion and salary among TV journalists that are also based on the aforementioned dimensions of the anchor's job. I will also discuss how all of these elements impact journalism's cultural authority.

13. The discussion of violations of the boundaries between objective reporting and commentary will be revisited in Chapter 5 on "How Journalism Restores Order When Its Borders of Practice Are Crossed."

Chapter 4
The Impact and Consequences of Anchors' Appearance, Personality, and Emotion

The key dimensions of television journalism—appearance, personality, and emotion—comprise what I am calling an individual TV journalist's signature style. The anchor's *signature* encompasses all of the defining characteristics of the anchor that, when combined, add up to the person we come to know uniquely as "Katie" or "Dan" or "Tom." Just as the journalistic community has defined appropriate parameters for each of the dimensions comprising the anchor's signature, it has also maintained exclusionary and limiting provisions for an anchor's successful signature. A controversial by-product of the successful positioning of the signature journalist on television has been the phenomenon of journalists themselves becoming celebrities. Although print and radio journalists did become well known for their work, the emergence and increasing centrality of appearance, personality, and emotion in TV journalism have increased the degree to which they can be exploited internally by the journalists and recognized externally by audiences. Directly tied in here are changes in the practices of selection, promotion, and financial compensation that over time have come to reward "signature" as much as traditionally defined "good" journalism.

The Anchor's Signature

The term "signature" encompasses the entire aura or presence of the anchor:

> There's a certain performance aspect to being on camera that's very important. You have to be able to make people trust you with just a few words out of your mouth which requires a kind of presentation and certain kind of confidence in a very specific way in yourself that is necessary to be successful as an anchor or a correspondent (personal interview with P.K., former veteran television news producer, 2006).

Signature has not remained the same over time but has rather interacted with the circumstances external to journalism. Some observers describe a marked

change in anchor signatures between the 1940s and 1960s. The "sunny side of the street" was popular with viewers in the 1960s, versus the tougher, "tell-it-like-it-is" signature of the 1940s (Alan & Lane, 2003). In both decades, America faced crises, but to a far greater extent, the crisis came from outside the United States in the 1940s, and external threats require less delicate handling. By the late 1960s, when the "South and the cities were crumbling under racial tensions and Vietnam brought the carnage of war into American living rooms, a softer style found a place" (Alan & Lane, 2003: 180).

This softer style continues to manifest itself in certain anchors' signatures, some of whose have been captured by comedic monikers. For example, their signatures have led Diane Sawyer to be called the "Ice Queen" while Katie Couric was "America's Sweetheart" and the "Girl Next Door" (Gordon, 2005; Lang, 2005, Ostrow, 2005). However, contrary to what one would expect from these nicknames, viewers found Sawyer's cool style more favorable than Couric's in 2006 (Newport & Carroll, 2006; "Diane Sawyer Tops Gallup Poll of Popular TV News, Talk Personalities," 2006). Although some characteristics are generally agreed upon to be pleasant or unpleasant, the overall signature is a matter of personal taste. Even so, a favorable signature is such an essential component of the anchor job that entire segments of television programs have been devoted to discussing the subject (O'Reilly, 2006). Analagous to a play within a play, TV hosts, whose own signatures are on display, host programs and moderate discussions about other anchors' signatures. In other examples of signature, CNN's Bill Hemmer became known as the 'Chad Lad,' during his coverage of Election 2000, and foreign correspondent Arthur Kent was nicknamed the 'Scud Stud' for his reporting during the Persian Gulf War.

While signatures are a contemporary phenomenon and topic of conversation, they are hardly new. Forty years ago, anchors' signatures had already become distinguished. David Brinkley's signature was characterized by his "wry delivery," "turn of phrase and use of words" (Gould, 1964). Following this characterization, it has been pointed out that the quality of the anchor's copy that is delivered over the air contributes to his or her signature. However, there is no singular dimension that is responsible for the journalist's signature. It is rather the ways in which the anchor employs his or her physical attributes, displays of emotion, and overall personality in delivering the broadcast on-screen that create the anchor's signature allure.

Bob Schieffer came to be characterized as a "straight-talking, people's tribune" "son of Fort Worth," who was seen as the possible "antidote for the reputation of CBS News as an organ of the East Coast liberal elite" (Tyndall, 2005). The signatures of other anchors became so well known that they were parodied on *Saturday Night Live*. Frank Reynolds had the rare distinction of having two regulars on *SNL*, Harry Shearer and Phil Hartman, do imitations of him (Alan & Lane, 2003). Gilda Radner created the "Baba Wawa" character on *SNL* for Barbara Walters, who could not pronounce her Rs.

Patterns of anchor signatures suggest why the anchor ideal is so constrained that very few people can measure up or fit within the window of opportunity (Diamond, 1980). Some of the aspects that have been thought essential to TV journalists' successful performances are that anchors should be more than just news readers and must possess intelligence, be able to think on their feet, and have a firm grasp of the stories on which they report. They must be able to write and report well but not *too* well. It has been suggested that CBS' Eric Sevareid became a commentator rather than an anchorman because he wrote and spoke complex thoughtful sentences (Diamond, 1980). While the anchor must convey a sense of intelligence and grasp of the story, his ability to connect with the common man is supreme among prized attributes. And although some in the community wish it was not the case, one's ability to speak simply and clearly so as to be understandable to the masses is sometimes regarded as incongruous with highly sophisticated or developed writing and reporting; those abilities put the TV journalist in another job category.

The ideal anchor must also be in the right age range—not too young or too old. According to a network past president in 1980, Mike Wallace would have been considered a candidate for Cronkite's anchor job a few years earlier when he was younger (Diamond, 1980). Additionally, as has been established, the ideal anchor must have certain "cosmetic advantages"— voice, presence, good looks (but not too good)—and display appropriate amounts of real emotion. Finally, the anchor must be a "company loyalist" and a "team player" who can "reflect the self-images of the people within the news organization" (Diamond, 1980). Meeting all of these criteria is a tall order. Tom Brokaw admitted to having tried to get rid of his "famous guttural l's," saying that "It mostly comes when I get tired or lazy with it. But, yes, I had a very good speech therapist in Omaha" (Zoglin, 2004). In the beginning of his career, Peter Jennings also worked to eliminate traces of his

Canadian accent for American television (Yellin & McGrady, 2005).

Some members of the community feel that the focus on the anchor's overall signature that is the product of many indefinable qualities sometimes leaves room for individuals to succeed professionally even when lacking the more cerebral qualifications:

> What seems to be valued on TV today is that people be unusual looking or have some kind of charisma, and that emphasis can be as superficial and unfortunate as an exaggerated emphasis on attractiveness. I think in the short run, the "performance" factors are over-emphasized by hiring executives (Joie Chen, CNN anchor, 2000).

It is not that the community completely rejects that signature is a part of the TV journalist's job. They object to the proportion of the job that it occupies and the prioritizing of signature over other qualities:

> There are performance aspects to it.... There are common sense aspects to it. There are aspects of discretion that come only with maturity. But that's all quite aside to reportorial basics and skill, some of which can be acquired and so on.... There are a lot of very pretty people on the air who don't know the first thing of what they're actually talking about. Who know, for example, that the way they actually talk should have this up and down broadcaster cadence, but who don't know where that actually comes from, which of the radio and then TV legends actually bequeathed that to us. They just know they have to do it. And I saw a very beautiful and brainless female correspondent recently say something like, "The suspect has been identified as—he's a 26 young year old...." She got tripped over her words and what it showed you was she knew there was supposed to be a certain kind of cadence to this...but she really was just throwing this out. It's like she knows that there's supposed to be X number of syllables (personal interview with Washington correspondent for one of the cable networks, 2006).

Despite the community's disapproval, the elusive "je ne sais quoi" of successful anchors' signatures is something anchors strive to achieve and something networks and audiences demand. Aside from an individual anchor's signature, the on-screen chemistry of dual anchors or anchor teams is as elusive and important. It is widely believed that the success or failure of many programs is directly correlated with the real and perceived ability of their co-anchors to complement one another and mesh personae. To name a few, the pairings of Katie Couric and Bryant Gumbel on the *Today* show, of

Barbara Walters and Harry Reasoner on ABC's evening news, of Tom Brokaw and Roger Mudd on *NBC's Nightly News*, and of Connie Chung and Dan Rather on CBS' *Evening News*[1] are all examples of anchor pairings that either lacked chemistry or did not have the right type of chemistry to make them viable with television audiences. In the failed team of Couric and Gumbel, the different signatures that could have worked as perfect foils to one another—he was pompous and ornery, she was good-natured and perky—instead led to the team's demise.

A lack of chemistry has similarly been blamed for the failure to achieve viewer loyalty in CBS' *Early Show*. The anchor's identity, as it is constructed through gender, race, ethnicity, age, and performative style, is held partially responsible for these successes or failures. Star Jones Reynolds' abrupt announcement in July 2006 that she was leaving ABC's morning program *The View* provoked much speculation and discussion in the press about the circumstances surrounding her departure ("Questions Surround Star Jones Reynolds' 'View' Departure," 2006). The only African American member of the show's team, Reynolds' contract was not renewed due to poor personal audience ratings. Incoming co-host Rosie O'Donnell had also made hostile remarks about Reynolds' lack of honesty about her appearance-altering procedures, and in all of the coverage of her weight loss and plastic surgery, it seemed as though Reynolds underwent these procedures to appease her own vanity, not for the health reasons that were cited in *Today* weatherman Al Roker's surgery. The negative press coverage was accompanied by discussion of her "excessively self-involved and pandering" behavior that included getting sponsors to donate free items for her "over-the-top" wedding ("Star Jones Says 'View' Partners Planned to Deceive Audience," 2006). In the end, Reynolds' signature no longer worked with those of the rest of *The View*'s hosts.

Just weeks after the announcement about Reynolds, *The View* was already actively searching for a replacement. Critics observed that the "roster of young women, none of whom have talk-show experience, suggests producers might be 'finding people they can groom into something. They did that with Star'" (Thomas, 2006). It was also suggested that "now that *The*

[1]. One survey by the Gallup Organization for Entertainment Weekly in 1993 found that the majority of respondents (61%) said they'd prefer to watch the CBS *Evening News* with Dan Rather and Connie Chung over watching the *Evening News* with Dan Rather by himself (Fretts, 1993).

View has all white hosts, it's just a matter of time before they'll want to consider the African-American audience" (Thomas, 2006). While *The View* team once possessed successful chemistry, the departure of Vieira for *Today* and the forcing out of Reynolds placed the show temporarily in limbo. On the other hand, it is believed that the on-screen chemistry of Diane Sawyer and Charlie Gibson on *Good Morning America* and of the *Today* team that included Couric, Lauer, Ann Curry, and Al Roker was what propelled these programs to the top of the ratings. The *Today* ensemble cast presented a façade so well glued that they touted themselves as a "family," and many viewers went along. For this reason, the introduction of Vieira as Couric's replacement was crucial. In the first *Today* broadcast with Vieira (September 13, 2006), the program signaled that things would be different—a new studio, a new family member, a "new day." But it also assured viewers that they would be getting more of what they had come to expect from Couric: the giddiness, the flirtatious joshing with co-hosts, and a large amount of self-disclosure to facilitate that essential rapport. For decades, networks have been trying to replicate the on-screen chemistry of the Huntley-Brinkley duo,[2] but their success has been hit or miss. This suggests that the matching of anchor signatures is a delicate task, and one in which success is difficult to engineer or predict. Much like a romantic relationship, even when each party's statistics seem to align on paper, there is no way of telling with which pairings a spark will ignite and what roles each party will assume.

Despite the inconsistent record of co-anchors and anchoring teams of the past, networks revisited co-anchoring and rotating anchor formats in 2005 and 2006. According to one report in the *New York Times*, ABC news president David Westin said the job had become too big for just one anchor ("ABC Names 'World News Tonight' Anchors," 2005). Three anchors replaced Ted Koppel on *Nightline*, and Elizabeth Vargas and Bob Woodruff were paired as the new ABC *World News Tonight* team. Vargas' appointment to the anchor chair was discussed as noteworthy as she was the first woman of Hispanic descent to be a network evening news anchor. Whereas previous female-male evening co-anchor pairings did not achieve the networks' desired ratings, and the female anchors were dominated by their male co-anchors, when Vargas assumed the co-anchor role, there was

2. Although even the Huntley-Brinkley chemistry eventually disintegrated when, in 1967, they publicly disagreed over an AFTRA strike that included a labor stoppage at NBC (Alan & Lane, 2003).

speculation that she might be the stronger of the two anchors—that she might push her male co-anchor Bob Woodruff to the wayside. That speculation quickly subsided after Woodruff was seriously injured while on assignment in Iraq in January 2006. Ironically, in a *Washington Post* article that came out on the same day he was injured, Vargas was quoted as saying that she had been envious that Woodruff had been traveling the world on assignment while she was at the anchor desk in New York (Kurtz, 2006). This arrangement—one at the desk in New York and one reporting from the field—was a new experiment in formatting that ABC had been pushing as an alternative to a single-anchor, traditional newscast replacement for Peter Jennings.

So far, there has not been a successful male-female pairing on the evening news. The Vargas-Woodruff pairing was too limited in duration to be evaluated critically. Male-female teams seem to find favor in the morning, and that was likely the reason *Good Morning America*'s executives added weatherman Chris Cuomo to the post-Gibson all-female cast (Jensen, 2006). Ensemble anchors must also be able to act and gab as a group, one in which the members like each other. Although it has often happened that among the ensemble cast, one anchor emerged as the alpha member, the viewer fiction that the anchors must create and exhibit is that of a cohesive team. Recent anchor tenures have made the evening news the time slot considered to be reserved for the soloist in the modern era. Katie Couric and CBS will continue to work to re-create her signature in the more solitary and composed atmosphere of the evening news. Prior to her *Evening News* debut, CBS embarked on an image-altering campaign for Couric that rivaled that of the most expensive and extravagant political campaigns (Steinberg, 2006e).

As they had in the past, at these recent junctures at which the journalistic community faced uncertainty caused by on-camera personnel changes, its members resorted to two familiar strategies—retooling the news program format and hiring anchors they thought would bring different styles to the job. In trying to achieve particular signatures, networks hazarded their educated guesses as to how to pick the perfect candidate who would exude the desired style based on the mix of the candidate's appearance, personality, and emotion. In cultivating these signatures across the decades, anchors and their benefactors spawned some controversial by-products—celebrity and fame—that would complicate journalists' cultural authority.

The By-Product of Signature: Fame

Watching the TV news anchors night after night, audiences come to know anchors by their appearance, personality, and emotion that comprise their signatures. Beyond the bond that audiences form with particular anchors, the appearance of anchors on the news, combined with their presence in other formats and venues, has catapulted them to star status. This status—an offshoot of the dimensions of the TV anchor as magnified on television—is seen as both desirable and despicable in the community.

The public has always been fascinated by people who report the news (Shepard, 1997). But the public's association of particular journalists with the stories they report is a more recent occurrence. Bylines came into general use only in the last 25 to 30 years as newspapers tried to personalize their approach. Until the television era, print journalists were the celebrities, with radio journalists temporarily becoming prominent. As has been outlined, amidst the cacophony of events that changed the social and political fabric of the nation in the 1960s, television journalists who covered those events became familiar names and faces to increasing numbers of viewers. This was a period in which the status of both television as an information medium and television journalists as the conduits of information in this new form was elevated sharply.

Gamson (1994) and Turner (2004) point to the significance of visual technology's role in fostering celebrity. Photography lent new importance to the representation of the individual and was increasingly employed in the media. The 'dissemination of the face' displaced the dissemination of ideas, laying the ground for the 'publicizing of people' (Gamson, 1994: 21). Daniel Boorstin described the celebrity anchor phenomenon in a nutshell: "Journalists are the creators of well-knownness. In the process of creating well-knownness for others, it's not surprising that some of them become celebrities too. It's inevitable" (Shepard, 1997: 26). Fame was a natural outcropping of journalists' appearances on TV night after night, but the journalistic community would come to view the fame that some television journalists achieved through their coverage of events of the sixties and seventies, and on into more recent decades, as both beneficial and detrimental to the community's overall well-being.

Whereas print and radio journalists became well known for their reportage, the fame of TV journalists is qualitatively different because they are *seen*. In this case, the medium through which they deliver their message

makes the difference. While a print or radio journalist gains recognition through his or her written or aired reports, most audience members do not know what he or she *looks* like. Therefore, these individuals are not easily identifiable at events in their public and private lives and thus do not become the targets of paparazzi chases and the subjects of water cooler conversation (aside from those about the actual content of their columns). Their pictures do not usually appear in the latest installments of celebrity gossip magazines. As is mentioned elsewhere in this book, this is changing as synergy increases across media platforms and journalists of one medium appear in another, but for the most part, it is still true.

Some observers believe that the legacy of TV journalists' coverage of important events and scandals such as Watergate is that "journalists were elevated to the status of elite celebrities which benefited a select few while harming the profession as a whole" (Shepard, 1997: 19). Celebrity journalists are distinguished by being noted more for who they are than what they are reporting. The details of their professional and personal lives become the subjects of news in themselves, sometimes overshadowing the *real* news they are supposed to be reporting. It has been suggested that having "superstar" status can make it difficult for a journalist to succeed on "the serious side of news broadcasting," as with Katie Couric's move to the *CBS Evening News* (Robert Thompson, head of the Center for the Study of Popular Television at Syracuse University, in Deggans, 2007). Thompson (in Deggans, 2007) believes Charles Gibson's transition to the evening news was eased by his lower profile and lack of "superstar" status. TV anchors become subsumed in a celebrity category that includes television and movie actors, politicians, and leaders in all other types of sectors. As a result of their ability to captivate audiences, "[anchors] are lionized, treated like movie stars...paid millions of dollars, and often ranked on a short list of the most important and trusted people in the nation" (Yoakam, 1993). Members of the community who unfavorably view the TV journalist's fame reason that "inevitably, the public comes to perceive journalists as being self-serving and arrogant," and "paradoxically, respect for journalists decreases as interest in them as celebrities increases" (Shepard, 1997: 19; Braudy, 1986). These critics of celebrity journalists question whether celebrity network news anchors are even journalists at all:

> Journalists are not supposed to produce "acts" themselves but rather produce discourse about the "acts" of others. As a specific type of

journalist, anchorpersons are farthest from the "acts" of others. They are the most distanced from the events they report, the least reportorial of all journalists, sitting and observing rather than doing (Zelizer, 1989: 79).

Others lament the status that celebrity anchors have achieved because of the undeserved power these critics feel they exert:

> ...uninvited, unelected, and with almost no public debate, [the anchors] have taken their place beside presidents, congressmen, labor leaders, industrialists, and others who shape public policy and private attitudes.... Of all these influential figures, however, only the anchor is in a position to exert personal control over the nation's primary medium of communication, the evening news...the inevitable potential for distortions in a system that elevates a single individual to a position of such power....Today the anchors of the evening news have become so powerful that they can cause the careers of correspondents to blossom or fade or they can derail the careers of executives to whom they nominally report (Matusow, 1983: 1).

However, the fame to which television journalists have risen was not achieved without assistance from industry machinations and journalists and industry employees. The networks, and not just the anchors, are culpable of creating and perpetuating the celebrity anchor frenzy through their "near-hysterical pursuit of individual stars" (Matusow, 1983: 279). Zelizer (1989: 75) observes that a multifaceted process undertaken by the "celebrity industry" contributes to the fame of TV journalists:

> Largely the result of advances in mass media technology, stardom today emerges from an intricate interlinking of different kinds of mass-mediated texts. The combination of promotional and publicity activities, coupled with the repeated and routinized mass media appearances of public figures within different production modes, have made possible the extension of celebrity status to different kinds of public actors. This is perpetuated by an elaborate industry for public discourse, which regularly engages in commentary, and criticism about these figures' professional (and nonprofessional) activities.

These assessments have been borne out in specific examples. Geraldo Rivera claims that in the early 1970s, he answered the networks' call for the "Beautiful Ethnic" and soon after, the "television news bosses" who see to it that their personalities become stars "created" him (Powers, 1978: 184). Akin to Zelizer's (1989) application of Lowenthal's idols of consumption

and production framework to the celebrity anchor phenomenon, Rodden (1989) also supports the notion that the success of celebrity anchors in part depends on the celebrity and media industries and institutions and on audience response. According to Rodden, "a person attains stardom upon the fortuitous convergence of his characteristics and a subject's projected desires." The responses of audiences contribute to making anchors stars, in addition to authoritative voices within groups that influence the "radiation of reputation" at group level, and the institutional network of production and distribution which circulates and values the anchor's reputation (75). "No reputations germinate in a value-free environment; all reputations flourish or perish in light of relations and access to power and influence" (xii). Thus, reputations are invariably "political," enmeshed in ideological beliefs and emergent from within concrete forms of social and institutional life. In his chronicle of fame, Braudy (1986: 3) concurs on this point with Rodden that "from the beginning fame has required publicity," but Braudy (1986: 5) also notes the celebrity's complicity in his or her own fame ("societies always generate a number of people willing and eager to live at least part of their lives in the public eye"). Anchors are some of these people.

Still, the repercussions of TV journalists' fame for the community are not all negative. Because news anchors are the most well-known U.S. journalists due to their highly visible positioning on TV, viewers identify with the anchors and form affinities and attachments to certain anchors that lead to reliable viewing behavior. The network news anchor is a unique type of journalist. He is crucial to network image and promotion and is important in terms of developing audience size (Becker et al., 1987). In this regard, celebrity journalists can be good for journalism: "People watch...TV shows because they enjoy the approach—even the timbre—of certain well-known correspondents. This is actually good for journalism. The people are well-known based mainly on something in their work, and their renown gets people to pay attention to the news" (James Fallows in Shepard, 1997:11).

Journalistic fame can serve other instrumental functions. TV journalists have found that their own celebrity can enhance their ability to "get" interviews and stories, even while it may hinder them in other ways. Barbara Walters has said that rather than hurting her in terms of getting stories, her celebrity has actually helped her occasionally in meeting future subjects (Powers, 1978: 177). The downside of this fame, as others have suggested, is that the fusion of the anchor's celebrity identity with that of his or her

interview subject can interfere with objective news coverage (Powers, 1978). Although some journalists find the idea of the reporter as pop media star offensive and have said that "the good journalist does not become part of the story he covers" for "a newsman does not *make* news [my italics]" (Rather, 1978: 279), others write that "network reporters and anchorpeople inevitably become celebrities in the same league as the newsmakers they cover" (Powers, 1978: 177). Cronkite was on George McGovern's list of potential vice-presidential candidates in 1972; Geraldo Rivera considered running for mayor of New York, and Barbara Walters socialized with Henry Kissinger. In 2006, CNN's Anderson Cooper came under fire from community critics for his celebrity antics, including injecting himself into an interview he conducted with movie star turned humanitarian, Angelina Jolie, and creating an interview atmosphere that resembled a conversation between two members of an elite club (Stanley, 2006a). Public perceptions that celebrity anchors move in the same social circles as the people they cover can lead to the appearance of compromised objectivity. Celebrity anchors also sacrifice personal privacy as part of the price they pay for the benefits of their success and fame. But as Rather discussed (1977: 274), anchors "cannot retreat from the curiosity of the very people whose interest your job depends upon."

While anchors themselves may not always take action to publicize their personal activities, they also do not shy away from coverage they garner. If personal activity makes the journalist look good and be perceived as more likable to audiences, then the information that has become public is usually deemed acceptable by the community and the networks. Unlike the humdrum facts about anchors of previous generations that became public knowledge, such as knowing that Walter Cronkite's father was a dentist and that he was from Missouri, as a result of the cultural obsession with celebrities, the personal information about today's anchors that makes it into the press is much juicier and potentially explosive. Katie Couric's first public relationship since the death of her husband years earlier was her on-again, off-again bi-coastal romance with TV producer Tom Werner, of Carsey-Werner Productions. The relationship became tabloid fodder, and pictures of the couple on outings in the Hamptons were splashed across the pages of celebrity gossip magazines and TV shows (Silverman, 2000). But if anything, the publicizing of the relationship only drew positive attention to Couric, who was painted as the widow who was now giving love a second chance. Capitalizing on the positive attention, the anchor granted a cover

story interview to *Good Housekeeping* magazine in November 2003 in which she discussed her love life, among other things.

Other celebrity journalists' personal relationships and events that have received widespread attention include Andrea Mitchell's romance with and then marriage to former Federal Reserve chairman Alan Greenspan and the marriage of *Wall Street Journal*'s Al Hunt and CNN's Judy Woodruff. Both marriages could have been seen as conflicts of interest, but instead, because they were publicly presented with care, both only elevated the status of the spouses involved (Roberts, 1997; Johnson, 1997; "More 'Power Couples,'" 1998; Rohrlich, 2002; "In Praise of Couples Who Stay the Course," 2004). These, like other news unions,[3] are alliances that serve to solidify the status of each person involved. Given the demands of journalists' jobs, it is not surprising that they date within small, elite social and professional circles. As she explains in her 2006 autobiography, Mitchell took great pains to maintain the wall between her marriage to Greenspan and her professional journalistic work. Although Greenspan and Mitchell were not secretive about their 1997 wedding, other journalists have vouched that Mitchell's relationship with Greenspan, as well as their outings together to the White House and to other affairs, do not impinge on her integrity or reporting (Johnson, 1997).

Other publicized anchor relationships include Kelly Ripa's appearance in television commercials for Tide-to-go stain remover pen with her husband, soap opera actor Mark Consuelos. Not only do they make their relationship public by allowing the paparazzi to snap pictures of their marital bliss ("Kelly Ripa Tells It Like It Is," 2005), but they exploit their celebrity marriage by appearing in the advertisements together. An allowance is made for Ripa, though, as she is not a conventional evening news anchor. She is co-host of *Live with Regis and Kelly*, a morning talk show on ABC, and the coverage of her marital bliss endears her to fans. Positive coverage of the birth of Christiane Amanpour's baby, as well as her marriage to James Rubin, former chief spokesman for the Secretary of State ("Frontline Journalist Has Baby," 2000; Cooke, 2000), NBC's Campbell Brown's marriage to Fox News analyst Dan Senor (Silverman, 2006), and the birth of Soledad O'Brien's children ("O'Brien: Two Girls Plus Twins Keeps Things

3. Some other examples of romantic unions among powerful news people include Neal Shapiro, former president of NBC News, and Juju Chang, ABC news reporter; Robert Iger, President and CEO of Disney, and Willow Bay, CNN anchor.

Busy," 2004; "Soledad O'Brien Gives Birth to Twins," 2004), collectively point to one conclusion: having children and dating or marrying someone respectable are seen as good things that positively impact the anchor's image. They highlight the human aspect of the anchor to audiences.

How TV anchors' fame functions in journalistic cultural authority

In addition to boosting audience ratings and rapport and the ability to obtain interviews, the anchor's fame is also central to the development and maintenance of journalistic cultural authority. The celebrity aspect of anchors is what makes them important spokespeople for the sub-community of TV journalists and for the journalistic community more broadly. The anchor is used to "focus attention on issues crucial to the community" and provide "institutionally correct notions of how to act" (Zelizer, 1994: 110). The anchor is employed by the network to legitimate journalistic authority through narrative and personalization (Zelizer, 1992). The network anchor adopts the role of interpreter, enabling him to speak authoritatively about events from a distant position (Zelizer, 1992: 135).

For these reasons, the journalistic community and the networks that employ star anchors sometimes look the other way and, at times, even condone and further the celebrity of journalists. In his 2000 autobiography, Koppel writes that the book contains opinions that he would never express on the air. This leads to an interesting question of why all journalists who seek to repress or hide their personal side on air feel that it is suitable to write about those areas of their lives in a different genre—an autobiography. Why is it acceptable to reveal personal sentiments in this medium? Why is there not concern that what is learned by readers will carry over to the television audiences, especially as often these autobiographies are published before the anchors' television careers are over, presumably so they'll sell? This practice is sanctioned by the journalistic community because it caters to and satisfies viewers' curiosity about TV journalists, furthering feelings of intimacy between anchors and audience members, who, having read the anchor's personal story, now feel as if they know the people who tell them the news even better.

The community and news organizations allow and even encourage TV journalists to publish these books because they perpetuate journalists' celebrity status, importance and authority. Zelizer (1992) discusses two ways in which journalistic celebrity is institutionally perpetuated—through

commemoration and recycling. Commemoration is generally organized around anniversaries of major news events and takes place in a variety of formats such as televised and printed retrospectives. These have included tributes to deceased and retired anchors; pieces produced to commemorate TV coverage of significant events in the nation's past; written accounts such as biographies, autobiographies, and other non-fiction books, and public self-examinations by journalists. For example, in 1983, CBS' *60 Minutes* devoted a program to looking at the anchors (Corry, 1983). Similarly, PBS's *Inside Story*, the series that examines the press, produced a program on anchors in general, and on Peter Jennings in particular in 1984 (Corry, 1984). Commemoration gives journalists routinized ways to promote their associations with major stories and to strengthen and reinforce their stature (Zelizer, 1992: 153). Recycling occurs when news organizations reprint or rebroadcast stories that originally appeared. This also reifies individual journalists' links with these stories and TV journalism's place in the telling and retelling of events. The activities of commemoration and recycling exploit celebrity as a memory system. They put journalists at the center of discourses of recollecting that involve discussions about technology and community standards. Recollecting through celebrity tales "thus effectively blurred distinctions between 'the event' and 'the event as told' in journalistic accounts" (Zelizer, 1992: 158). In these ways, journalistic fame serves to create and perpetuate the grandeur of individual journalists in journalistic lore. It cements journalists' places in history and their authority as the witnesses and sense-makers of these events—in short, it solidifies journalists role as cultural authorities.

In recollecting in order to maintain cultural authority, memorializations of retired and deceased journalists have taken the form of printed obituaries, interactive online slideshows, and televised tributes. Occasionally, even before anchors retire or die, their networks compile their greatest hits into videos and DVDs that are for sale to the public (Barbara Walter's "25 Years of Ground-Breaking Interviews" is for sale online in the ABC News DVD Collection). For the journalistic community, these tributes represent a kind of ritualistic reassertion, rearticulation, mourning and performance for the public all at once. As Carlson (2007) writes, "journalistic success, embodied by the deceased eminent journalist, is used to promote journalistic authority":

> The discourse around these figures shapes the collective memory of journalism by retelling the journalist's career through a framework that

positions the deceased journalist as evidence for the merits of journalistic values and norms. This discourse further occasions a public evaluation by journalists of the defacement of those values and norms in an attempt to support the cultural authority of journalism. In this way, memorialization simultaneously engenders an active affirmation and signaling of journalistic values among working journalists (Carlson, 2007: 2).

The act of memorializing reinforces the recognition of journalism's authority by its own members and audiences, a necessary element in legitimizing journalists' work. "The prevalence of media criticism underscores the point that journalistic authority is not assured automatically, but rather must be continually upheld, recreated, and negotiated" (Carlson, 2007: 166).

In these instrumental acts of memorialization, members of the older generation of TV newsmen are often referred to as pioneers and models of journalism's bygone glory days when standards were set and upheld. Upon his retirement from CNN, Bernard Shaw was discussed as one of the CNN founders who helped make 24-hour news a fact of life ("CNN Anchor Bernard Shaw Leaving the Network," 2000). NBC anchor John Chancellor was remembered as having helped define television news ("John Chancellor—In Memoriam," 1996). In discussions of Mike Wallace's retirement from *60 Minutes*, he was called a pioneer who helped invent the television interview (Steinberg, 2006). Women thus far have been largely excluded from these memorializations as their presence was not seen in force on TV until the 1970s: thus, most of them have not yet reached retirement age.

Lengthy retrospectives are usually reserved for time slots soon after an anchor's death. Although they are still discussed, less time and fanfare are devoted to retirements. Untimely deaths, particularly when anchors are still in their prime (such as Peter Jennings and David Bloom), prompt the most elaborate displays by the community. Jennings was memorialized as having become the youngest national network anchor when ABC News hired him at the age of 26 in 1964, as a pillar of the "Big 3," and as marking the end of a television era (Steinberg, 2005). Bloom represents a different context of discourse in memorialization—journalists killed in action (KIA) (Carlson, 2006). In his memorializations, Bloom was remembered for his "human connection," as a "consummate pro," "the face of the Iraq war," and a "reporter at heart" who "chafed at being anchor" (Alter, 2003). KIA journalists like Bloom are granted war hero status by the journalistic

community. Bloom was also remembered as a pioneer of a new satellite technology he was using at the time of his death. Similarly, after the death of CNN correspondent John Holliman, his Persian Gulf War coverage and honors he received were all mentioned in material the network released ("CNN Correspondent John Holliman Dies in Car Crash...," 1998). Again, the construction of memorialized journalists as pioneers and heroes reasserts their place in cultural history and vests them with hallowed status.

For this reason, the controversies that marred some famous anchors' reputations later in their careers were conspicuously omitted or hidden within articles of memorialization. David Brinkley and Dan Rather were both discussed as grand figures in the TV news arcade. Although discussions of Rather's retirement alluded to his professional mishaps including "Memogate" (Johnson, 2005), at the time of Brinkley's death, ensuing discussions omitted mention of his controversial ties to ADM ("Pioneer Newsman David Brinkley Dies at 82," 2003; Conan, 2003).

Who is chosen as the "agent of memorialization" (Carlson, 2007) is as telling as the form and content of the memorial itself. The most prominent faces from today are selected to be the agents of memorialization for the biggest names of yesterday. After the death of Peter Jennings, his famous news colleagues at his own network and others, not to mention President George Bush, offered their words and memories of the celebrated anchor ("Former Friendly Rivals Remember Jennings," 2005; "GMA Anchors Recall Peter Jennings," 2005). Jennings praised Brokaw when he retired in 2004 ("Brokaw Says Farewell to 'Nightly News,'" 2004). These agents take on a double role of constructing the memorialized subject as an elite figure while affirming, through their authority to speak, their own status as elite figures and authorities (Carlson, 2007).

The Hierarchy of Journalistic Cultural Authority[4]

Within American journalism, contestation persists about who is considered a journalist and who should be included in the journalistic community or in *which* journalistic community (Borden and Tew, 2007; Hayes et al., 2007; Ugland and Henderson, 2007). The journalistic community defines itself in

4. Portions of this section were previously published in "The Hierarchy of Journalistic Cultural Authority: Journalists' perspectives according to news medium." *Journalism Practice*, Vol. 3, No. 1, February 2009, pp. 59-74, and are reprinted here with the permission of the publisher, Taylor & Francis Ltd. http://www.tandf.co.uk/journals.

part "by proclaiming the moral seriousness of its most cherished ... forms," and these forms are used by working journalists "to take one another's measure" (Oates & Pauly, 2007: 332).

On one hand, the journalistic community wants to reap the positive benefits of the television journalists' external fame and recognition by the outside world, but internally—inside the community—TV journalists are still considered the problem partners of the field. Internally, they are talked about as inauthentic, whereas print journalists are the genuine craftsmen. So there is a discrepancy between externally, those the public most readily identifies with, and internally, those the journalistic community values most.

Television has affected the levels of credence that journalists believe audiences pay to different types of media and the levels of legitimacy and professionalism that different journalists attribute to various types of journalism (i.e., print, radio, broadcast, online). Internally, the credibility of television anchors is questioned and their status sometimes resented:

> Many outlets fail to do a good job of distinguishing between opinion and fact. As a result, audiences see people who look like one another on sets that look alike with similar graphics either expressing strong opinions or reporting the facts. Is it any wonder that the audience starts to believe that it's all the same? ...We could end up in a world where, implicitly, none of us—not the audience and not the reporters—even believe any longer in the truth (Former ABC News President David Westin, 2005).

Some journalists question whether TV anchors and hosts should even be considered journalists at all. These discussions, in particular, raise the issue of the titles these people are given. Critics point out that although TV newspeople in the United Kingdom are rightfully referred to as "newsreaders," accurately reflecting what they actually do, a marked difference exists in the way they are regarded and talked about in the U.S.:

> ...the English have no use for imperial trappings for their television newspeople. It would never occur to them to describe them as 'anchor man' or 'anchor woman.' It is quite enough to call them what they are: 'news readers' (Valenti, 1984).

Reflecting the difference in regard for anchors in the United States and Britain, in 2007, the highest paid anchor in Britain, Natasha Kaplinsky, was referred to as a "presenter" by the head of BBC News and was reportedly earning one million British pounds on Britain's Channel Five evening

newscast, compared to Katie Couric's more than $15 million per year (Dowell and Holmwood, 2007). Like Couric, Kaplinsky had co-presented the BBC 1 breakfast TV show, and she was also a contestant on the British program *Strictly Come Dancing*, before being promoted to reading the 5pm and 7pm news. The British press refers to her as a newsreader or autocue reader (Walden, 2008; Eyre, 2006) and even an "autocutie." Canadian anchors have petitioned for salaries on par with their U.S. counterparts, but even the most well-known anchors there earn salaries significantly lower and are less influential than the most famous U.S. anchors (Miller, n.d.; Rutherford, n.d.).

Although the terms "anchor" and "host" are often used interchangeably in the U.S., some journalists see a clear distinction. Commenting on the trend toward informality and having anchors "befriend" the audience on TV news, in the tradition of the "happy talk" instituted by consultants in the 1970s, former public radio reporter Brad Linder said he thinks "there's a lot of phoniness in that. Exactly what turns me off more than anything is when they're trying so hard that you don't respect them as a person. You think they're a person, but you think they're a person who has a really bad script" (personal interview with Brad Linder, former WHYY public radio reporter, 2006). In fact, he said that the word "anchor" may be a misnomer in these cases: "Well, I don't know if I'd even use the word anchors so much as host—on those morning programs."

At a panel discussion held at the Newseum in 2009 (IFC, 2009), Fox News' Greta Van Susteren and NPR's Juan Williams, a cable news anchor and a radio correspondent, respectively, engaged in a public argument about journalistic legitimacy. Williams said to Van Susteren, "What you do on your show is not reporting. People watch Greta and they think they're watching a news show." Van Susteren replied, "At least they watch," a dig at the diminishing audience for straight news reporting and radio news in particular.

However, externally, community members have demonstrated their recognition of the evening television news anchor as the pinnacle of the journalism hierarchy:

> For more than two decades, the magnitude of a news event could be measured, at least in part, by whether Mr. Jennings and his counterparts on the other two networks showed up on the scene. Indeed, they logged so many miles over so many years in so many trench coats and flak jackets

that they effectively acted as bookends on some of the biggest running stories of modern times (Steinberg, 2005).

What is clear from both sides of this discussion is that television journalism and its accompanying celebrity have blurred the traditional guidelines for cultural authority by obscuring the lines between opinion and factual reporting and between news and entertainment. As Baym (2005a) observed, "discourses of news, politics, entertainment and marketing have grown deeply inseparable; the languages and practices of each have lost their distinctiveness and are being melded into previously unimaginable combinations" (262). This deeply troubles many in the journalistic community. Writing about the signing of Matt Drudge to ABC Radio where he won't be subjected to the same standards that apply to ABC Radio News reports, former ABC *Nightline* anchor Ted Koppel found this a matter of concern:

> He presents himself as a reporter, and ABC Radio listeners can be excused for assuming that the standards for one reporter appearing on ABC Radio are the same as for all others. If Drudge's flexible attention to accuracy is to be the new standard, that's not a comparison I cherish. (2000: 162).

CNN anchor Lou Dobb's opinionated style has also stirred controversy among community members. As an article in the *New York Times* (Swarns, 2006) pointed out, "by repeatedly presenting his forceful opinions on illegal immigration and other subjects…Mr. Dobbs has stepped squarely into the debate over whether cable news anchors are breaching the bright line that has traditionally separated commentary from news." Some journalistic organizations and analysts have said that Dobb's style falls into the tradition of advocacy or point-of-view journalism (Tom Rosenstiel, director of the Project for Excellence in Journalism, in Swarns, 2006); others are concerned that "cable executives continue to bill such programs as traditional newscasts without flatly and clearly stating that the rules of the game have changed."

Dobbs represents those television journalists who have made it their trademark to brashly provoke, taunt and argue with interview subjects about topics on which they clearly have an opinion. And although these techniques defy community norms, they are once again sanctioned by networks when

they lead to increased viewership.[5] These program formats also blur the ideological lines between news and entertainment. In 2006, Lou Dobbs created a firestorm when he continuously sounded off on his program with strong criticisms of illegal immigration. Although CNN's ratings increased and in February 2006, Jonathan Klein, the president of CNN's domestic networks, said CNN had been encouraging anchors and journalists to bring more personality to the news (Swarns, 2006), just one month later, Klein said that CNN did not see its programming or anchors moving toward an opinion-centered format (Carter & Steinberg, 2006). Echoing those who, decades earlier, had argued against journalistic advocacy (Downs, 1968), Koppel (in Swarns, 2006) said that anchors and reporters who blend commentary and news should not describe themselves as journalists: "The moment you start inserting your own passions, in whatever direction, it ceases to be journalism."

At the center of this debate is the question of whether certain types of journalists should have the exclusive rights to journalistic cultural authority. The issue also involves differing conceptions about what the "right" kind of journalism is and who its purveyors should be. Although journalists continue to push traditional boundaries, the community has not yet reached a consensus about whether it will make room for the kinds of journalists and journalism that straddle these lines.

Critics from all sides contend that journalists fail to fulfill their democratic roles by adopting biased perspectives in their reporting of the news (Goldberg, 2002; Coulter, 2002; Ackerman, 2001). In recent years, there has been a proliferation of opinionated anchors, or hosts, on news programs. Fox News' Bill O'Reilly prides himself on providing news from "a working-class point of view" and is widely thought of as conservative although he maintains that his views are not (Ackerman & Hart, 2001). Because the most prominent opinion-mongers in cable, including O'Reilly, Sean Hannity, Joe Scarborough, and Tucker Carlson, are unabashed conservatives, MSNBC's Keith Olbermann, who says he finds himself "in

5. Although an anchor who is well known and favorably perceived is the best scenario for a network and its ratings, an anchor who is well known and disliked is still preferred in terms of ratings than one who is liked but unknown. Examples of these two cases are Bill O'Reilly, who was widely known but rated unfavorably by a high percentage of respondents, and Brian Williams who was favorably rated but known to fewer respondents, according to a 2006 Gallup poll (Newport & Carroll, 2006).

the same part of the ballpark as a lot of liberals," attracted attention for his criticism of the Bush administration (Kurtz, 2006c). The slide into conservatism of Fox News's Brit Hume, formerly of ABC News, also did not go without notice (Kurtz, 2006d).

Expressions of opinion have always been readily accepted by the journalistic community when they are demarcated as such. Traditional journalistic norms have condoned op-ed sections of newspapers and opinion columns for decades, so long as they are clearly cordoned off from the rest of the paper. Movements such as new journalism and advocacy journalism entailed the insertion of the journalist's perspective and opinions in stories. Therefore, what is really at issue is not that these are journalists on TV expressing their opinions, but that they are doing so under the auspices of news programs and news divisions and being billed as news and not commentary. Another factor in the distaste for opinion journalism on TV may be that TV visually exploits the spectacle of bombastic sounding off. So something journalistically unattractive is visually interesting to viewers, benefiting network ratings, and making it even more distasteful to traditional journalistic values.

A slightly different phenomenon has also been discussed in the press: the politics-journalism "merry-go-round" that some TV news personalities are on (Kurtz, 2006e). Tony Snow, George Stephanopoulos and Tim Russert are among those who have made the journey from politics to journalism, and in some cases, back again. Snow, a former speech writer for the first President Bush, was the host of *Fox News Sunday* from 1996 to 2006, when the White House announced he would succeed Scott McClellan as the new White House spokesman. Stephanopoulos, a former political adviser to President Clinton, presently hosts ABC's *This Week*. Russert, formerly NBC's Washington bureau chief and host of *Meet the Press*, until his untimely death in June 2008, worked for Democrats Mario Cuomo and Daniel Patrick Moynihan before leaving politics in 1984. Chris Matthews, Joe Scarborough, Mary Matalin, James Carville and Pete Williams are also on the list of those who have jumped between politics and television. As Kurtz (2006e) writes, the list "could fill an entire newspaper page."

In addition to opinion journalism and the revolving door between journalism and politics, community members attribute other factors to the sense that "the anchor chair isn't what it used to be." Some hold the

increasing presence of tabloid content on the news responsible for "the entire industry's stumble backward":

> The anchor, of course, is the ultimate symbol of hard news—the stern-jawed figure who appears when the going gets tough. The problem is that broadcast news has relatively little patience with that approach, creating a few lonely islands of such sobriety surrounded by a turbulent tabloid sea...they're as apt to be...discussing Britney Spears' love life, as they are to be reporting on anything truly substantial. These fluffier pieces are otherwise known as the stuff that pays the bills (Lowry, 2004).

Print journalism as the top of the authority hierarchy in many respects

Whatever the community's opinion is of television journalists and television news as compared to other types of journalists and journalism, it is most often conveyed through the printed press.[6] Through printed journalistic discussions, it is clear that media beat reporters and writers for the major newspapers are largely the arbiters of professional decency and standards (Fengler, 2003). Scholars who have examined media self-criticism have found that it may play one of several roles. It may aim to expose and eliminate external threats to journalistic coverage or serve to persuade the public that news organizations are capable of self-improvement and self-regulation (Haas, 2006; Zelizer, 1997). In this way, it may be a kind of ritual sacrifice, performed in the hope that it can persuade the audience to regain its faith in journalism and to sustain ratings and readership (Bishop, 2001). So although they do not possess the outwardly identifiable celebrity of their TV colleagues, these print media beat reporters become famous in their own right in a different capacity.

Since the advent of TV news in the 1950s, a handful of key media beat reporters have authored the bulk of the stories on the field. Among the critics with the most impact in the early days were Jack Gould of the *New York Times*, who reported between 1946 and 1972, and Lawrence Laurent of the

6. Sean Aday (in Entman, 2004) has also constructed a hierarchy of news sources, but rather than according to cultural authority within American journalism, Aday's ordering is in terms of the medium's ability to spread information and activation of counter-frames. He ranks types of news organizations by their ability to shape a given news story and pass it along to other outlets. In his scheme, he places elite newspapers at the top, followed by television news, and then radio and magazines. Aday's hierarchy is a key component of Entman's Cascade Model Theory.

Washington Post in the 1960s and 1970s ("Television Criticism (Journalistic)," n.d.). Among longtime syndicated columnists, in addition to *New York Times* and *Washington Post* columnists distributed nationally, were Associated Press' Cynthia Lowry and Jay Sharbut. Weekly and monthly magazines and trade publications such as *TV Guide*, *The Hollywood Reporter*, *Variety* and the *New Yorker* developed well-known TV beat writers as well. The *Washington Post's* Tom Shales from 1977 onward, the *New York Times'* Jacques Steinberg and Alessandra Stanley, the *Philadelphia Inquirer's* Gail Shister, and Howard Kurtz, who doubles as columnist for the *Washington Post* and host of *Reliable Sources* on CNN, are among the most prolific and highly regarded media reporters of recent times. Even TV executives themselves acknowledge the position of these media reporters and have been known to tell inquiring employees to read these reporters' articles to gain information about the goings-on in their own organizations. Because all discussions and reports about television journalists in the printed press are written by print journalists, even when these reports are not expressly about one type of journalist's perceptions of another, they are revelatory due to the mere fact that print journalists are the writers.

Further confirming the role that print media reporters play in articulating and creating a written record of community opinions, many television journalists make reference to things they read about their field in print. For example, in a personal interview with NBC News correspondent Andrea Mitchell (2006), Mitchell paraphrased from an article about Bob Schieffer that had run in that morning's *New York Times*. The autobiographies of anchors are also littered with references to print articles they have read about journalism in general and about themselves in particular. They are blatantly self-aware and self-conscious of the printed press's coverage of them and their craft. In his book, Koppel (2000) cites what he reads about himself and the media in *Newsweek*, Howard Kurtz's column in the *Herald Tribune*, and the *Wall Street Journal*. In her autobiography, Stahl (1999) also admits to reading and caring about what is written about her and her field in print, including a column by William Safire in the *New York Times* about women reporters, an article by Tom Shales in the *Washington Post*, and criticism in *TV Guide*. Similarly, as portrayed in the 2005 movie *Good Night, and Good Luck*, the journalists in the movie care what the newspaper critics write about them—they eagerly await the first early edition in the morning. There are two layers—they care about what is written for themselves and they care to

know what viewers will read about them. Thus, it is evident that when the interpretive community of journalists seeks to disseminate its verdict on a particular issue or event, it does so through the printed press.

Though the community is large, print media reporters establish relationships with select members of the community who become their go-to sources on hot topics. Correspondingly, when the community feels the need to express its feelings regarding certain issues, it does so through particular voices. Spokesmen for journalistic organizations such as SPJ, BEA, NAB, RTNDA, and PEJ as well as elite members of the field such as network anchors, national newspaper and magazine editors, and TV and radio news executives, are often the unofficially designated voices. There is no formal election to decide who will speak through the press for the community, but members of the community learn through informal channels that the media beats of popular press publications, as well as printed professional and trade publications, are where they can keep up with the pulse of their field. Although these channels make their sentiments available to all—including the general public—this is a primary method through which the journalistic community maintains its standards and practices.

The External versus Internal Hierarchy of Authority as Recognized by Journalists

In line with the observation that journalists seem to take their cues from, or at least rely on, the information about their community that is provided by print journalists, all journalists articulate a definite sense of a hierarchy of credibility and prestige according to medium. Print journalists say that TV journalists are better situated and more highly regarded by the public but not by print journalists, an opinion mostly warranted by television journalism's emphasis on style over substance, reliance on and preoccupation with the technology that they hide behind, and the fact that those people who appear on-screen are often not the ones responsible, or at least solely responsible, for gathering the information for the stories they present:

> When you're working at a paper like I do, when you start going to news events and you see that broadcast journalists, their mikes, their cameras, their vans, everything sort of takes precedence over everything else at either manufactured news events like a press conference or real news events like a murder on a street. You're constantly being elbowed out of the way...as a print journalist, you have certain needs in terms of complete...information

> and people sort of standing still to answer your questions for a while, which are constantly stampeded by the—broadcast journalists need film or they need an audio clip—they don't really need in-depth information (personal interview with Chris Satullo, 2006).

In particular, newspaper journalists' poor regard of television journalists also stems from their own feelings of insufficient recognition and poor treatment relative to their TV counterparts. Some newspaper journalists feel that what they do "is a lot harder, involves a lot more questioning, a lot more ability to process information." Even so, most sources "are a lot more excited about being on radio or TV than print. We always get short shrift, and that builds up a level of animosity that then gets transmogrified over time into a sort of broader critique about the shallowness of broadcast journalism" (Chris Satullo, 2006). However, in some cases, newspaper journalists acknowledge that inadequacies in television journalism are not the fault of the individual journalist, but rather a product of a system and infrastructure in TV news that is, in their eyes, inherently flawed. This flawed system provides crutches that enable journalists who lack the ability to think for themselves or don't really understand the issues they report on to get by and be rewarded:

> In terms of asking the logical follow-up, the question that was screaming out to be asked, if you really know the issue in-depth, if you're understanding of the issue is more than having been briefed by a producer ten minutes before you walk on air.... You have an army of producers... who do the work that is much more analogous to the work that print journalists do and they're feeding into the person who's the on-camera presence...there's just a sense that there's an element of theater, a trick being played on the audience in which they're completely complicit, but the anchor pretends to know much more and presents as his own work stuff that is really work of a number of other people. And then reaps enormous prestige and awards for that (Chris Satullo, 2006).

Some print journalists also believe that TV news anchors were set up to fail—that the entire institution of the network news anchor was insupportable: "… the image and the burden put on that person to be totally reliable, totally wise and totally accessible interpreter of the world for an increasingly variegated American public" was too high. These print critics say that it was just a matter of time before the flawed system's demise:

"sooner or later, no matter even if Dan Rather wasn't Dan Rather, something like that was gonna happen and somebody like him was gonna have to resign in disgrace because the burden is just too high" (Chris Satullo, 2006).

These same newspaper journalists have also explained that part of their animosity toward television journalists stems from occasions when scandals in TV journalism, due to the visibility of the anchor, come to stand for journalism as a whole and that when breakdowns occur in TV journalism, the public tends to think that it's happening to journalism as a whole. As print journalists, they are bothered by the notion that TV anchors are considered emblematic representatives of journalists, and that the kind of high-profile mistakes they have made, such as in the CBS reporting of President Bush's National Guard service, are seen as endemic in daily practice. But scandals are not relegated to TV journalism alone. The false reporting of Jayson Blair, Janet Cooke and Jack Kelley have marred print journalism as well. What all types of journalists take issue with is "journalism being judged on the basis of its highest profile screw-ups" (Chris Satullo, 2006).

There is also resentment due to the habit of TV journalists generating their initial story ideas by culling the newspaper for stories written by print journalists who won't get credited on air. This is admittedly a common practice by TV news production employees. For many, the workday begins by scanning the pages of the daily papers and clipping or highlighting stories that could become part of the day's program. Throughout the day, these TV news employees continue to check the news wires (AP, Reuters, UPI) as the show's bookers call to try to arrange interviews with the stories' subjects.[7] Although this is common practice and has become an institutionalized part of the TV news process, it is a "cause of some self-examination among print journalists" who are understandably frustrated that their story—seen by mere hundreds or thousands of readers—gets picked up on TV and "the audience is intrinsically larger...you write the story, you do most of the groundwork and then a producer comes in after you and basically interviews who you interview, and then all of a sudden *60 Minutes* or *20/20* is getting credit for the expose" (Chris Satullo, 2006). These newspaper journalists contrast their own "slow, patient, unglamorous work" with the flashiness of TV news that

7. As early as 1966, Walter Cronkite said that the TV networks "are basically dependent on the wire services" (Fensch, 1993: 29).

piggybacks off of their drudgery. But here again, print journalists blame the TV news system for this effect, pointing out that the way that the TV news production process is set up does not leave much time for lengthy investigations. In some respects, newspaper journalists are self-proclaimed martyrs. They maintain that they have no interest in working in television precisely because of the reasons given above, but at the same time, they remain somewhat jealous of their TV counterparts, whom they perceive as receiving more attention for less work.

Although print journalists are largely critical of television journalists, the relationship is not one-sided: "...we [print journalists] constantly made fun of them for being shallow. They [TV journalists] constantly made fun of us for having bad hair and bad shoes and not knowing how to talk on camera—all of which was true both ways..." (Chris Satullo, 2006). There also are elements of TV journalists' jobs that actually command respect from print journalists, such as their ability to think on their feet and perform while multitasking:

> There are all kinds of skills in terms of the way you speak, thinking concisely, being able to think and do complicated things while somebody's talking a million miles a minute in your ear, those are all skills, they're just different skills...it's just a different journalistic process in broadcast...the anchor has to have all kinds of judgment and has to be a manager, just as I have to be a manager and journalist at the same time (Chris Satullo, 2006).

Thus, the relationship between print and broadcast journalists is much more nuanced and complex than a simple jealousy between rivals. Although print journalists are alienated by the technological and structural trappings of TV, they still acknowledge that lumping all TV journalists together under one unworthy roof is unfair:

> I looked at all the stuff when Peter Jennings died. I watched the tribute at ABC news. And I actually felt bad. I felt like I'd been mean to Dan Rather, that that wasn't fair, that Peter Jennings and Dan Rather and Tom Brokaw are actually of considerable credentials as journalists.... But there is something about the degree to which the process and the surface of the network news absorb so much of the professional talent and energy that people who work on the broadcast—that not a whole hell of a lot is left for what we would consider the hard work of journalism (Chris Satullo, 2006).

Television journalists affirm the sentiments of their print counterparts. They say that print reporters do the honorable work, and they believe print reporters have a low regard for TV journalists. According to TV journalists, there has always been a premium attached to being a columnist or the beat reporter for celebrated papers such as the *New York Times*, the *Washington Post*, the *LA Times*, or the *Wall Street Journal*. That status has changed somewhat with the internet and people going to new media, which has changed the traditional pecking order. TV journalists also cite key differences between broadcasters and print journalists that have always existed such as the discrepancy in earnings (television journalists generally earn more money) and the fact that television is a visual medium. "TV journalists have to be more aware of appearances. Sure, sometimes that's a barrier. But these days, there is more focus on good reporting and important information than appearances" (personal interview with Andrea Mitchell, NBC News correspondent, 2006).

The playing field has been leveled to some extent in recent years with print journalists "going on television, going out and earning lecture fees and making a lot of money as well." But according to Mitchell (2006), for a long time, *New York Times* reporters could not go on television. There was an in-house rule against it. "So that rule by its very existence said something about the attitude at the bible of print journalism: we don't want you there—don't demean yourself by going on television. Those days are over. Now, the *New York Times* has its own in-house television operation."

Mitchell (2006) said that she is aware of the views print journalists have about her and her colleagues and the reasons why, which she says are to some extent legitimate:

> I think that newspaper people who are less tied to the camera are more likely to be out there physically, wandering the halls of the Hill.... it certainly is one of the reasons why print people who are out there hustling and talking to sources tend to disparage a lot of television people who just kind of grab it off the video and throw it together without doing their own reporting. There's a laziness that gets built into the system.

This view of TV journalists has kept them out of journalistic associations that felt they were ineligible for membership. For example, according to Mitchell, the Gridiron, a Washington, D.C., journalism club, only began accepting television journalists in 2006 even though "they've been around for a hundred years." Even TV journalists themselves mention that in TV

journalism, there is the greater possibility of an unqualified or undeserving journalist sliding through the cracks:

> Most of America thinks that the anchors understand everything that they're talking about...that the anchors write their scripts. I remember for years people were surprised to know they just sit there and read... let's face it we've...worked with anchors before who can't handle unscripted stuff...there are plenty of them that could never spontaneously deal with breaking news and couldn't write their own stuff, and I think it's bad because they need to have an understanding of what they're talking about (personal interview with G.B., television news booker, 2006).

Once again, the TV journalists are not solely to blame. In an era where fame and flash have taken precedence over solid and substantive reporting abilities in efforts to secure the financial bottom line, the networks are responsible for facilitating the careers of sub-par journalists:

> I've been at two networks, two shows in a row where they were desperate for a name, and they hired the biggest names they could get and neither of these people were—they were by far not the smartest people to anchor a show, but they just wanted a name. And I hate to say it but it comes down to money in this business, as well as all business, right? (G.B., television news booker, 2006).

Radio journalists see themselves as having higher credibility than television journalists but lower credibility than print journalists—their prestige falls in the middle of the other two media. Illustrating the tension between the external recognition that TV journalism receives and the low place it is designated on the credibility scale within the community, one radio reporter admits that some television news reports do an excellent job of telling the story, but many of his peers don't respect TV news and think "radio is closer to print, much more of an art, and television is all crap..." (personal interview with radio reporter, 2006). However, it is difficult for them to maintain that view when they look at how they are valued in society. These radio journalists rationalize that because more people watch television news, and television news reporters and anchors make a lot more money, then "there's probably a reason for that" (personal interview with radio reporter, 2006). They also consider the positive and negative aspects of the television medium. While television news reporters sometimes have three or four minutes to tell a story, which is more than many radio reports get, they

also have pressure to fill a certain size news hole every day and that forces them to rely on the same sorts of "shootings and car chases and whatever they can guarantee is gonna fill [the time]." Although they believe that some TV news reporters do their jobs well, others "will walk into an event with the newspaper article that they printed out that morning that counts as their research" (personal interview with Brad Linder, former WHYY public radio news reporter, 2006).

For television journalists, television clearly takes precedence over radio, as colorfully illustrated by this excerpt: "the CBS bureau motto was "f**k radio," the attitude one was expected to adopt when working on a television story" (Stahl, 1999: 14). In this vein, other television journalists have expressed their views about where radio falls in the journalism hierarchy: "I think they're even seen in lesser terms than the TV people because they literally get 30 seconds to... their dispatches" (personal interview with Washington correspondent for one of the cable networks, 2006).

No matter how members of the journalistic community internally rate the esteem of TV journalists, externally, TV journalists are treated as though they are at the top. In the late 1970s and early 1980s when TV journalism was at its apex, even though all of the events on foreign [presidential] trips were covered by assigned pools, television was so powerful and important that the three network White House correspondents got into every pool (Stahl, 1999). According to Stahl (1999), 1979 was the peak of network news power. Roughly 120 million viewers tuned into the three networks each night. TV news was so predominant and influential that its deadline became the deadline of the entire federal government. Television reporters were given reserved seats in the front row of the press room, first class seats on the press plane, and choice positions were saved for network camera crews on the platforms. Other journalists have maintained that this position of prominence still holds true when it comes to covering recent political or other types of events:

> ...on the plane...the wire service reporters usually got really good seats near the front near the candidate staff. Then the correspondents from the networks also were up there. Then the *New York Times, Washington Post.* Those folks generally had seats near the front of the plane and then the rest of us were somewhere in the back. If Karen Hughes came down the aisle and wanted to do a little briefing, we're all straining to hear over the jet engines from 10 rows away. Those guys are all up there generally being

able to hear what she's saying (personal interview with B.D., newspaper reporter, 2006).

But there are also unwritten codes of conduct among journalists. As Stahl (1999: 42) writes, "it was one thing when the 'primitives' (what the newspapermen called the cameramen) shoved me aside; they had to get a clear shot. But there was a code among the reporters: we were as civil to each other as possible given the circumstances."

When the Hierarchy Gets Put Aside

Although there are clear unspoken opinions and perceptions journalists of one medium hold about others, several journalists reiterated that fellow journalists all treated each other respectfully and at times even helped each other out. When it comes to issues that pose a threat to journalism generally, print, radio and television journalists express solidarity as common members of a single journalistic community. When news consultants entered their world and became a growing presence in the 1970s, TV and print journalists alike were on the same side against the station and network executives who condoned the consultants' use. Throughout the decades as particular incidents have threatened journalists' freedom of speech, they have stood as one collective body of journalists to deflect these threats. Journalists of different formats come together for a common good in coverage of certain types of stories. Being part of the White House press corps or traveling as part of the presidential press corps provide some of these instances:

> You're all kind of equalized if you travel together and suffer together on these presidential or secretary of state-type trips, where you're all getting two hours of sleep and you're all bleary eyed.... In fact we help each other out in ways that would surprise people. If there's something that's on the record or is if it's going to be part of the record and one of us misses it, and we say to the other guy, 'Hey we missed that; could you give us your tape or help me with that transcription?' or whatever, we'll help each other— because next time it will be you who's screwed up or whose eyes were averted at the wrong time (personal interview with James Rosen, Fox News correspondent, 2006).

Assisting fellow journalists is not exclusive to those within the same medium either. Among the select group of reporters who are with the government press corps, a pool that includes TV, wire, print, radio and stills

photographers, "we all recognize that...we're all here. And in the briefing room...people try to help each other pursue given threads of inquiry, despite the fact that one is from radio and one is from print and one is from TV, or whatever," said Rosen (2006). However individual journalists are not fully accepted "within the fraternity" until they have "traveled and suffered," and thus been initiated by sitting with the rest of the unit on the same plane on which they all are "wearing the same grungy clothing...eating five meals a day...all gaining 20 pounds more than you should...not getting enough exercise... not seeing your spouse." Once they have satisfied the rites of passage into the traveling collective, they are "all in the same boat so to speak" (personal interview with B.D., newspaper reporter, 2006) and are eligible for the benefits and protections that membership in that collective affords.

Even outside of these traveling bands of journalists, while tensions exist between journalists from different types of media, there are also strong friendships and feelings of respect across these boundaries, as illustrated by Koppel's (2000) account of the tremendous showing of television journalists, including the three major network anchors, at the memorial service for *Washington Post* TV columnist Jack Carmody. It seems that a fine line exists where television and print journalists are in somewhat adversarial and competitive roles, but in particular regard to those print journalists on the TV beat, they simultaneously develop relationships of friendship and mutual admiration. One final category of comparison between journalists is network versus local television. Network journalists tend to reference local TV journalism in illustrating the poor quality and practices to which local broadcasting contributes. Journalists in other media, however, use examples from local TV news to make their points about the negative aspects of TV news more generally, blurring local and network together:

> ...there's a lot about what's happened in broadcast journalism—and journalism in the time I've been in the business and particularly at the local news level that only reinforces the feelings most print journalists start out with. I mean look at the nightly news even in a major city...it's still if it bleeds, it leads. Ten minutes of a 22-minute newscast is devoted to promotion of that network's TV shows masquerading as news in one way or another. And then there's sort of their notion of investigation as the hardy perennials of—there's scuzziness in the bathrooms at the Houlihan's and that kind of stuff. You know you can live in [this city] and if you watch the TV news every night, you would have no sense or very little sense of

what the political, social or economic issues facing the city are. It would basically consist of—the sense of the city would be it's a never-ending sequence of murders, fires, festivals (Chris Satullo, 2006).

Although most community members can clearly distinguish between local and network news, and within TV journalism, local news is considered a training ground and stepping stone to a more respectable network assignment, the problems of one become conflated with problems of the other when detractors seek to justify the superiority of their own medium or point out reasons for their distaste of television.

Selection and Promotion

With all of its positive and negative consequences, the celebrity and reputation of television journalists become factors in their selection and promotion. As alluded to in the previous section, this also becomes a source of tension between different types of journalists and complicates the hierarchy of authority.

The practices of selection and promotion within television journalism reward the TV journalist's signature and fame as much as traditionally defined "good" journalism. The discourse surrounding network anchors points to the ways in which television has altered the entry routes into journalism and how different types of journalists feel about these altered paths into the profession. The generation of television reporters who came to prominence in the 60s and 70s often had been trained in the wire services or radio and gained experience as foreign or war correspondents or by working their way up through the newsroom ranks:

> A lot of people in TV—we're talking about on-air people—they come from the wires, they come from radio; increasingly that's less the case.... The older folks, the people—I consider Watergate modern times, but that is ancient history to people now—and you are a veteran if you go back to the first Bush or the first Clinton term. You're a grizzled veteran now! Kind of scary. People who go back to Reagan and Bush tended to be from print or radio (personal interview with James Rosen, Fox News, 2006).

Many journalists still believe that "there is no substitute for working as a print journalist prior to becoming an anchor" and that the "kind of instinct, born of long experience in the news trenches," is lacking in many of the "air-

brushed, blow-dried, happy talkers who read Americans the news each day" (Paige, 1998: 8).

In contrast, the trajectory of TV journalists in the 80s and 90s was generally somewhat different. They were given entrée into the field through journalism schools or by working one's way up through the newsroom ranks (see anchor biographies from ABC News, NBC News, CBS News, and CNN). Several journalists point out the changes in the entry routes to television journalism that they have observed among the younger generation of reporters. The progression for this younger generation follows a route of communication and journalism programs in college or graduate school and then on to stints behind the camera at local affiliate stations, to time on air at those stations, to the ever-sought-after move to a network position. The fact that today's on-camera reporters often lack significant time in the field troubles some members of the community:

> I do worry that our on-air people were never reporters...talk shows are spewing out commentators but they have never covered the basics... I do worry that we're not training this next generation of TV journalists properly (Andrea Mitchell, NBC correspondent, book signing, 2005a).

Others believe that communication or journalism degrees are superfluous to a successful journalistic career and that aspiring journalists would be better served by courses of study that broaden their perspectives and ground them in history and politics—fields they consider essential to a good reporter's understanding:

> ...if I get my hands on someone who's still in college and hasn't yet declared a major, I tell them don't major in journalism or communications. And they say why not, if they're gung-ho on being on-air...I say...because all the things you learn in that kind of program you learn on the job anyway, and it's better for you if you become a reporter with some foundational knowledge in an area that gives you a prism through which to view the world.... Politics or history or international relations, but anything will do, English literature, biology...you will take a view...that will inform your writing and it will give it a cast that no one else will have and it's valuable (personal interview with Washington correspondent for one of the cable networks, 2006).

Those who try to dissuade aspiring journalists from pursuing journalism degrees do so because they feel that these students only learn the mechanics—the technical skills—without the practical and in-depth knowledge that enables them to become informed reporters:

> What we see are a lot of little rat-like creatures who come out of these journalism and communication programs who know everything about the mechanics and they're gung-ho producers who say all right, I know how to tease out the show, I know how to make the weather hit on the ones, they don't how many people sit on the Supreme Court, they know nothing about Congress or about the Constitution or civics in general (personal interview with Washington correspondent for one of the cable networks, 2006).

Part of the problem with those who pursue careers in TV journalism is that, in contrast to aspiring journalists of previous decades, the new wave of aspiring journalists seeks the appearance of their faces on TV and the notoriety that comes with it rather than solely wanting to contribute to uncovering and reporting events of importance to viewers. According to journalists in the community who hold this view, this new wave wants to skip the less glamorous grunt work and posts that their predecessors took as stepping stones, and leap directly onto the screen: "The few who make it to the national stage generally have earned their stripes...but a lot of kids in journalism school 'want to go straight out of school and be an anchor'" (Neil Hickey, former editor-at-large of the *Columbia Journalism Review*, in Paige, 1998: 10). NBC correspondent Andrea Mitchell wrote that she gets emails and calls from young women asking for advice about how to get into television, but almost always, their goal is to be a "television anchor" (Mitchell, 2005: 82). Rarely do they say they want to be journalists. According to Mitchell, few understand that "the best anchors, only the credible, successful ones, are, first, good reporters. Not many of these eager aspirants are prepared to be desk assistants, researchers, and associate producers, in small television markets if necessary, before getting that first job in front of the camera" (Mitchell, 2005: 82). This attitude is in part due to institutional changes at the networks that have enabled this way of thinking to continue and be validated:

> It used to be that you would go out to a little TV station somewhere in Podunk and do everything and work your way up market to market. Now with the proliferation of cable, people just get thrown on the air. Often they

can't write, they can't report. Sometimes, they had no experience in journalism at all—there used to be sort of a niche where sometimes women would end up doing weather reports at local stations, and I'm not talking about professional meteorologists, but sometimes they were people who were on air without a whole lot of experience in journalism. And now that can happen even more easily with people just needing to fill up that 24-hour cable field. It's not good for the profession and certainly isn't helping the viewers (personal interview with Andrea Mitchell, NBC News correspondent, 2006).

An examination of the bios of the major anchors and correspondents for the big three networks in 2005-2006 reveals that most started in local news. Exceptions are NBC's Lisa Myers, who was a print reporter first, and MSNBC's Lisa Daniels, who was a lawyer first (NBC correspondent biographies accessed through MSNBC.com). Other anchors who have deviated from the most common path are CNN's Wolf Blitzer and Fox's Greta Van Susteren. Van Susteren was a prominent criminal defense attorney in Washington, D.C., when CNN tapped her to be a legal commentator during the O.J. Simpson trial (Foxnews.com anchor bios). Blitzer earned his master's degree in international relations and served as a newspaper foreign correspondent prior to coming to CNN (CNN.com Anchor Bio). Former MSNBC anchor Dan Abrams is a law school graduate, though he never practiced and instead began his career reporting for Court TV. Abrams' unusual background is perhaps what led him to be tapped as the day-to-day boss at MSNBC (Carter, 2006a). Though it happens rarely, on occasion, anchors move from network to local television, as was the case of Max Robinson who had been an anchor for ABC *World News Tonight* and then moved to Chicago to become anchor of the local news there. This reversal of the "normal" progression of an on-camera reporter's career—to go from network to local news—is considered by many a demotion or a step backwards, although in some cases, it may be a personal choice.

For many prominent network television anchors and reporters, a major stepping stone on the path to the anchor chair was a stint as White House correspondent. As Mitchell (2005) explains, White House correspondent was considered the most authoritative beat among the correspondent jobs, and there was still reluctance to accept that women could handle it. It was the beat that was often used as "a testing ground for future anchors" (Mitchell, 2005: 136). However, recent incidents have led to a reassessment of the role of White House correspondent; it may not hold the same cachet as it once

did: "It was the glamour beat; that's where you put your star reporter," said CBS News anchor Bob Schieffer (in Learmonth, 2006). But nowadays, "with unprecedented message discipline and a dearth of free agents willing to divulge real information" there is a new level of frustration to the beat. "While the heady act of walking through the White House gates to work can sustain some reporters for a career, the cloistered atmosphere can be dispiriting" (Learmonth, 2006). Since the White House is increasingly more sophisticated and efficient in handling the press corps, "You don't get many scoops out of the White House—no one does," says Fox News host Brit Hume, who was ABC News' chief White House correspondent during the Clinton administration (Learmonth, 2006). According to other journalists, the beat is "confining, both physically and intellectually," said ABC's Terry Moran, who left the White House beat to join *Nightline*. "You're cooped up in a bubble all the time; they herd you like sheep.... The president makes news by saying and doing things, so your stories are often, 'The president did this today'" (Learmonth, 2006).

The false excitement of the post, along with the low level of industry and autonomy that the assignment actually requires prompted Bob Schieffer to say that he has contemplated sending an intern to the White House to take notes and sending the reporters to Capitol Hill, where there are 535 members of Congress, all with their own agendas and motivations to talk (Learmonth, 2006). One network television news correspondent who has held the White House post explains that today, networks frequently have more than one White House correspondent to jockey for the number one, two and three positions. He also reiterates that the beat is less glamorous than it seems or than it once was:

> When someone thinks of a Washington correspondent or a White House correspondent, their notions of it tend to be stuck in the Dan Rather, Sam Donaldson era. Whereas there's all kind of Washington correspondents now, and a lot of it is smoke and mirrors, 'cause your relatives see you standing in front of the white columns at the White House, but in fact you're spending 58 of every 60 minutes in some cramped pigsty of a booth. You're there frantically trying to juggle elements rather than having lunch with the deputy so and so (personal interview with Washington correspondent for one of the cable networks, 2006).

The diminished prestige of the White House beat means it is no longer a prerequisite for the anchor's chair. As others noted, Katie Couric's move to

CBS News from the *Today* show meant that two of the three network anchors do not have any White House experience, and NBC's Brian Williams spent less than two years on the beat. Learmonth (2006) observed that the morning shows increasingly offer a clearer path to the exalted evening anchor job. "The starkest example of that new reality was when CBS passed over John Roberts for *Evening News* anchor, a move that ended up depriving the network of TV's most recognizable White House correspondent when he moved to CNN in February" (Learmonth, 2006).

The diminishing prestige of traditionally sought-after assignments is a sign of a more widespread restructuring in TV news. Talk shows, either in the form of morning shows or evening interview programs, seem to be taking the prized place of the White House beat, with getting the best interview and guest replacing a White House scoop. Similarly, the prestige of the State Department beat has also declined (Kimball, 1994). By 2006, CNN was the last network to have a correspondent at the State Department, and they transferred theirs, Andrea Koppel, to Capitol Hill in April 2006 (Studio Briefing, 2006). According to one report (Jaffe, 2006), the era of State Department coverage "is over, as far as TV goes." ABC's Jonathan Karl was also moved from the State Department to the national security beat, and ABC has no plans to replace him at the State Department.[8] This is yet another example of effects of the television medium, which relies on stunning and interesting visuals to attract and hold viewers' attention and which prioritizes those elements of the news broadcast over traditional comprehensive and reliable coverage of major branches of government: "[Secretary of State Rice] can make for dashing footage in her travels, and getting on the plane is still a plum assignment. But diplomats talking diplomacy does not make for great TV" (Jaffe, 2006). To many journalists, the fact that morning shows have become the route through which one reaches the anchor chair, rather than experience as a field reporter or on a political beat, means that in the battle between style and substance, style has begun to win out. These new routes to promotion reward signature and its components of personality,

8. In addition to TV news effectively shunning these formerly stellar assignments, print media outlets have begun to abandon Washington beats as well. In February 2009, Howard Kurtz observed, "thirty-two of the nation's newspapers, representing 23 states, had their own Washington bureaus last year—fewer than half the number of the mid-1980s" (Kurtz, 2009). In the beginning of 2009, several more newspapers closed their bureaus and operations in Washington.

opinion and emotion as the markers of a successful journalistic performance.

The relative ease with which new journalists ascend to network on-camera positions and the new paths through which they reach these jobs represent a break with the experiences of TV journalists of previous generations. Community norms that were established with the journalists of the fifties, sixties and seventies in mind, have been perpetuated through professional lore. Professional lore is the body of knowledge that journalists and organizations systematically circulate among and about themselves (Zelizer, 1992: 159). It helps journalists and news organizations mark appropriate standards of practice and authority. In line with this professional lore, upon the retirement of Dan Rather and death of Peter Jennings, a plethora of stories made mention of Rather's and Jenning's stripes that were earned in the field as war correspondents and reporters during crises. Of Jennings, it was written that he was a man "who came into the anchor chair absolutely prepared to do the job, from years and years of reporting in the field, which is precious and not easily duplicated" (Steinberg, 2005a). Similarly it was noted that "As CBS *Evening News* anchor... Rather led the newscast from the field. Dubbed 'Gunga Dan' as a *60 Minutes* correspondent for his field work from Afghanistan, Rather continued to present himself as the lead field correspondent for *Evening News* instead of its New-York-bound newsreader" (Tyndall, 2004).

The repeated mention of the anchors' experiences in the field and ability to report unaided and impromptu speak to the importance the journalistic community places on this type of training and work necessary to legitimize one as a journalist. Field training is emphasized as an essential to earning one's place in the anchor chair. According to an informal survey of industry veterans and academics, "most media watchers generally agree [that]...a solid grounding in basic news reporting still is essential for a top anchor or correspondent, preferably, but not necessarily, in the print media" (Paige, 1998: 9). But while the community struggles to uphold notions about the proper journalistic experience required to be elevated to the most prominent positions on television, network decisions about hiring and promotion thwart the community's efforts.

In a rare attempt to exemplify community standards and uphold journalistic lore, this emphasis on field reporting was visible again in discussions about the injuries incurred by ABC's *World News Tonight* co-anchor Bob Woodruff and his cameraman when an Iraqi roadside bomb

exploded next to the military vehicle they were riding in (Kurtz, 2006a). While some critics asked what the network was doing sending a top anchor into a dangerous war zone, and wondered whether it was for a ratings boost, TV journalists were quick to defend ABC's move and to point out that anchors have always gone out to cover the news (Walter Cronkite first visited Vietnam in 1965), that Woodruff was an experienced correspondent who knew the risks he was taking, and that reporting from the road can personalize a story and should be preferred to having the anchor spend his career in a studio reading off a teleprompter (Kurtz, 2006). As CNN's Wolf Blitzer put it:

> I think one of the things our viewers like is they know I've been out in the field, covered news for 30 years, I've got a track record...whether in the Middle East or Iraq or traveling all over the world as a White House correspondent or a Pentagon correspondent, so I think when you're reporting the news as an anchor, you have a lot more credibility with the viewers than if you're just a handsome guy who's got a nice voice...I think you're a much better anchorman if you have that. If you've been out in the field and you've done reporting—serious reporting—and you know what you're talking about, I think you're a lot more credible with the viewers than if you're just a news reader (personal interview with Wolf Blitzer, 2006).

Although it seems to be losing ground, the journalistic community continues, through discussions directed at both internal and external audiences to reassert traditionally established ideas about the certain types of training and qualifications that were prerequisites to achieving an on-air assignment as anchor or correspondent.

Another important part of professional lore are origin narratives that set "the parameters of successful entry into the community" and provide tales of professional acclimatization that can be used as templates for other journalists (Zelizer, 1992: 160). This type of professional lore was responsible for re-circulating tales of beginner's luck and determination overcoming obstacles. The fact that Jennings was a high-school dropout who transformed himself into an urbane, well-traveled and recognizable journalist was considered remarkable (Steinberg, 2005a). This fact was included in the majority of the articles reporting on Jennings' death and tributes to him. The ways in which Jennings' education is discussed as substandard as is his success in going against the odds as a high-school dropout make it clear that

a high school degree is considered the minimum prerequisite for a journalist. Yet, at the same time, these discussions also reveal that his curiosity and diligence, perhaps driven by the need he felt to make up for his lack of formal education, rendered him an excellent journalist.

Many stories similarly have been told and retold about the humble beginnings of the careers of well-known anchors and correspondents. They are stories full of perseverance, bravado and luck. One such story is that of Brian Williams, who started his journalism career at a small TV station in Kansas:

> The experience did not bode well. I was led to believe I had been a spectacular failure...I couldn't get any other stations to view my tapes. One station had me escorted away by security. So I returned to Washington, where I had lived since college, got a basement apartment at 35th and O streets, and looked at the help-wanted ads. One was for a Chyron operator at WTTG, typing words onto the television screen...I had been typing away on the Chyron for the 10 o'clock news for several months when [the news director] called me into her office...She said, "You've been watching the newscast every night. Who's the worst reporter on our staff?" I told her she couldn't be serious. When she said she was, I gave her a name. She said, "You're absolutely right—he's horrendous. I like you. You start in two weeks" (Palmer, 2004).

Although pathways into the journalism world and to promotion within the field have changed overall, for women and minorities in particular—as has been touched on in previous sections—they faced tougher barriers and, in some ways, still do today.

The Impact of Race, Gender and Ethnicity on Selection and Promotion

Female network television reporters and anchors have made inroads into the field in areas previously monopolized by men, such as sports reporting (Alfano, 1983), but even so, today some network heads still doubt that female anchors possess the necessary "gravitas" to anchor during major news events and crises. For example, Elizabeth Vargas was pushed out of the anchor seat and Charlie Gibson was substituted to anchor and delivered the news when terrorists bombed London twice in July 2005. Meredith Vieira believed she was fired from *60 Minutes* because she was pregnant with her second child (Stahl, 1999: 399). In June 2006, Elizabeth Vargas became a catalyst for reexamination of treatment of women in the workplace when it

was announced that she would not return as ABC's *World News Tonight* anchor after her maternity leave (Noveck, 2006). Even as recently as the second George W. Bush inauguration in 2005, Mitchell (2005: 400) writes that she was one of only four NBC women correspondents with major roles: "Forty years ago, there weren't any. Today I am part of an accepted generation of women journalists. In 1969, I was stopped at the press room door...at a time when women broadcasters were still rare and unwelcome." Other journalists express concern that television journalism is no longer thought of as a serious long-time career and is instead becoming trivialized as an occupation for pretty women:

> What I fear in journalism is that it becomes a girl's job the way we used to see nursing in a pejorative way or teaching. It's what girls do before they get married. It's losing its image as a lifetime profession. If you go to journalism schools, you find that classes are overwhelmingly female, filled with very attractive women. That's not a bad thing, but there's the expectation that all of these pretty women are going to be on TV. It's also very low-paying at the entry level. I think that in a lot of families, certainly there's a sense that I don't want my son taking a job making $15,000 a year...there is often the expectation that a son will make more and have a solid financial career. Families are more willing to let a daughter take a chance on becoming the next "Connie Chung" (Joie Chen, CNN anchor, 2000).

They question whether women even want the anchor job anymore: "Growing up, I always looked to the nightly news chair as...the ultimate...I no longer feel that way...the anchor for the most part has been reduced to a half-hour reader" (former NBC *Nightly News* correspondent Giselle Fernandez in Kennedy, 1995). Some also believe that "too many younger women have become accomplices in undermining their hard-news credibility—particularly in local news, where flashy outfits and sexual come-ons mirror the poor sexuality-as-career-advancement judgment..." (Lowry, 2004). As for minorities in network news, it has been suggested that "the diversity question lies squarely in the hands of white journalists. Why? White journalists make up the majority of reporters on the streets, and editors making the decisions—both coverage and hiring. Therefore, the impact that white journalists have on the diversity, or lack thereof, in media coverage is

immense" (Kimbrough-Robinson, 2006).[9] A 1993 study found that 64.3 percent of those delivering the news were men (Walsh, 1996).

Self-Selection

Although decisions about selection and promotion of TV news personnel rest largely with network executives, many journalists have made conscious decisions to opt into or out of on-camera positions. Some journalists who do not occupy on-air TV positions explain that even with the fame and perks that an on-camera position affords, the drawbacks are also substantial enough to have kept them and some of their colleagues away. A lack of ownership over one's projects and inability to follow through from beginning to end, in addition to lacking the desire to be on-camera, were cited by some journalists as reasons for opting to remain behind the scenes. Some journalists opt for a production track, reasoning that they are more interested in being the person who comes up with the story idea, spends the time fleshing it out, gets the people on board to participate and sits in the edit room to make it come to life, "because the best correspondents do all those things, but at the levels that we work, they don't have the time to do it themselves most of the time and that's what the problem is, because you know what the realities are—correspondents are required to multitask on several stories at once and that means that you can't really own them in the same way as you can as a producer" (personal interview with P.K., former veteran television news producer, 2006). Doing one's own story research and having a sense of autonomy are repeatedly cited as factors in opting out of on-camera career tracks:

> We have no research teams...if you want some research done you usually have to do it yourself or ask an intern whose instinct you may or may not trust.... So I personally, even though I know I could make a lot more money if I did commercial radio or if I did commercial television, am not interested in doing those things. I might consider at some point working in print, but I don't think I would go to the other two—and I think that does have a lot to do with my perceived autonomy to report the stories, to do the research, the reporting, the producing mostly on my own, that I feel like I

9. And as far as American journalism still has to go before diversity is truly realized, journalism in other countries seems to have even farther to go; French viewers recently saw their first black news anchor (Bennhold, 2006).

have some control over what I'm doing (personal interview with Brad Linder, former WHYY public radio news reporter, 2006).

There is the recognition among these journalists that the structure of TV news production is such that a single news story may get divvied up and distributed to several people in an assembly-line fashion to piece it together little by little. The tasks in constructing a TV news piece are departmentalized: one person may "pitch" the story idea; another may do the background research; another may book the interviews with sources; another may travel to obtain usable footage; still another may edit the piece; finally the TV reporter will do the introduction, transitions, voice-overs and conclusion to the piece. In contrast, print reporters are often responsible for all phases of a news story from beginning to end. Similarly, radio reporters such as Brad Linder perceive themselves to be one-man operations. This is the draw for them; they are in control of the products they produce.

Journalists also tend to agree that those who pursue on-camera positions self-select into that track because they seek to be on camera and have an affinity for performing: "I'm not really a person who burns to have my face on camera, and it really is very important if you want to be on the air that it be important to you. Otherwise you're not going to do the best job possible" (personal interview with P.K., former veteran television news producer, 2006). There is the presupposition that those who have chosen a career on television revel in the limelight, a position that inherently connotes vanity and a need for recognition. TV journalists themselves have admitted that this is true, saying that "you cannot be successful as an on-air talent unless and until you totally embrace your egomaniacal tendencies" (Washington correspondent for one of the cable networks, 2006). A 2006 study supports the connection between narcissism and seeking jobs on television ("Who Do Celebrities Love Most? Themselves," 2006).

Sacrifices are required in most cases when pursuing an on-camera reporting career, such as moves to less-desirable locations, very low salaries, and the potential for rejection—other reasons given for not seeking reporting jobs on television:

> I sent out my tapes and got a job offer in West Virginia, and it was gonna be like a quarter—at the time I think I was making like $60,000, and I was gonna get like $12,000 to go be…an anchor in West Virginia. That is what you have to do to get your start, and I just couldn't bring myself to do it…I'm not opposed to going to a place like that, but I didn't want to make

that little money, and you really—in hindsight 20-20, of course, I wish that I would have done it right out of college when I wouldn't have minded having that crappy lifestyle...there's a lot of rejection (personal interview with G.B., television news booker, 2006).

Relative to other television news positions in major metropolitan markets, entry-level on-camera work is notoriously low-paying, and in most cases, is still very hard to get even if it entails relocating to markets sometimes well beyond the top 100. There is also no guarantee that a reporting stint at a remote local station will lead to a more auspicious placement in a larger market. Thus, it is more likely that only young journalists who are unattached and have fewer obligations at the beginnings of their careers will be willing to undertake the challenge. Only the success stories become well known, but for every news anchor who achieves success, even at the local level, there are hundreds—maybe even thousands—of other journalists who aspired to an on-camera network news position and never made it. Those who have made the sacrifices necessary to be on-air confirm the difficulties involved and assert that those jobs are not for the faint of heart:

> There are people who think maybe they want to be on air and...you have to put up with a lot of crap. You go out to some small town in the middle of no place and you make very little money and you get worked very hard. And you know what? You shouldn't put up with that if you're only halfway into it. Because those slots—as awful as they are on you—are very fiercely contested by the people who know, like me, that there was nothing else they could do in this business, nothing else in the world they could do; that they had to do this. So it's almost morally wrong to take one of those slots if you're halfway with it (personal interview with James Rosen, 2006).

The on-camera TV journalist's job requires a character that is able to sustain an often transient, unrooted and dramatic lifestyle for a prolonged period of time. Even successful anchors and correspondents admit that "for all its satisfaction...the demands of this profession are relentless" (Mitchell, 2005: 390): "Along this journey, I have made sacrifices I sometimes regret, although none so important that I would take the path not chosen. As I was warned so many years ago, this is indeed a course for a long-distance runner..." (Mitchell, 2005: 401).

Of course, other journalists, supporting this study's earlier assertions about the emphasis placed on physical appearance in TV news, explained that they are simply not cut out, either in appearance or personality, for an

on-camera job, and so their decisions to pursue off-camera work were partly a matter of self-selection and partly decisions made for them:

> …look at this face. I have a great face for radio or print. So, no, I never wanted to do TV…what I did well, about the only distinctive skill I had when I was young, was writing so I knew I wanted to do something with writing. And newspapers seemed to be one of the places where you could actually make a living instead of starving[10] (Chris Satullo, 2006).

The failure of *Washington Post* reporter Sally Quinn on the *CBS Morning News* in the 1980s remains a reminder of the inherent, and perhaps innate, traits that help to determine which area of journalism one is directed into or chooses (O'Connor, 1992). However, the chasm between television and print journalism may be closing. Print and television organizations that were previously competitors are beginning to team up in moves toward convergence. Print and television journalists have already started working with each other, increasing the potential for print reporters to appear on camera (Hallman, 2006). Some of these partnerships have rough starts, and some fall short of true realization. Former newspaper editorial editor Chris Satullo (2006) explained that his paper's partnership with a local TV affiliate "was a very badly conceived experiment." As he described the program, "it was a very uneasy difficult marriage between print journalists and a print journalism sensibility but basically the on-air talent that they hired were TV journalists."

Along with changes in practices of selection and promotion, television has also wrought changes in the levels of financial compensation for journalists. This is another area in which the signature and celebrity of TV anchors are rewarded more than traditionally defined "good" journalism.

Financial Compensation

As Calabrese (2005: 278) writes, on-air talent is an "important and volatile commodity that stations 'need' to be able to trade at-will, just as professional sports team owners trade players," and the compensation of professional athletes and network anchors is comparable. Compensation is an element

10. In additional correspondence in March 2009, Satullo, by then at WHYY, noted that his comments in 2006 reflected a more viable newspaper industry and have a new meaning in the wake of the industry's shrinkage and collapse by 2009 and Satullo's own move to a public broadcaster.

often brought up by journalists as a measure of their status within the news world:

> Well certainly there's a financial hierarchy. I think on the national level, the average national TV correspondent makes more money than the average national print correspondent or the average national radio correspondent. The average print report gets into details of the subject with much greater depth than the average TV report. And so I think there is a sense not often spoken of in polite company that...TV people are superficial and that the print people really know what's going on and there's some basis for that (Washington correspondent for one of the cable networks, 2006).

Journalists in other media are blatantly aware that, aside from at the lowest levels, broadcast journalists are paid better, far more celebrated and famous than they are: "Their economic utility is far greater than our economic utility. That is a cold hard fact" (Chris Satullo, 2006). Although these journalists from other media acknowledge that many TV journalists working in smaller stations around the country earn very little, "it's a pyramid. The peak in the pyramid is very high, much higher than print journalists. It's a difficult pyramid to scale, but as always, you tend to focus on the people who are at the top of the pyramid and their rewards are extraordinary" (Satullo, 2006).

The discrepancy in salary between TV anchors and other types of journalists was not always so large. The background and finances of journalists have changed over time. Several scholars have commented on these changes in the socioeconomic makeup of journalists, noting that journalism in general became an elite profession whose members were better educated and better paid than the average American (Cronkite, 1990; Shepard, 1997). Network anchors' salaries, in particular, climbed to previously unimaginable amounts as the networks and audiences came to rely on individual stars. In 1965, Huntley and Brinkley were receiving approximately $200,000 a year, which, in those days, was a significant salary for news anchors (Alan & Lane, 2003). Before Barbara Walters left NBC for ABC in 1976 and became the first television journalist to command a million dollar annual salary, salaries at the top of the industry were $100,000 to $150,000 (Gerard, 1989). By 1989, Diane Sawyer was earning $7.5 million under a new five-year contract with ABC, Connie Chung was receiving at least $1 million a year, and even local news anchor Ernie Anastos would make more than $1 million per year after leaving WABC for WCBS in New York (Gerard, 1989). They would all join the million-dollar club that

included Tom Brokaw, Dan Rather, Peter Jennings, Ted Koppel, Barbara Walters, Bryant Gumbel, Mike Wallace and other top network correspondents and local anchors in the largest markets. By 1998, the ten highest paid network anchors' salaries ranged between $4.5 and $10 million (Adalian, 1998).

A 1998 *Variety* article explained that these enormous payments were justified by the reasoning that the success of television's leading journalists is crucial to profitability (Adalian, 1998). Reiterating this justification, in 1999, Roger Ailes, the head of Fox's news division, told *Forbes* magazine that "there are only about a half-dozen network people who can put eyeballs on a screen today…the networks have to use them as much as they possibly can" (Kafka, 1999: 248). If news programming accounted for as much as 40 to 50 percent of a station's profits, then an anchor who attracts the largest and most desired constituency for advertisers would bring in premium rates. Those higher advertising revenues would easily make up for higher salaries.

On the other hand, others have reasoned that the most important reason it is so difficult for TV news to make money is that the salary structure is completely divorced from reality (Cordtz, 1987). These members of the community feel that television news salaries have nothing to do with journalism and are instead the salaries of entertainers. But in addition to resentment from other journalists, the huge salaries paid to TV anchors "undercuts their on-camera pose as ordinary people speaking to, and for, ordinary people" (Cloud & Olson, 1996: 32). The "elevated economic levels present the image of journalists putting more emphasis on celebrity status than presenting truthful news facts," and the "publicity surrounding the high-paying contracts of the network news anchors tends to tarnish the public image of these celebrities" (Robins, 1998). It was believed by some in the field that when Katie Couric went public in 2002 with the fact that she had "arm-wrestled NBC into giving her a four-and-a-half-year, $65 million contract, Couric lost credibility with middle-class viewers" (Gordon, 2005):

> When you have a woman who is pushing 50 coming into your living room at 7 A.M. dressed in an extremely age-inappropriate manner and making ridiculous comments like, "Oh, $100 for a skirt, I can't imagine paying that"—when everyone knows what she's earning—it doesn't sit well (a *Today* staffer in Gordon, 2005).

In light of the potentially negative effects of others gaining knowledge of anchors' salaries, high-paid journalists have oscillated between desiring their salaries to be kept quiet and wanting them publicized as a mark of achievement. Even though one after another, newspaper articles say that it is network policy not to disclose anchors' salaries, the authors of those stories always seem to be able to find an anonymous source who will provide a number. For example, in December 2001, it was widely reported that Katie Couric and NBC agreed on what was believed to be the largest financial deal ever signed in television news at the time, reaching beyond $60 million for four and a half years (Carter, 2001). The availability of these sources leads one to wonder if the salary leaks aren't intentional. Nevertheless, in May 2006, media companies anxiously petitioned the Securities and Exchange Commission (SEC) to drop a proposal dubbed the "Katie Couric clause" that would require them to disclose how much they pay their top-earning non-executives such as news anchors. The designation came from Couric's reported salary of $15 million dollars per year that she is paid as the anchor of the *CBS Evening News with Katie Couric* (Wutkowski, 2006). Companies said the rule could scare away high-profile individuals who prefer to keep their financial terms private although this is highly unlikely in the case of TV anchors. They also suggested that disclosure of the salary of a highly paid non-executive "could cause employee morale issues and provide our competitors with sensitive information that could be used to solicit the employment of our [talent]" (Wutkowski, 2006). Again, it is unlikely that this proposal would escalate these risks that are already present in the TV news world. And although the public disclosure of such huge anchor salaries could turn some viewers off, it has the potential to have the opposite effect as well; viewers who hear of the salaries may tune in to see for themselves what makes these anchors worth it.

Beyond the Boundaries

This chapter has explored the elements of television journalism that the journalistic community wishes to deny the existence and importance of yet still tolerates and capitalizes on. The result of this tension is a complex web of discourse created by the weaving back and forth of conflicting motives and opinions. The following chapter analyzes the actions of television journalists that go beyond community toleration. Thus, this next chapter examines the actions by journalists that violate even the elastic boundaries of

the community and the ways in which the community deals with these violations of its codes.

Chapter 5
How Journalism Restores Order When Its Borders of Practice Are Crossed

The previous chapters discussed the elements that television introduced into journalism and the ways that these elements stretched the boundaries of the journalism community to the pleasure or chagrin of community members. However, even when the community expresses its displeasure over the effects of some of these television dimensions, it allows them to exist, acknowledging them as necessary evils. In contrast to these disliked but accepted features of television journalism, there are other occasions when television journalists act in ways that go beyond community toleration. These actions violate community mores and etiquette, and over the decades of TV journalism, the community has developed ways of dealing with them.

Similar to Breed's (1955) conception of social control in the newsroom, community dialogue provides the unwritten rules journalists learn by listening and observing what happens to others. When journalistic standards are perceived as having been breached by a television journalist, community boundary maintenance takes place. Some scholars have referred to this phenomenon as "paradigm repair" (Bennett et al., 1985; Berkowitz, 2000; Reese, 1990; Hindman, 2005; Cecil, 2002). In Reese's conception (1990), the news paradigm is an occupational ideology whose major feature is the principle of objectivity and which provides an accepted model and practical guide for journalists' behavior. Bennett et al. (1985: 55 in Reese, 1990: 391) have observed that "like all paradigms, the news model faces the problem of 'anomalous or troublesome cases that fall partly within the defining logic of the paradigm, yet fail to conform to other defining characteristics of the paradigm.'" These non-conforming cases threaten the paradigm by calling into question its limitations and biases, and therefore must be "repaired" (Reese, 1990: 391).

Theories of image restoration and paradigm repair have been utilized in exploring how journalism organizations attempt to repair their own images and that of journalism in general when news paradigms are challenged. This

type of journalistic maintenance work draws attention to and reinforces the core tenets of the culture when those tenets are drawn out for public scrutiny and criticism. This maintenance work performs "double duty" by reaffirming professional ideology in both the mind of society and in the minds of journalists who belong to and believe in that professional culture (Berkowitz, 2000: 125).

These violating acts and the ways in which the community works to repair them are the subject of this chapter. I employ case studies and theories of paradigm repair to explicate this process. I also analyze the reasons that certain actions by TV journalists are seen as breaches of community norms, while others are sanctioned. Additionally, this chapter will demonstrate how these reasons are offshoots of the conflictual ways in which the journalistic community regards the elements that have been delineated as products of the TV journalist's job. Among the borders of appropriate practice that television journalists are perceived to have erroneously crossed are borders of impartiality, borders of retirement, borders of careful reporting, borders of community loyalty and borders of celebrity.

Crossing the Borders of Impartiality

Notions of impartiality and conflicts of interest in TV journalism have been works in progress. As early as 1955, the *New York Times'* Jack Gould was calling television "a medium of compromise" and wrote that controversial shows suffered because of the sponsors' desire to reach as large an audience as possible even at the sacrifice of program quality. That same year, the withdrawal of Alcoa's sponsorship of CBS' *See It Now* hosted by Edward R. Murrow prompted more discussion of commercial sponsorship of news programs (Gould, 1955). Although single-sponsor programs were largely done away with in subsequent decades, networks have maintained strict rules about not giving preferential treatment to advertisers in their news coverage and have sought to restrict the participation of their anchors in activities that may appear to compromise the journalist's or the network's objectivity.

As such, violations of the borders of appropriate practice include occasions when TV journalists fail to avoid conflicts of interest. Avoiding conflicts of interest as a journalist is part of the canon of good practice, and the community is quick to criticize and repair damage when breaches of this rule occur. The celebrity industry has made it difficult for high-profile journalists to maintain the split between their public professional personas

and their private lives. Inevitably, leakages are produced across these boundaries, and, as the most visible and widely known journalists, anchors' boundary crossings are most likely to be caught by the public eye. These leakages manifest themselves in certain ways, such as 1) when journalists insert stories about themselves during news broadcasts (telling anecdotes, adding editorial comments); 2) when stories about journalists make the news; 3) when journalists appear in other venues (on other TV programs, at non-news events); 4) when journalists grant interviews about themselves in print publications or write autobiographies; 5) when journalists are implicated by associations (spouses or partners, organizations to which they give money). Some of these categories have been addressed in other chapters. However, there are numerous examples of occasions when it becomes publicly known that journalists are acting outside their roles as journalists, when information about journalists' personal lives is made public, and when journalists choose to divulge this information themselves. All of these occurrences affect public perception of journalists as objective reporters of the news and feed the celebrity frenzy that surrounds them.

There are examples from the beginning of broadcasting of journalists going beyond the typical boundaries of the profession. For example, Walter Cronkite, the proto-anchor trusted beyond a doubt, went to Vietnam and upon his return, gave his opinion on national television that the war would never be won on military ground and that the only end was negotiation. This expression of opinion was condoned by the journalistic community, but others have not been. For example, in 1972, Geraldo Rivera went on leave of absence without pay from WABC-TV's *Eyewitness News* to campaign for Senator George McGovern. The action followed a debate about the rights of TV newsmen to publicly participate in causes, political or otherwise (O'Connor, 1972). ABC, like the other networks, put severe limitations on this type of participation. The explanation for these limits is that the newsman is a celebrity only by virtue of his association with the news operation, and any endorsement will automatically involve not only the individual but the news organization as well. However, the American Civil Liberties Union and Rivera contended that these rules were a violation of the reporter's constitutional rights, to which the networks replied that the reporter has no constitutional right to be an employee of that news organization and if he does not wish to adhere to the organization's ground rules, he may seek employment elsewhere (O'Connor, 1972). At issue for the

networks was the credibility of the reporter. They believed that a reporter publicly identified with one side of a cause cannot readily be believed to report objectively about that cause. This reasoning—that participation on behalf of a cause precludes the independent judgment expected of a journalist—is a major tenet of the journalistic community. So why the exception for Cronkite? There are several plausible explanations. First, perhaps his status with the nation was *so* great that he was permitted this violation of community norms. Second, the president publicly acknowledged and agreed with him, absolving Cronkite of potential wrongdoing. Third, his opinion was perceived to be derived from personal knowledge and was so heartfelt that it resounded with a public among whom the opinion was so popular that it did not upset or challenge the majority. Rivera had not achieved Cronkite's revered status, nor was his action seen as noble or in line with mass opinion. It is, in fact, difficult to think of many examples involving TV news anchors in which a breach of the sacred community principle of avoiding conflicts of interest has been sanctioned, although there actually are a few others.

Few could find fault with Katie Couric's very public campaign against colon cancer that entailed her use of network air time to have her live colonoscopy shown on-screen and her heavily covered celebrity fundraiser "Hollywood Hits Broadway" held aboard the *Queen Mary 2* to benefit colon cancer education and research (Barker & Freydkin, 2004). In fact, the campaign was so successful that it led to a significant increase in the numbers of people visiting their doctors for colonoscopies, which the medical profession dubbed the "Couric Effect" (Healy, 2003). Couric's actions were acceptable as they too were viewed as noble and without political motives. And like Cronkite, who had witnessed first-hand the disturbing scenes of an unsuccessful war in Vietnam, Couric had personal experience of colon cancer as it claimed the life of her husband. The acceptability of Couric's actions on behalf of a worthy cause may have set a precedent for other anchors. Paula Zahn and Ann Curry have both received awards for their contribution to breast cancer prevention ("Anchors & Reporters: Paula Zahn," 2006; "About the Show: Ann Curry," 2006). In fact, there are few anchors who do not publicly show their support for an altruistic cause—medical or otherwise.

Couric received considerably more flak[1] for other decisions she has made. In 2003, Couric swapped places with Jay Leno and hosted the *Tonight Show* (Silverman, 2003). Couric also cameoed as a prison guard in *Austin Powers in Goldmember* and said it is acceptable for journalists to take roles in movies—as long as they are not playing reporters on screen: "A lot of newspeople play anchors or reporters—or themselves—on TV, and I think that can possibly blur the lines.... But I don't think anybody will get me confused with a prison guard of questionable sexual orientation" ("Osbourne Sued over Show," 2002). Couric's appearances on the *Tonight Show* and in the movie were seen as harmless, but they might not have been had she already assumed the evening news anchor position. And although Couric believes extracurricular work for journalists is acceptable so long as they are not playing reporters, CNN's Bernard Shaw did just that when he appeared in the movies *The Lost World* and *Contact* (Shepard, 1997), and Couric herself, along with fellow newswomen Joan Lunden, Faith Daniels, Paula Zahn and Mary Alice Williams, played a guest at a baby shower for their fictional counterpart Murphy Brown on an episode of that CBS sitcom (Elliott, 1993). Although some observers see these appearances as a natural product of television, which thrives on personalities (O'Connor, 1992), members of the journalistic community did not take as kindly to these actions, which undermine the credible, professional persona journalists are supposed to cultivate (although Couric's was a lesser offense since she was in a hybridized morning show capacity at the time), nor did they approve of some actions of other anchors. CNBC's Maria Bartiromo got in trouble for saying she had a thousand shares of Citicorp when she was interviewing the chairman of Citicorp (Fox News Watch, 2004), and Dan Rather publicly apologized for being the featured speaker at a Democratic Party fund-raiser co-hosted by his daughter in Texas (Silverman, 2004). These last two cases, like Rivera's, are much more cut and dried. When politics and the subjects of stories are not involved, the line between appropriate practice and conflicts of interest is much harder to define and often shifts on a case by case basis.

Journalists are witnesses to events and can often offer perspectives unique to their positions. For these reasons, they make interesting interview subjects and are often called upon by other news or talk programs,

1. Herman and Chomsky (1988) characterize "flak" as negative responses to the media that include complaints, threats, petitions, letters and articles. In the Couric cases, these responses came from inside and outside the journalistic community.

sometimes on rival networks. Over the years, CNN's *Larry King Live* has featured interviews with Dan Rather, Bob Simon, Katie Couric, John Stossel, Ed Bradley, Peter Jennings, Tom Brokaw, Diane Sawyer, Barbara Walters, Matt Lauer and Ted Koppel among other journalists (CNN.com Transcripts). In these instances, these TV journalists are appearing outside of the confines of their own programs, but they are still present in their professional capacities, behaving in a manner that befits a television journalist. And once again, their exposure in a venue other than their own can attract new viewers to their own programs. At least this is what their networks hope when they allow them to make these appearances. Because they are still speaking as journalists, and on behalf of the journalistic community, as long as they positively and accurately represent their field, these types of activities, although outside of their normal routines, are condoned and even supported as they bolster journalism's cultural authority by offering up individual members as experts whose perspectives are sought after and heeded. In these cases, there are no inherent conflicts of interest.

Although TV anchors are not the only journalists whose behavior may cross the borders of impartiality and require boundary maintenance, this type of border crossing is particularly associated with them for some of the reasons that have already been laid out. Only national network anchors have the instant physical recognizability among the American public that contributes to their famous signatures, and this leads to their being in great demand for speaking engagements and as pitch people and very highly compensated for these activities. Even the most well-known newspaper journalists receive fewer offers and less financial compensation on average.[2] Although they are known for their words on the page, few audience members would be able to instantly identify them in a television commercial. So although the border crossings and community boundary maintenance that takes place in response to these violations are not unique to this group, the effects of these crossings are magnified for TV anchors.

Anchors for Life: Crossing the Borders of Retirement

The community mandate to avoid conflicts of interest and any activity that may lead to the perception of compromised impartiality does not end for

2. The website of the International Speakers Bureau, www.internationalspeakers.com, provides descriptions and fee ranges for all of the journalists from print, radio and TV that they represent.

journalists after they've officially relinquished their professional roles. The community stretches this rule to its limits. When anchors capitalize on their fame after retiring, their participation in endeavors that are not consistent with their former roles as journalists still draws controversy and protest from members of the profession. Almost immediately after stepping down from his anchor post at CBS in 1981, Cronkite had to defend his appointment as a director of the board at Pan American Airlines for which he would be paid a salary and given free travel on the airline while he remained at CBS as a correspondent (Schwartz, 1981). CBS said that regular correspondents were not permitted to accept corporate directorships, but Cronkite's was a "special case," and Cronkite himself justified his decision by drawing a distinction between regular correspondents and his position as *special* correspondent, which would enable him to pick and choose his assignments so as to avoid any conflicts of interest (Schwartz, 1981). Still, executives at ABC and NBC disapproved of the move. Again, Cronkite alienated some in the journalistic community when he was paid $25,000 to make a documentary for the chemical industry-sponsored American Council on Science and Health (ACSH). For that fee, he narrated the pro-pesticide documentary, "Big Fears, Little Risks," which aired on PBS stations in 1989 (Naureckas, 1989). Ironically, Cronkite had chastised corporate endorsements by journalists, saying they sent the wrong signal (Kurtz, 1998). "Even doing it in retirement might indicate a favoritism toward one company or another while we were active," Cronkite said of David Brinkley, even though Brinkley had left ABC News before he agreed to become a television spokesman for Archer Daniels Midland (ADM), the Illinois-based agribusiness giant that pleaded guilty to price-fixing in 1996 but had also helped sponsor the Sunday morning program he launched in 1981, *This Week with David Brinkley*. Many of his colleagues were "aghast" (Kurtz, 1998) and considered the job a degradation of the former newsman's values and stature. To become a spokesman in the first place was seen as cheapening the self-worth he had earned as a respectable journalist—a sell out. But his becoming a spokesman for a company publicly exposed for its illegal practices was doubly disappointing.

Former NBC and CNN anchor and correspondent, Mary Alice Williams, also ignited discussion when, after retiring from journalism, she became a consultant and spokeswoman for Nynex Corporation (Elliott, 1993). Williams was far from the first former newscaster to turn pitchwoman. One

of television's first anchors, John Cameron Swayze, left NBC in the 1950s to pitch Timex watches. In 1989, Linda Ellerbee, formerly of NBC and ABC, appeared in newscast-like commercials for Maxwell House coffee (Elliott, 1993). Former *Today* co-anchor Deborah Norville moderated a mock television program for Philip Morris with ABC sportscaster Dick Schaap, and former *CBS This Morning* host Kathleen Sullivan reemerged as a Weight Watchers spokeswoman. Even Brinkley's old partner, Chet Huntley, was a front man for American Airlines after leaving his NBC anchor chair (Kurtz, 1998).

But although Williams and others were no longer network news employees when they began their advertising careers, the issue was whether their clients were trading on the reputation they built during their careers as reporters. The journalism community has drafted different rules, somewhat arbitrarily, according to the type of program a journalist appears on, and it has not always held fast to its own rules. For example, Katie Couric and Bryant Gumbel were prohibited from making commercials, but weatherman Willard Scott, *Good Morning America*'s Joan Lunden, and CBS *Sunday Morning* host Charles Osgood were permitted to do so while still holding their TV jobs (Elliott, 1993; Kurtz, 1998). ABC justified Lunden's case by saying that the program on which she appeared, *Good Morning America*, was produced by ABC's entertainment division, not its news division, unlike its counterpart at NBC (Elliott, 1993). These exceptions illustrate how corporate motives can trump journalistic values. In determining what situations pose conflicts of interest and require policy enforcement, networks make distinctions according to their own self-interests. In 1994, CBS felt it had to have Osgood as the replacement for Charles Kuralt as the host of CBS' *Sunday Morning*. It wanted the anchor so desperately that the network agreed to violate its own policy that prohibited news anchors' involvement in advertisements. Osgood accepted the new host position on the condition that he was allowed to continue his duties on *The Osgood Files*, three-minute commentaries that were broadcast weekdays on CBS radio. Some commercials that ran during *The Osgood Files* were written and read by Osgood for extra pay, plugging brands from Total cereal to Hurd windows (Elliott, 1994). Along with the editor of the *Columbia Journalism Review*, who noted that a newscaster having an obligation to an advertiser was the crux of the problem, network executives acknowledged concern about whether viewers would be able to distinguish between the different roles

Osgood would occupy and admitted that they would have preferred not to have been put in the situation. However, CBS attempted to assuage concern by remarking that Osgood's credibility would enable him to step out of one role and into the other. Another question was whether Osgood's new status with CBS News would provide a "halo effect" to his commercials, causing listeners to give them more attention and credence (Elliott, 1994). Osgood's dual employment represented a clear conflict of interest as well as an exploitation of his network anchor status, both frowned upon by the journalistic community.

A more recent example of a TV network redrawing the boundaries around its anchors and potential conflicts of interest is CNN's use of its anchors and correspondents to promote CNN Events division activities. The new division launched in 2006, under the auspices of the advertising sales department, will put on panels, conferences and meetings on newsworthy subjects sponsored by CNN's advertisers who will be acknowledged on the invitations and at the events (Elliott, 2006). The events will not be televised on CNN, but network anchors and correspondents will serve as speakers and moderators. Although CNN says the advertisers will not have control over the content, critics believe the practice will raise questions about who controls the agenda (Elliott, 2006). Rather than employing an ethical demarcation in anchors' involvement in promotional activities, networks base their allowances on whether the anchor's activity will further the network's own goals.

Other examples of former anchors and correspondents prompting criticism from the journalistic community are the publishing of books that don't reflect well on the industry, such as Bernard Goldberg's *Bias* (Rendall & Hart, 2002). Goldberg's book crossed the boundaries of community loyalty, even if he had already retired from the field. However, in 2003, without protests from the community, Cronkite agreed to write newspaper commentary for King Features Syndicate (Astor, 2003), and Ted Koppel began writing a *New York Times* column shortly after his reign as ABC *Nightline* anchor ended. With these exceptions, even after journalists retire from their official capacities, they are still the targets of flak from the community for leveraging the fame of their former roles for new commercial endeavors. The Cronkite and Koppel exceptions, which include Koppel's book which was released while he still held the ABC *Nightline* post, were made, as discussed in earlier chapters, because they bolstered journalistic

authority and extended journalists' prominence and credibility as cultural leaders. Other anchors' autobiographies—and they are numerous[3]—have been similarly exempted from criticism as they also convey positive images of the field. They do not threaten to expose indelicacies of the field or community and instead continue to paint noble pictures of journalists' work.

TV anchors are not the only journalists who write books about themselves and their careers. Bob Woodward of the *Washington Post* and Watergate fame has offered books and commentary outside of his role as an editor of the *Post*. This relationship of his extra-curricular activities to his job title has been contentious at times (Carr, 2006). As a newspaper superstar and legend, his books and interviews command much attention, and he has been involved in some of the most sensational journalistic revelations in the history of the American media and government. Only TV anchors command equal attention for having been involved in far less fantastic events.

Positive accounts of former anchors' experiences are easier to locate than those that criticize the field, and this is no surprise given the lifetime appointment of those individuals who reach the utmost prominence in TV journalism. Although it is once more an unwritten rule, it still stands as part of the journalistic community's code that once an anchor, always an anchor. Like ex-presidents in the United States, the TV anchor is supposed to live on into eternity as a revered figure with a sacred position in the nation's and media's lives. This is why the fate of Dan Rather after his retirement from the *CBS Evening News* was so troubling. Not only had Rather practically been forced into early retirement by the "Memogate" scandal, but by June 2006, his role at CBS had been all but eliminated. He was allowed to maintain an office and a secretary but had no affiliation with any CBS program (Steinberg, 2006).

For a veteran newsman who wished to continue actively pursuing stories, staying with the network under those conditions was not an option for Rather. According to culturally established scripts, this was not supposed to happen to a legendary anchor. Rather should not have faced an abrupt and sour premature end to his auspicious reign. His treatment by CBS violated

3. Other autobiographies include Andrea Mitchell's *Talking Back* (2005), Bob Schieffer's *This Just In* (2003), Dan Rather's *The Camera Never Blinks* (1977) and *The Camera Never Blinks Twice* (1994), Lesley Stahl's *Reporting Live* (1999), Walter Cronkite's *A Reporter's Life* (1996), and Ted Koppel's *Off Camera: Private Thoughts Made Public* (2000).

the unwritten rules about the treatment of retired anchors—the few who have reached the TV journalism apex and hall of fame—which is akin to the professorial emeritus status extended in academia, which allows the individual to maintain his status, dignity, and sense of productivity into old age. Like a federal judge, who is appointed for life, network television news anchors are appointed for life, no matter when their official duties actually end. As long as they act in ways acceptable to the community and do not exploit their good fortune in unseemly ways, they are entitled to reap the benefits of their previous stature in retirement. For anchors, once they are in the public eye, they are always in the public eye. Their positions extend their careers beyond retirement.

By publicly criticizing anchors' actions through both popular and professional forums, the journalistic community sends a warning to other journalists about what kinds of behavior are unacceptable and in which contexts. When other journalists encounter these signals, they are made aware, or reminded, of those actions which pass without challenge and those which receive flak. In this way, community dialogue about anchors' transgressions creates and affirms guidelines for professional practice.

Crossing the Borders of Careful Reporting

A different sort of community maintenance and repair takes place when journalists have breached rules of careful and ethical reporting. According to theories of paradigm repair, denial, evading responsibility, reducing offensiveness, mortification and corrective action, are among the strategies an individual journalist or organization may utilize to restore his or her reputation (Hindman, 2005). Paradigm repair has been used to analyze some of the most severe cases of unethical reporting in print journalism such as those of Janet Cooke and Jayson Blair. But with print journalists who commit these egregious acts, the revelations of their actions often take longer to uncover and be understood. It also takes more time for their faces and backgrounds to become known to the public. It was years after he first began committing plagiarism and false reporting that the public actually came to know what Blair looked like and where he had come from. It was only after Janet Cooke was awarded a Pulitzer Prize that her face and story became known, which led to her downfall. In contrast, when severe breaches of reporting practice occur in television journalism, the publicity surrounding them is usually swift and the journalists already well known. In applying the

paradigm repair framework to challenges in the history of network television news, it is possible to analyze which strategies were employed in each case to maintain community norms and restore the organization's reputation and the resulting consequences for those stories' reporters.

In 1992, *Dateline* NBC failed to disclose how it had rigged a crash test involving a GM pickup truck. By 1993, NBC News had admitted they had rigged the pickup truck explosion being videotaped to illustrate an expose on truck safety. Although the fifteen-minute segment that preceded the rigged explosion contained interviews and industry documents that supported the NBC piece, in the fallout from the incident, producers and executives involved with the segment were fired outright and the president of NBC News, Michael Gartner, resigned. The rigged explosion violated core principles of good journalistic practice: fairness and accuracy. The show's anchors, Stone Phillips and Jane Pauley, who, with acts of mortification and corrective action, confessed and apologized for the incident on air, were spared. According to one report on the event, never in the history of network television news had two anchors "gone on national TV and eaten so much crow" ("GM Drops Its Lawsuit against NBC News...," 1993). Press accounts at the time declared the beginning of the end for NBC News (Lorando, 1995), and NBC's "unprecedented mea culpa did not prevent almost universal condemnation" ("GM Drops Its Lawsuit against NBC News...," 1993).

But just three years later, *Dateline* had "risen from the ashes. A news show that had seemed to commit journalistic suicide in full view of its audience not only recovered, it [was] the fastest-growing newsmagazine going" (Lorando, 1995). In an attempt to reduce the offensiveness of the violation and justify her continued place on the program, Pauley said that she believed that the NBC-bashing got a little out of hand and thought the show's quick recovery a measure of vindication:

> Nobody in the media can be too sanctimonious on this count.... The public was not shocked with a capital "S." There was a great deal of skepticism toward the media before this happened. Had no transgressions ever occurred before us, we would have been pilloried by the public the same way we were in the press.... There is some value from time to time in seeing a news organization taken to task for a lapse in standards. I just wish I hadn't been as close to the epicenter as I was (Jane Pauley in Lorando, 1995).

As a matter of fact, the show's anchors, Pauley and Phillips, were likely just the unfortunate front men on a poorly conceived episode of an otherwise highly respected program. While on one hand, the anchor benefits from being perceived as the person responsible when things go well, the downside is that he or she is blamed when things go badly. And although it is an ideal that rarely is borne out on a daily basis, anchors are supposed to have a hand in crafting the programs they host from beginning to end and are ultimately held accountable for the accuracy of their content. Nevertheless, the behind-the-scenes production staffers are the expendable personnel when someone must take the blame for a public blunder. Although the anchor must act as the designated apologizer to viewers, his job is usually safe. He is too valuable in terms of forming and maintaining a connection with the audience to be let go.

A similar scenario played out in a 1998 incident at CNN when the network aired a broadcast of its *CNNewsstand: Time*, a joint venture of CNN and *Time* magazine. "Operation Tailwind," as the story was entitled, was an investigative report that asserted that the U.S. government used sarin nerve gas in 1970 during the Vietnam War to save troops that were sent into Laos to kill defectors. Upon learning of the story, the U.S. government denied ever having used sarin. CNN tried to confirm the use of the gas but came up short. Their only source was elderly and suffered memory loss. In an attempt to evade responsibility, CNN then explained that reporters had mistaken the number on a fax with compromised legibility corresponding to sarin for the number of another non-biological weapon. Finally, in a move toward corrective action, the producer of the segment, April Oliver was forced to resign, and the correspondent on the story, Peter Arnett, who had gained much fame and respect for his coverage of the Gulf War in the early 1990s, received a severe reprimand and came close to being fired. Shortly thereafter, *Newsstand: Time* was defunct. Like the *Dateline* truck scandal, again in this case, the behind-the-scenes producer was dispensed with and the on-air correspondent's job was saved, albeit barely. However, Arnett's credibility was so severely damaged by this incident that his career would never fully recover. As Cecil (2002) has observed, in addition to repair work that takes place through printed community discussion, discourse-extensive repair work can also occur on news analysis broadcasts such as PBS' *Washington Week in Review*, CNN's *Reliable Sources* and Fox's *Fox News Watch*. Journalists acting as panelists on news analysis programs build boundaries

between themselves, as representatives of the mainstream objective news paradigm, and the deviant behavior of a few "bad journalists" (Cecil, 2002: 46). In the "Tailwind" case, these programs deconstructed the deviant behavior and in its place reasserted the objective news paradigm. Interestingly, CNN covered its own mistakes, having been accused of failing to properly confirm the Tailwind story and of abandoning its own journalistic agents when criticism of the story arose (Cecil, 2002: 48).

In contrast to these first two cases, a third case had a different result for the personnel involved. In 2004, CBS News discovered that it had relied on a faked memo about President George W. Bush's National Guard Service in the reporting of a *60 Minutes* story during the election year. CBS said it was an honest mistake, and though they initially stood by their story, Dan Rather later apologized on air in an act of mortification and correction. Amidst the outrage for what became known as "Memogate," the story's producer, Mary Mapes, resigned, and Dan Rather followed soon after. Attempting to minimize the severity of the incident and the uproar it caused, the journalistic community pointed out that Rather had long been a target of "conservatives who accuse the media of bias since his coverage of the Nixon White House during the Watergate era" ("Dan Rather Signs Off 'CBS Evening News,'" 2005).

These incidents illustrate the particularities and varying consequences involved in TV journalism's paradigm repair. In the *Dateline* incident, the anchors were spared and those behind the scenes took the fall. Conversely, in the "Tailwind" and "Memogate" cases, the anchors and correspondent were among the casualties of the repair. Compared to Rather, the career records of Pauley, Phillips and Arnett were clean before the scandals they encountered. In contrast, Rather's career before "Memogate" had been plagued by multiple scandals and accusations of political bias. This put Rather in a weaker position to deflect or weather the "Memogate" scandal. Additionally, the consequences of the scandals for the anchors were proportional to the nature and power of the offended parties. Rather's offense involved a sitting president capable of quick mobilization of political and public relations forces against the anchor and his network. It was also not the first time Rather had been perceived to favor the Left, making it easier to put the new mistake into an established frame. Arnett's offense was almost as serious—he alienated the U.S. military. In Pauley's and Phillips' case, they offended General Motors, a major corporation, but the offense was not inherently

political and therefore carried less power to ruin their careers. For the journalistic community, these incidents would become part of the canon of examples of what not to do. When journalists witness the apologies star anchors are made to give and the embarrassment they suffer as a result of their violations, they receive a strong message about how similar violations will be punished. The community hopes these journalists will be more likely to think twice about staging an event for a news piece without disclosing it and more likely to double check the documentation before reporting on the president's or government's record. Additionally, these cases and others are printed and reprinted in journalism textbooks as reminders for future TV journalists of potential pitfalls.

Crossing the Borders of Community Loyalty

As has been touched on, once a journalist has moved into the highest echelons of the TV news world, he or she is expected to hold that position for life. Especially while still working, anchors are supposed to convey the utmost confidence in their colleagues and in their purpose as journalists. This re-assertion and positive affirmation of TV journalism's value and stature continue well past the official borders of an anchor's retirement. This exchange of a career in the limelight with all of the privileges that come with the anchor job for unflinching and unending loyalty to the journalistic community is the unwritten agreement anchors, their employers and the journalistic community, are parties to. When an anchor defies this agreement by criticizing his colleagues or the community's practices, the community shows little mercy.

Among those who have crossed the borders of community loyalty is Max Robinson. In 1981, Robinson, the first African American network television news anchor, was guilty of blasting his own journalistic community about discriminatory practices in a speech he gave at Smith College. According to network anchor Carole Simpson (in Alan & Lane, 2003: 236), Robinson criticized ABC in particular as well as the other networks for being racist because he was not called upon to do the inauguration coverage. Of the three major anchors including Peter Jennings, Frank Reynolds and himself, Robinson would get whatever was the least important role. "He got into a lot of trouble for making that speech, not because it perhaps was not true, but because it reflected badly on his employer.... His big mistake was nailing ABC and how he was treated in a public venue, apparently without ever

having gone to them to complain ahead of time," said Simpson (in Alan & Lane, 2003: 236). Among other events, such as Robinson's refusal to attend the funeral of his co-anchor Frank Reynolds, with whom he had feuded, this led to Robinson's professional demise. ABC remained bitter until Robinson's departure, and Robinson never overcame the bad feelings his speech created (Alan & Lane, 2003: 237). Robinson had tried to parlay his very visible position into public advocacy, "with which some anchors and all networks are uncomfortable: controversy breeds difficulties" (Alan & Lane, 2003: 240). Robinson was not the first journalist to commit this sin nor would he be the last. As Alan & Lane (2003: 230, 236–237) noted, "In his audacious, outspoken commentary on the industry, Robinson evoked memories of Edward R. Murrow and, in particular, the blasting Murrow gave the industry in 1958 at the Radio-Television News Directors Association and Foundation convention. That speech just about finished Murrow," as Robinson's 1981 speech just about finished him. As the invited speaker at the RTNDA convention, Murrow used the opportunity to express his concern about the commercialization of network news and journalists' timidity in tackling controversial subjects. Murrow knew his message would be "uncomfortable, and unwelcome" and even began his speech by saying that he may be accused of "fouling his own comfortable nest" (Alan & Lane, 2003: 35). He was correct. In addition to slighting the industry of which he had been an integral part, he was also guilty, as was Robinson, of failing to handle the matters behind closed doors. Within three years of their speeches, both Murrow and Robinson left their networks (Alan & Lane, 2003: 230).

Former CBS correspondent Bernard Goldberg was another TV journalist who criticized his own field with the writing of *Bias: A CBS Insider Exposes How the Media Distort the News*, his harsh critique of TV journalism's—as he saw it—liberal leanings. After publicly condemning the work of his former colleagues in a column in the *Wall Street Journal*, Goldberg was, not surprisingly, "disowned by CBS and by Dan Rather in particular" (Dvorkin, n.d.). Ostracized by these former colleagues, Goldberg resigned in the summer of 2000 after 28 years with CBS. Goldberg did not publish *Bias* until after he had officially relinquished his ties to the news organization, and some saw his as a case of sour grapes (Rendall & Hart, 2002). Goldberg says he was attacked both internally and externally by CBS and called an "extremist" (Dvorkin, n.d.). But as in other prior incidents, CBS did not like being attacked in the press by one of its own, especially without fair warning

(Dvorkin, n.d.). Within the journalistic community, criticizing the field after working in it for years is biting the proverbial hand that feeds you. The community prefers that people with gripes deal with them within the confines of private venues, even though the community's chief method of maintenance is public discourse. The appearance of solidarity is of utmost importance for the community and disloyal members are punished by expulsion.

Crossing the Borders of Celebrity

There are still more situations in which journalists may overstep community boundaries. Journalists can capitalize on their celebrity status in ways that are unacceptable according to community standards. Although anchors' fame is leveraged by the journalistic community to bolster its authority, in certain circumstances, the community views the exploitation or abuse of journalistic fame as signature run amok—an unpleasant overdose. Unlike the benign and even beneficial uses and cases of celebrity to which the community turns a blind eye, certain deleterious exploitations of celebrity warrant special attention and amelioration. These are the behaviors the community singles out for public display and reprimand.

In some instances, journalists seek to earn money, fame or other intangibles by exploiting their celebrity. Auletta (2003) and Fallows (1997) are among those who have bemoaned the phenomenon of celebrity anchors who get paid for giving lectures. The list of elite journalists who have given speeches for money is quite lengthy and includes some of the biggest names in television news.[4] Lecture fees can stretch from thousands of dollars to tens of thousands of dollars to the six-figure mark, depending on the anchor and the occasion. Some observers believe that in "the era of talking heads," the "growth of large-scale for pay speaking is directly connected to a seemingly separate phenomenon; the spread of TV talk shows modeled on *The McLaughlin Group*" (Fallows, 1997: 84), but "the two trends—more journalists on the lecture circuit, and more journalists on TV—cannot be understood apart from each other....The lecture circuit matters because it is

4. Among those who give fee speeches, Auletta (2003) lists: Cokie Roberts, Brit Hume, David Brinkley, Robert Novak, Rowland Evans, Mark Shields, Michael Kinsley, Fred Barnes, Morton Krondacke, Gloria Borger, Wolf Blitzer, Andrea Mitchell, Chris Wallace, Chris Matthews, and David Broder.

the way for journalists to make real money, and the talk shows matter because they are the way to get lecture dates." Some big-name newspaper reporters and columnists are also hits on the lecture circuit, and some critics of the fee speech practice believe that high speaking fees provide the incentive for these print journalists to be more controversial so that they will be called to appear on TV talk shows, thereby increasing their attractiveness for the lecture circuit (Marvin Kalb,[5] in Glaberson, 1994). And although journalists may deny that their behavior is affected by this new source of income, they cannot undo the way this practice changes the public's view of prominent journalists and journalism as a whole. Additionally, some observers call it a double standard when the same TV journalists who criticize the paid special interest groups in Washington accept fees from some of those same groups. As one *New York Times* article pointed out, the large fees paid to journalists also draw attention to the "awkward fact that a small number of stars make a large amount of money in a profession that would prefer to be viewed as merely noble" (Glaberson, 1994).

One defense for the ethicality of fee speeches by journalists is that they are private citizens and not elected officials. This is the justification Sam Donaldson invoked after being paid $30,000 for giving a lecture to an insurance group. However, this contention is highly debatable. The fear that large speaking fees could damage the credibility of journalism has led many news outlets to establish guidelines prohibiting or restricting the fee speeches anchors may deliver (Shepard, 1995:18). Whether or not the payment would actually influence the reports of a journalist was less the issue than the concern that viewers would *perceive* the payment to have influenced the journalist. As Richard Wald, former ABC senior vice president of news, explained, "When we report on matters of national interest, we do not want it to appear that folks who have received a fee are in any way beholden to anybody other than our viewers. Even though I do not believe anybody was ever swayed by a speech fee, I do believe that it gives the wrong impression. We deal in impressions" (Shepard, 1995: 9).

In June of 1994, ABC News issued new rules about fee speeches—largely the same ones that were in place at the *Wall Street Journal* and the *Washington Post*. In 1996 NBC also prohibited news employees from taking speaking fees from corporations and trade associations that take positions on

5. Kalb is a former network correspondent and director of the Joan Shorenstein Barone Center on the Press, Politics and Public Policy at Harvard University.

issues. That policy also prohibits staffers from taking honoraria from any group they might cover and requires all paid appearances to be approved by management. As a result, some journalists have decided to continue making speeches without accepting fees.[6] Tom Brokaw deposited his speaking fees into a foundation that doled them out to worthy causes (Glaberson, 1994). But some see the fee speech debate as a sign of a larger problem of journalists-turned-celebrities:

> In tandem with its first cousin, the television pundit show, the this-mouth-for-hire syndrome underscores so much of what is wrong with the field today: journalism as entertainment, and journalists as entertainers; journalists and politicians as part of an elite, living in a rarefied world far removed from the mundane realm inhabited by their viewers, readers, listeners and constituents (Reider, 1996).

Even so, other television journalists feel that the distinctions made by the community and their networks are arbitrary. Jeff Greenfield, formerly of ABC and CNN, gave approximately fifteen paid speeches a year in the late nineties and beginning of the 21st century. Greenfield argued that "nearly everything he did could be deemed a potential conflict," and he was "uneasy with the distinction that newspapers like *The Wall Street Journal* or *Washington Post* make, which is to prohibit daily reporters from giving paid speeches to corporations or trade associations that lobby Congress and have agendas yet allow paid college speeches," reasoning that "even universities have legislative agendas" (Auletta, 2003: 193).

However arbitrary they might be, the distinctions made in the mid-nineties still stand at the networks. As such, paid college speeches are still allowed, but the anchors who give them are careful about the impressions they leave. When it was made public that Katie Couric had received $110, 000 for delivering the commencement address at the University of Oklahoma in May 2006, her reps were quick to say that she would be donating the money to charity (Oldenburg, 2006; "Fishbowl NY: Update: Couric's $110K Fee Donated to Charity," 2006). The pressure exerted by the journalistic community on its members in regard to extra income they may seek through their celebrity is intended to protect the community and its members from

6. Among these who Auletta (2003) lists are Tom Brokaw, Peter Jennings, Dan Rather, Ted Koppel, Jim Lehrer, Bob Schieffer and Brian Lamb.

unseemly self-indulgence and abuse of audiences' good will. With this particular issue, community criticism has been shown to be an effective management technique as it prompted individual news organizations and their members to adopt rules regulating fee speech.

Another type of situation in which the celebrity of TV journalists is exploited, sometimes in ways that violate community notions of propriety, is when information about these journalists' personal lives becomes the subject of news. Although in many cases, the journalist has little to no control over the publicizing of these stories, networks and the journalistic community can still be upset by them. In contrast to personal activity that makes the journalist look good and be perceived as more likable to audiences, when an action or relationship is seen as illicit or inappropriate, the journalist can lose favor with audiences, employers and peers. This is driven by the image of the anchors that the journalistic community and the networks would like to project to audiences and advertisers. Journalists are supposed to abide by the highest ethical standards in their professional lives and in their personal ones as well. No matter who is responsible for putting them on their pedestals in the first place, once there, they serve as role models. Impropriety in either personal or professional spheres can impact public perceptions, and a disparity between the two spheres detracts from the unified picture of the anchor.

In contrast to anchors' personal relationships with other high-profile partners that positively impact their public images, the potential conflict of interest that Maria Shriver's marriage to Arnold Schwarzenegger posed when Schwarzenegger began campaigning for California governor caused Shriver to relinquish her position with NBC *Dateline* (Gay, 2004). Even though NBC had supported her continued tenure, citing Andrea Mitchell's ability to continue reporting without interference from Alan Greenspan's job, Shriver, who had not been impeded by her status as a member of the Kennedy family, felt that her journalistic integrity would constantly be scrutinized. A target of far more salacious gossip, former CNN anchor Daryn Kagan's relationship with conservative talk show host Rush Limbaugh did not serve to elevate the status of either party (Leiby, 2004). For example, Devin Gordon, writing for MSNBC's "Newsmakers" column in 2004 wrote:

> He's 53 and a rabble-rousing, right-wing radio host; she's 41 and a card-carrying member of the liberal media elite. According to the *Post*, Kagan's friends are, to say the least, "surprised." Limbaugh has been a bachelor

since June, when he showed just how serious he is about protecting the institution of marriage by divorcing his third wife. It's probably too early to discuss round four, but at least for the time being, Rush is off the market.

By 2006, the couple had parted ways, and shortly after, Kagan left CNN to start a news website (Steinberg, 2006d). The attention Kagan received because of her public relationship with Limbaugh was not the kind that boosted her favor with audiences or that was likely to please her network and colleagues.

Of course, it is another unrealistic ideal of the journalistic community to expect its members never to falter or show their *humanness* in any aspect of their lives, which are perpetually on display. Bree Walker's anchoring career came to an end when she publicly defended herself against a rival news broadcaster who had chosen to focus an entire program on Walker's very personal decision to have children knowing that they could be born with the same genetic defect that left Walker with deformed hands and feet ("Encore Presentation: Interview with Bree Walker, Jim Lampley," 2004). CBS was angered by Walker's response—they preferred that she ignore the attack— and although the network did not fire her, it cast "a pall" over her career. Walker did not seek to draw attention to herself or her decision but reacted in a way most women placed in such a situation would have—she defended herself. Neither Walker nor her own network sought to capitalize on her personal travail. Instead, another TV journalist sought to make a name for herself by stirring a public debate about one of her colleagues. This action, in itself, violated community standards of appropriate behavior—to be loyal to your own community and its members—although the anchor in question received no reprimand.

Unlike Walker who did not intend to bring trouble upon herself, other anchors have abused their celebrity in less innocent ways that have prompted criticism. Katie Couric has received much positive attention for her private comportment, but unfortunately for Couric, she could not prevent information about a less felicitous action on her part from getting out. In July 2006, it was reported that the anchor was granted access to the cockpit of a commercial aircraft on which she was a passenger in order to speak to the captain to persuade him to delay the flight so that her producer could accompany her ("Couric Delays Flight," 2006; "Nothing Will Stop Katie Couric," 2006). A spokesman for Couric confirmed and tried to justify Couric's behavior, but a passenger was quoted widely in reports of the

incident as saying, "Using your celebrity in the post-9/11 age to stop a flight is diabolical." The incident provided fodder for Couric's critics who saw the action as part of a larger pattern of the anchor's diva behavior ("Katie Couric Demanded Delay in Takeoff," 2006; "Couric Delays Flight," 2006). It was an abuse of Couric's celebrity and displayed an air of entitlement that marred her image, as it would have damaged that of any journalist. There was no official comment from her new network, CBS. Couric's behavior crossed community boundaries of celebrity as it did not paint a positive public picture of her or journalists in general. Instead, because she is a visible representative of journalism's highest echelon, it had the opposite effect. It is possible that Couric's fans might defend her by thinking they would have done the same for a friend. The difference is they would not have expected and been granted special treatment especially in an age of heightened terror alerts.

All of these border crossings reflect the vacillating boundaries of community norms and the ways in which network anchors deal with their celebrity power and utilize it, for good or ill. Anchors' boundary crossings and the community's public criticism of them have a pedagogical function in that they become examples for journalists and for the world of what is not tolerated and what happens to those who transgress. As such, through media discussions, the journalistic community attempts, sometimes unsuccessfully, to regulate the actions of its famous members.

Chapter 6
Conclusion: What Community Discussion about Anchors Reveals about Journalism

> The arrival of a new communication technology can be threatening to the identity of an established media institution. The capacity to radically alter the way the job gets done raises the possibility of fundamentally altering the nature of the job itself, and to redefine the job is to redefine the institution.
>
> Gwenyth Jackaway, 1995

This book has been a study of adaptation and improvisation. Specifically, it has been an examination of the ways in which an established interpretive collective responded to technological innovations in communications. Just as Jackaway tracked the media wars that ensued from radio's challenge to newspapers in the twenties and thirties and found that ultimately the contest between media is a contest of values, so too has that been found to be true of television journalism's challenge to previous forms of journalism. Journalists' adaptation to television technology manifested itself in particular ways. These ways, as personified by the network television news anchor, threatened the existing identity, practices and values of the established journalistic community. TV anchors and reporters practice journalism in a way that radically alters the nature of the journalist's job. When one is dealing with interpretive struggles, they are often a matter of degree and proportion. TV journalism played upon certain tensions that already existed to a lesser degree within the journalistic community about the journalist's appearance, personality, fame, emotional displays, qualifications for selection and promotion and compensation. TV inflated the proportion of the journalist's job that these dimensions comprised and made these dimensions clearly visible.

But the increase in the emphasis placed upon these elements of the journalist's job that were radiated by television is taking place more broadly in journalism of all kinds. Through synergistic and symbiotic arrangements between different news media, journalists of one medium traverse that medium's boundaries to be present in another medium. Newspaper

journalists are featured commentators on television talk shows. Newspaper and internet journalists have their pictures and sometimes even live video of them posted next to their columns or articles. TV journalists blog online. Many journalists are no longer even employed by a single medium or news outlet.[1] With the ever-decreasing numbers but increasing size of media conglomerates who own media outlets, journalists and their work in one organization are easily traded and transformed across platforms. This cross-pollination of journalists across media, as well as larger cultural shifts toward a society that endorses and places a premium on the elements that television trades on (celebrity gossip, plastic surgery, makeover narratives, reality TV) have led to increased focus on these elements for print, radio and internet journalists as well. Television has merely been the fast lane for accelerating and obviating the presence and focus on these elements.

Through informal social control exerted through interpretive community discussions, the journalistic community has struggled for some fifty-odd years to strike a balance between its traditional values and these dimensions highlighted in television practice. It has done so in patterned ways around key junctures and events in TV journalism's history. And while the community recollects parallel events in its past, it continues to play out new discussions about similar events as they occur. This cycle of remembering and rehashing demonstrates the community's limited success in halting permeation of the dimensions it finds offensive. But at the same time, the social pressure it exerts on individual journalists has been shown to curb undesirable behavior in the short-term. While it may be impossible to determine beyond a doubt which led to which—television's emphasis on certain dimensions or society's move in the same direction—the interpretive journalistic community has been unable to fully impede their momentum. Yet the community neither concedes to these elements nor renounces them outright. In this way, it is caught in a perpetual tug of war. The content of community dialogue about these elements is the community's incessant "dance."

However, instead of viewing the decades of community discussion about features of television journalism as a failure to reach a resolution between old and new fixtures of the craft, this bickering is actually the mark of

1. This was predicted by Bardoel (1996: 389): "Moreover, the journalist's work will be increasingly less bound to specific media."

productive community behavior. As Fish (1980) noted, the notion of an interpretive community assumes a communal give and take in the working out of meaning, which, in turn, implies that interpretive communities are in no way antithetical to argument. Argument may, in fact, may be prerequisite to a certain type of argument: "Consensus about the role of an event in the life story of a community is never total and certainly not automatic; various members from the community inevitably disagree about how to interpret it" (Brewin, 1999: 226). Instead, it is the movement towards consensus through interpretation which keeps the community relatively cohesive and protects its institutional power base. This requires shared assumptions about what behavior is appropriate and which standards should be applied to events and actions. The common ground of an interpretive community, therefore, lies not in agreement over how the community ought to interpret what happened but in the common interpretive tools used by all members of the community in debating and discussing an event's meaning (Brewin, 1999: 226). From this perspective, the journalistic community's ongoing conversations can be seen as successes in themselves.

Going Forward

This book has illustrated the ways in which the rules and borders of the journalistic community have shown themselves to be flexible and malleable in response to new technology. The journalistic community can and will adapt. The fact that the community has not completely rejected new elements and developments that TV, and now newer media, has introduced is evidence that the community can evolve. It now faces challenges from online and mobile news, social networking applications such as Twitter, and citizen journalism and blogging. Journalism is clearly a craft in flux, with constant new threats from an ever-changing technological, cultural and political landscape. Since the days of print, it has managed to survive and retool, although these actions are painful and go against the community's dogmatic, petulant, and stubborn nature.

In terms of predicting where journalism will go on its next round, this book has pointed to the increasingly fluid boundaries of the craft. The threat of new technology and new forms of news media to the existing journalistic community in general do two competing things: 1) they make the community cling even more steadfastly to its present and traditional principles and standards in some instances, and 2) force it to be flexible in adapting and

reinventing itself so that it doesn't become obsolete and expendable.[2] In the case of TV's challenge to journalism in particular, since the initial merger of TV and journalism, the community, through interpretive dialogue, has continuously expanded its repertoire of rules, exceptions, examples and justifications surrounding TV journalists' conduct. Over time, each new incident adds to the community's body of experience. In this way, one could compare this ever-increasing and evolving body of discussion and knowledge in the journalistic community to the way that academic research and discourse evolves or the way that laws and legal interpretations evolve. And extending this comparison, like patterns in legal and academic discourse, patterns have emerged to the decades of journalistic community discussion. The more discussion and knowledge available, the more informed and sophisticated the approach should be to evaluating new examples. Rather than regarding a new technology or critical event as an end to recognized forms of journalism, the role of the technology or event should be seen as "providing a stage for journalists to reshape their professional practices in accordance with new preferred forms of technology." In this way, new technology "extends, rather than deadens, journalism as we know it" (Zelizer, 1992a: 351). Discussing the challenges posed by a new technology "offers reporters a stage on which to evaluate, negotiate, and ultimately reconsider ideas about professional practice and appropriate boundaries of journalistic authority" (Zelizer, 1992a: 351).

However, although journalism excels at exploiting institutional memory in some ways, it struggles to revive or sustain it in other ways. Although journalists may recollect through commemorative and recycling activities that enhance their authority, the memory of how past breaches of appropriate behavior were handled is often short. So some discussions of anchors' behavior seem to be reinventing the wheel and rehashing old arguments. This is where these patterns can be seen, as well as in the rarer instances when new incidents are viewed with an eye to similar incidents in the past.

It is possible to extrapolate and predict the community's reception of newer technologies than television; they will deal with them in similar ways. We can predict that the community's first response to the challenge of new technology will be to discount it, reassert the virtues of its current practices, and deny its new practitioners recognition as community members. There are already signs of this first response as illustrated by John Carroll, former

2. Zelizer (1992a) refers to the community's eventual reluctant change as "surrender."

editor of the *Los Angeles Times*, who said in the PBS *Frontline* program "News War: What's Happening to the News," that:

> [Newspapers are] the principal engine of journalism in America.... Most of the other media are recyclers of what newspapers produce.... I estimate that roughly 85 percent of the original reporting that gets done in America gets done by newspapers.... It is very evident that the new media, the media that are coming along with the Web, are investing almost nothing in original reporting. If newspapers fall by the wayside, who's going to do the reporting?... Who will...make sure that things are being done properly?... The only people who are going to be left standing as journalists in great numbers will be newspapers.... the Web opens up vast possibilities for good journalism and already has created many new voices that are valuable. But I don't think we can turn this thing over entirely to bloggers and citizen journalists. They're valuable, but there are things they can't do (Talbot, producer, 2007).

But once it becomes clear to the community that "altered boundaries of appropriate practice are inevitable" (Zelizer, 1992a: 349), they will be confronted with and will consider new ways of adapting:

> Journalists were slow to embrace [the internet]. It felt odd. It felt like this thing had different deadlines. Who really reads it? We're all middle-aged.... So we were slow to embrace it. Business sides of newspapers were slow to embrace it, too, because they ...didn't see how they were going to make money from it. So we were slow...But my God, what a good thing it is now once you embrace it. First off, it feels just like the afternoon papers I started for. You get the story; you put it up. I like that. That appeals to the competitive part of me. I get e-mails now from people all over the world who read stories that they like, who read stories that I like sometimes, too. I have readers I never would have had. I have readers I never could have dreamed of having. When we do a big story, we have more impact than we ever could have had. I'm speaking as a journalist whose job it is to disseminate information. It's the best thing that's ever happened to us (Dean Baquet, former *Los Angeles Times* editor in Talbot, producer, 2007).

According to Pulitzer Prize-winning *Wall Street Journal* reporter Steve Stecklow (2009), "print is dead. The newspaper companies have been unbelievably stupid and negligent... giving their content away for free online makes no sense." Stecklow explained that the *WSJ* stays afloat by charging money for the WSJ.com which generates $60–$70 million in online subscriptions. *"The Journal* can get away with it because they offer premium

content you can't get elsewhere." He added that other papers are trying to figure out a way to start charging and want to all start charging customers together at the same time without violating anti-trust laws. He also added that "Craigslist completely eliminated classified ads" and that although "the Internet may be destroying newspapers, it's the world's greatest tool for investigative reporting."

Washington Post executive editor Marcus Brauchli (IFC, 2009) said he is "confident that a new [journalistic] model [for business] will emerge" but he agreed that news organizations tend to be reactive rather than proactive in terms of adapting to new technology, and that it is journalists' nature to be resistant to change. Brauchli compared newspaper companies to General Motors in that they have both been slow to realize the need for and effect change in their business models until faced with a crisis. Cable news anchor John King (IFC, 2009) defended CNN as embracing new technology, citing the holograms they used during the 2008 election and that he'd recently spent time inside one of their new "trucks full of HD broadcast equipment." In response to King, the *Washington Post*'s Norm Ornstein (IFC, 2009) called those "bells and whistles." Over time, those who practice journalism with this new technology will come to be seen as legitimate and will be accorded entry into the community. In this way, journalism will again be redefined. With new technologies, "journalists continue to engage in generally the same activities of news gathering, although they may emphasize and reveal different aspects of the process for public viewing" (Zelizer, 1992a: 349). However, each new form of journalism and its journalists are seen as progressively less pure, less legitimate, relative to older forms.

Over ten years ago, Bardoel (1996: 387) wrote presciently of the digital revolution and its impact on journalism:

> As well as—and not primarily instead of—the existing media, modern communication technology will lead to…new journalistic practices. These will not be "the same old journalism but with better tools" (Koch, 1991: xv, xxiii). As is always the case at the start of major technological innovations, only first ideas and experiments provide a glimpse now of what the future may hold. In the beginning, new services are apt to resemble the old and it will take some time before they are applied according to their own functionality.

This has been true of television technology as it will be with newer technologies. In fact, this is already being borne out with the internet and mobile technologies. As with television, at first the journalistic community was resistant, but with their tremendous popularity and generation of revenue, it is evident that adaptation is necessary. This is consistent with Ruggiero's (2004: 92) findings that between 1994 and 2004, "journalistic reluctance to accept internet news content as 'objective' as compared to traditional media news content" has weakened over time.

Some television news organizations are already well under way in diverting their resources to the web: "Rapid technological and financial changes that are throwing many traditional media businesses into upheaval" are considered among the foremost issues facing television companies (Carter, 2007). CBS' *60 Minutes* has entered into a joint venture with Yahoo whereby *60 Minutes* and extra material that did not make it into the televised program are available to internet users (Talbot, 2007). CBS has also made its entire *Evening News* broadcast available online for users to download free at their convenience. As *60 Minutes* executive producer Jeff Fager said, "I don't think we've seen the model, I know we haven't seen the model, for how broadcast journalism is going to end up on the Internet, but it has to go there. It has to. I mean, you don't see anybody between 20 and 30 getting their news from the evening news; you see them getting it online..." (Talbot, producer, 2007).

At an event sponsored by YouTube at Google's Washington, D.C., headquarters in January 2009, producers and directors for Foxnews.com and CNN.com, as well as executives in charge of online content for the *Washington Post* and the *New York Times*, discussed the ways their organizations are making use of online and mobile technologies and building their "online presence" (YouTube, 2009). Lila King, senior producer for CNN.com and CNN's iReport.com, said that the vocabulary within the newsroom is changing and that what used to be called a news "story" is now referred to as a "mosaic" when it is engineered for multi-media formats. Ann Derry, editorial director of video and television for the *New York Times*, who supervises all of the *Times'* online video programming and its television partnerships, said that "at first, other journalists at the organization were resistant and looked down on journalists who were using video. Then there was a major shift and they realized they all needed to do it, and that sources *wanted* to be on it and talk to people." According to Derry, print journalists

using video are "not the fat girls at the prom anymore."

In the midst of a world financial crisis and shrinking economy, some television stations are replacing their traditional news-gathering crews with "one-person 'multimedia journalists' who will shoot and edit news stories single-handedly" (Farhi, 2008). Moves to the so-called "one-man band" approach "will blur the distinctions between the station's reporters and its camera and production people. Reporters will soon be shooting and editing their own stories, and camera people will be doing the work of reporters, occasionally appearing on the air or in video clips" on the stations' websites (Farhi, 2008). As with every new news technology in history, there are always those who forecast the demise of older existing forms, but they do not disappear. In the case of television, it will increasingly occupy a smaller piece of the media pie, but it is unlikely to disappear altogether. Inevitably, questions will continue to be asked about whether network television news will continue to exist and whether anchors will continue to be necessary. Although the players who are the objects of these discussions differ from decade to decade, the subjects remain largely the same. As the *American Journalism Review* (Smolkin, 2006) observed in 2006:

> Nightly news is hot again, if hotness can be measured by the number of inches devoted to the anchor race in the nation's newspapers and magazines. Suddenly, the evening newscasts have what their morning print counterparts can only dream of: buzz and opportunity.

Since the completion of the research for this book, anchors have continued to be involved in headline-making stories. Between September and November 2006, Katie Couric's performance on the new *CBS Evening News* was the source of numerous critiques and commentaries, some, as expected, about her wardrobe choices and the degree to which her personality was showcased or stifled (Stanley, 2006b; Shales, 2006). In other critiques and comments, some women have rooted for Couric because of the important step she represents for women in news, but other women believe she may be botching this golden opportunity (Bradley, 2006). Couric's program briefly received a ratings spike during and immediately after her revealing interview with Republican vice presidential candidate Sarah Palin in September 2008, but the rise was short-lived. Once again, news articles surmised her departure from the *Evening News* slot before her contract expires in 2011 (Friedman, 2009).

PBS anchor Charlie Rose was also the subject of discussion for the potential conflict of interest that his actions posed when he hosted a dinner honoring Wal-Mart stores' chief executive after having interviewed the same chief executive about the chain's environmental initiative less than three months earlier (Barbaro, 2006). Additionally, Jane Pauley made the paper for suing the paper, the *New York Times*, saying she was misled to believe she was being interviewed for an article on mental health when she actually was being featured in an advertising supplement ("Jane Pauley Sues *New York Times* over Ad Supplement," 2006). The death of long-time *60 Minutes* correspondent Ed Bradley in November 2006 prompted a slew of obituaries and tributes both in print and on television (Steinberg, 2006f) as did the death of NBC's Tim Russert in June 2008. Russert had been expected to lead NBC's political coverage during the 2008 presidential election, and his absence was frequently referred to by other journalists in their coverage.

In July 2009, the passing of Walter Cronkite at the age of 92 was marked by news outlets too numerous to mention and commented on by a list of notables including President Obama, Arianna Huffington, Dan Rather, Katie Couric, Don Hewitt, Barbara Walters, Bob Schieffer, Robin Williams, Diane Sawyer, George Clooney, Bill Clinton and Ted Koppel ("Colleagues: Cronkite 'Consummate Newsman,'" 2009; "Remembering Walter Cronkite," 2009). *60 Minutes* creator Don Hewitt also died in August 2009 at the age of 86. One lengthy obituary and retrospective article in the *New York Times* noted that with the deaths of Cronkite and Hewitt, "CBS News has now lost two of its biggest pillars in a little over a month" (Steinberg, 2009).

In September 2009, NBC's *Today* show announced that presidential daughter Jenna Bush Hager would join the broadcast as an education correspondent ("Bush Daughter Jenna Hager Joins TODAY Staff," 2009). More groundbreaking news came also in September 2009 when ABC News announced that Diane Sawyer would replace retiring Charlie Gibson in the evening anchor slot, making it the first time in broadcast news history that two female solo anchors would occupy the evening news desks ("Gibson to Step Down as Anchor of 'World News,' 2009). In November 2009, Lou Dobbs announced on his own program that he would be leaving CNN (Dobbs, 2009). These comprise only a sample of what continues to be discussed in regard to network television news anchors.[3] As such, interest in

3. Some other items have included: Diane Sawyer's commitment in 2007 to continue on ABC's *Good Morning America* (Steinberg, 2007); CNN *Headline News*' brash hosts

anchors, while it may not be increasing on the television screen as measured by viewer ratings (Steinberg & Carter, 2006), is holding steady as measured by the media discussion about them.

The ratings of the anchors of the past three decades present a paradox: Brokaw, Jennings and Rather presided over the greatest erosion in network evening news ratings ever, and by the standards of the 1960s and 70s, their ratings and market share are generally acknowledged to be a disaster (Alan & Lane, 2003). Yet there was far less public rumbling then about changes and reshuffles of the anchoring assignments than in any other period of TV journalism. In this respect, "the anchors are a sort of eye at the center of the news hurricane" (Alan & Lane, 2003). Their long tenures presented a veneer of stability to what otherwise was a period of unprecedented change in the national news landscape (Alan & Lane, 2003: 354). Over ten years ago, some critics already believed that a "striking change has taken place in the journalist's place in American pop culture" generally, and that whereas journalists were once seen as "gruff and hardbitten yet unwilling to yield to cynicism and always ready to fight for the right," today's reporter is seen as "a boob or bounder" (Hanson, 1996). With this perspective in mind, it is possible to say that journalism in the era of television has always been unstable. The latest upheaval in 2005–2006 may not be as unique or unsettling to the craft as some believe.

That being said, perhaps the significance and prestige of the TV news anchor will never again be equal to the levels during Cronkite's tenure or the period of Brokaw, Jennings and Rather. Perhaps one or more of the networks will go out of the business of producing news. Perhaps journalism in general will continue to fall in esteem and credibility. Contrary to Zelizer's (1992a) reasoning that journalistic practices and models do not die, they evolve, McChesney (2006) believes that this may truly be the verge of a new journalism era—what he calls a "critical juncture"—when things are up for grabs, when there is a range of opportunities to have a greater influence in setting a course for the future, and when people can intervene and weigh in and change the outcome. He thinks that the case can be made that the digital revolution is on par with the revolution of the printing press—that there is and will be equal upheaval.

attracting viewers in prime time (Cohen, 2006); and George Stephanopoulos' move up in the ratings (Steinberg, 2007b).

Others echo McChesney's belief, pointing to a move toward a hybrid model of journalism that abandons traditional approaches (Lisheron, 2007) and observing that "at the end of the 20th century, journalism must once again seek its place in a changing society" (Bardoel, 1996: 389). Some wonder if journalism will find its place with opinionated news anchors such as MSNBC's Rachel Maddow, and a change in the basic tenets of news itself. According to Peter Kann, the Pulitzer Prize-winning chairman of Dow Jones, there are "fashionable new philosophies that argue there are no basic values of right and wrong, that news is merely a matter of views" (Lisheron, 2007). Others ask whether the shift in the balance of power in news with bloggers, tweeters (those using Twitter) and users having more power will be temporary or permanent, possibly resulting in a new journalistic model, or a return to an old model—"open-source" journalism (Rosen, 2005). Jim Brady, former executive editor of washingtonpost.com, believes it will become a popular assumption and expectation that all types of news organizations "will do everything—they will all become part of the same enterprise" (YouTube, 2009). Other changes to the TV news landscape include "agency technologies," such as DVRs, TiVos, menu lists, and channel grids that enable users to control the time they watch programs and avoid ads, all which affect the balance of power between viewers, producers and industry (Newman, 2009). Newman (2009: 5) suggests that these technologies of agency may actually improve television's status as a medium within culture because they enable audiences to be more active in "personalization, customization, navigation, interactivity, choice, and empowerment."[4]

In the face of these changes, television news will not fade away. Some of the same basic psychological, social and intellectual needs that have always caused audience members to seek out and connect with particular types of journalists and journalism will continue. People will continue to desire information about the world around them. Certain types of information will continue to be most welcome and palatable when delivered by other people. The November 4, 2008, television news coverage of election night bore witness to the contemporary importance of TV news in society. Even though the event was being reported through every news medium, the final results of the election and Obama's victory were not considered official by audiences

4. Newman (2009) cites A.D. Lotz, *The Television Will Be Revolutionized* (New York: New York University Press, 2007) here as having used the term "technologies of control."

until the TV networks had confirmed it on their broadcasts.[5] This event also demonstrated the continued existence of the communal experience of watching television news, as many gathered in bars or attended viewing parties on election night. The visual, personal, emotional and dramatic elements that television made possible in conveying the news appeal to innate human characteristics, and it is unlikely that these characteristics will disappear. Will their form evolve? Undoubtedly, yes (the proliferation of niche newscasts on the internet is underway, as is the availability of televised network newscasts on the web). Will they disappear? This reasoning points to the contrary. Will professional journalism become obsolete? Probably not, but definitions of "professional" and who will be considered a professional journalist will change.

5. On election night 2008, the big three broadcast networks attracted an average of 32.9 million viewers between 8 p.m. and 11 p.m. The big three cable news channels attracted 27.2 million viewers on average during that period, up 58% from 2004 (Pew Project for Excellence in Journalism, 2009).

Appendix 1
Textual Sampling Methodology

All articles that were returned from the searches described below were considered for relevance by evaluating both headlines and the full text of articles. All relevant articles were saved to an electronic database, except for those that were exact duplicates of articles that appeared in more than one place. For example, AP articles were often run in several major and minor newspapers. In these cases, only one copy of the article was saved in the database, but a notation was made of its occurrence in other venues.

Boolean Search Terms

In varying combinations: "television," "news," "anchor(s)," "newscaster(s)," "reporter(s)," "journalist," "broadcaster" and individual anchors' names.

LexisNexis—full-text searches

Search of All Major U.S. Newspapers Available through LexisNexis

The Major Papers search feature through LexisNexis includes, but is not limited to, the following:
Washington Post since 1977
USA Today since 1989
New York Times—abstracts since 1969; articles since 1980
LA Times—past six months
Boston Globe since 1988
Atlanta Journal-Constitution since 1991

Searches of Major Papers were performed for the following time intervals:
1950–1960
1960–1970
1970–1980
1981–1985
Yearly after 1985 through 2006 as searching for more than a year at a time returned too many items.

Search of Time Inc. Publications through LexisNexis

All publications from 2003 through 2006. Searches only returned items from 2003 onward, even though engine claims to go back to 1996.

Search of All Magazines and Journals through LexisNexis—Search of Headlines, Lead Paragraphs

Year by year search; otherwise returned too many items. Includes, but is not limited to, the following:
Editor & Publisher 1993–2006
Columbia Journalism Review 1991–2006
American Journalism Review 1995–2006

News Transcripts

Searched All Transcripts (includes National Public Radio transcripts).

Proquest

Editor & Publisher since 1975
Columbia Journalism Review since 1975
The Quill since 1975

Proquest New York Times Historical Newspapers Database

Searches were performed for the following time intervals:
1945–1950
1950–1955
1955–1960
1960–1965
1965–1970
1970–1975
1976–1980
1981–1985
1986–1990
1991–1995
1996–2000
2001–2005

Appendix 1

Network Websites

Using the available website search features, the following sites were searched with the same search terms as listed above:

ABC
NBC
CBS
CNN
Fox News
MSNBC
CNBC
PBS
NPR
BBC

Organizational Websites

RTNDA	FAIR
SPJ	AIM
AEJMC	PEJ
NAB	
BEA	

Additional Websites Consulted for Particular Related Items

E! Online
New York Magazine
Salon.com
Slate.com
The New Yorker online
The Philadelphia Inquirer
People.com

Broadcasts

The determination of which television broadcasts to look at was driven by the discussion of key broadcasting moments in the texts under review. Broadcasts were obtained from several news archives, including NBC, CBS, and Vanderbilt Television News Archives.

Appendix 2
Interviews Conducted

After interviewees granted me permission to record our conversations, I did so with a digital recording device. Recordings of all interviews were personally transcribed by the author.

Personal Interviews Conducted

(2006, 28 February) Phone interview with B.D., male newspaper reporter.

(2006, 23 January) Phone interview with Wolf Blitzer, CNN.

(2006, 19 January) Phone interview with G.B., female veteran television news booker.

(2006, 29 July) Phone interview with G.C., female audience research analyst for broadcast TV network.

(2006, 4 March) Phone interview with Brad Linder, former WHYY public radio reporter in Philadelphia.

(2006, 23 February) In-person interview with Andrea Mitchell, NBC News. Interview material updated by Andrea Mitchell through personal correspondence on August 6, 2009.

(2006, 17 January) Phone interview with P.K., female former veteran television news producer, CNN.

(2006, 16 March) Phone interview with James Rosen, Fox News correspondent.

(2006, 16 February) In-person interview with Chris Satullo, Executive Director for News and Civic Dialogue, WHYY, public broadcasting in Philadelphia, and former *Philadelphia Inquirer* editorial board editor.

(2006, 8 March) Phone interview with Alan Wurtzel, President of Research, NBC. Additional email correspondence from March 3, 2009.

Bibliography

"ABC Names 'World News Tonight' Anchors." (2005, 6 December). The Associated Press.
"About the Show: Ann Curry." (2006, 29 June). *Today* show, MSNBC.com. http://www.msnbc.msn.com/id/4515786/.
Ackerman, S. (2001, August). "The Most Biased Name in News: Fox News Channel's Extraordinary Right-wing Tilt." FAIR: www.fair.org/extra/0108/fox-main.html
Ackerman, S. & Hart, P. (2001). "Bill O'Reilly's Sheer O'Reillyness: Don't Call Him Conservative—but He Is." *Extra!* July/August, 2001. Fairness and Accuracy in Journalism.
Adalian, J. (1998, 13 July). "Nets' Gold Raises Anchors; Top Newsies Nab Megabucks from Name Recognition." *Variety*, vol. 371, no. 9, pp. 25–27.
Adams, V. (1964, 15 September). "Cronkite to Take Election TV Role." *New York Times*, p. 75.
Alan, J. & Lane, J.M. (2003). *Anchoring America: The Changing Face of Network News*. Chicago and Los Angeles: Bonus Books.
Alfano, P. (1983, 15 November). "Female Reporter Breaks a Pattern." *New York Times*, p. B12.
Allen, C. (1995). Priorities of General Managers and News Directors in Anchor Hiring. *The Journal of Media Economics*, 8(3), pp. 111–124.
———. (2003). "Gender Breakthrough Fit for a Focus Group: The First Women Newscasters and Why They Arrived in Local TV News." *Journalism History*, 28:4 (Winter).
Allen, J. (2006, September). "Wit, Wisdom & Warmth—Meredith Vieira: Uncensored." *Good Housekeeping*, Vol. 243, No. 3, p. 105.
Alter, J. (2003, 6 April). "Consummate Pro with a Human Touch: When Bloom Said 'Buddy' He Meant It." MSNBC.com. http://www.msnbc.msn.com/id/3070573/
"Anchorman." (1974, 24 March). *New York Times*, p. 220.
"Anchors & Reporters: Paula Zahn." (n.d.). Accessed on October 16, 2006. CNN.com: http://www.cnn.com/CNN/anchors_reporters/zahn.paula.html
Astor, D. (2003, 16 June). "Cronkite: New Op-Ed Anchor." *Editor & Publisher,* Vol. 136, Issue 24, p. 36.
Auletta, K. (2003). *Backstory: Inside the Business of News*. New York: The Penguin Press.
———. (2005, 1 August). "The Dawn Patrol: The Curious Rise of Morning Television, and the Future of Network News." *The New Yorker*: www.newyorker.com.
Auster, A. (n.d.). "Cronkite, Walter." Museum of Broadcast Communications. http://www.museum.tv/archives/etv/C/htmlC/cronkitewal/cronkitewal.htm
"Backstage Confessions from 'GMA's' Wardrobe Supervisor." (2006, 18 January). ABC News.com: http://abcnews.go.com/GMA/story?id=1513559

Bagdikian, B. (2000). *The Media Monopoly*. Sixth edition. Boston: Beacon Press.

Baker, C. E. (1994). *Advertising and a Democratic Press*. Princeton, NJ: Princeton University Press.

Barbaro, M. (2006, 23 October). "Media Talk; Interview and Then Dinner Crowd PBS' Comfort Zone." *New York Times*, p. C4.

Bardoel, J. (1996). "Beyond Journalism: A Profession between Information Society and Civil Society." *European Journal of Communication*, 11(3), pp. 283-302. In H. Tumber (Ed.) *News: A Reader*. Oxford, 1999, pp. 379–391.

Barker, O. & Freydkin, D. (2004, 26 April). "On QM2, All the Deck's a Stage." *USA Today*, p.3D.

Barnhurst, K.G. & J. Nerone (2001). *The Form of News: A History*. New York: Guilford Press.

Barnouw, E. (1966). *A Tower in Babel: A History of Broadcasting in the United States, Volume 1—to 1933*. New York: Oxford University Press.

———. (1968). *The Golden Web: A History of Broadcasting in the United States, Volume 2 –1933–1953*. New York: Oxford University Press.

———. (1970). *The Image Empire: A History of Broadcasting in the United States, Volume 3– from 1953*. New York: Oxford University Press.

———. (1975). *Tube of Plenty: The Evolution of American Television*. New York: Oxford University Press.

Barrett, M. (1975). "Moments of Truth?" The fifth Alfred I. DuPont-Columbia University *Survey of Broadcast Journalism*. New York: Thomas Y. Crowell.

Barsamian, D. (1999, 10 November). Interview with Robert McChesney: "Media Matters: Monopolies, Pacifica, NPR & PBS." Boulder, CO: *Alternative Radio*. http://www.alternativeradio.org/programs/MCCR004.shtml

Bauder, D. (2007, 7 February). "'Today', Cable Successes Push Jeff Zucker to Top of NBC Universal." The Associated Press.

Baym, G. (2005, 28 October). "Beyond Infotainment: Political Media in the Age of Discursive Integration." Invitational colloquium presented at The Annenberg School for Communication, University of Pennsylvania.

———. (2005a) "The Daily Show: Discursive Integration and the Reinvention of Political Journalism." *Political Communication*, 22, pp. 259–276.

Becker, L.B., Fruit, J., & Caudill, S. (1987). *The Training and Hiring of Journalists*. Norwood, NJ: Ablex Publishing Corporation.

Bennett, W.L., Gressett, L.A., & Haltom, W. (1985). "Repairing the News: A Case Study of the News Paradigm." *Journal of Communication,* 35, pp. 50–68.

Bennhold, K. (2006, 14 August). "For French Blacks, a Face on TV News Is Only a Start." *New York Times*. http://www.nytimes.com/2006/08/14/arts/television/14anch.html

Berkowitz, D. (2000, August). "Doing Double Duty: Paradigm Repair and the Princess Diana What-a-Story." *Journalism*, vol. 1, no. 2, pp. 125–143.

Berkowitz, D. & TerKuerst, J.V. (1999, September). "Community as Interpretive Community: Rethinking the Journalist-Source Relationship." *Journal of Communication*, Vol. 49, Issue 3, pp.125–136.

Bishop, R. (1999). "From Behind the Walls: Boundary Work by News Organizations in Their Coverage of Princess Diana's Death." *Journal of Communication Inquiry*, 23, pp. 91–113.

———. (2001). "New Media, Heal Thyselves: Sourcing Patterns in News Stories about Media Performance." *Journal of Communication Inquiry*, 25, pp. 22–37.

Blair, G. (1988). *Almost Golden: Jessica Savitch and the Selling of Television News*. New York: Simon & Schuster.

Blau, P.M. & Scott, W.R. (1962). *Formal Organizations, a Comparative Approach*. San Francisco: Chandler.

Bone, J. (2001, 28 July). "Andrea Thompson." *The Times* (London).

Borden, S.L. & Tew, C. (2007). "The Role of Journalist and the Performance of Journalism: Ethical Lessons from "Fake" News." *Journal of Mass Media Ethics* 22, pp. 300–314.

Born, G. (2004). *Uncertain Vision: Birt, Dyke and the Reinvention of the BBC*. London: Secker and Warburg.

Bradley, P. (2006, 26 September). Book signing and discussion of *Women and the Press* (Northwestern University Press). Barnes & Noble, Rittenhouse Square, Philadelphia, PA.

Bradley, R. (2005, 20 September) "Must-Cry TV." http://www.tompaine.com/articles/2005/09/20/mustcry_tv.php

Braudy, Leo. (1986). *The Frenzy of Renown: Fame and Its History*. New York: Oxford University Press.

Breed, W. (1955). "Social Control in the Newsroom: A Functional Analysis." *Social Forces*, 33, pp. 326–335.

Brewin, M. (1999, July). "The Interpretive Community and Reform: Public Journalism Plays Out in North Carolina." *Journal of Communication Inquiry*, vol. 23, no. 3, pp. 222–238.

"Brokaw Says Farewell to 'Nightly News.'" (2004, 2 December). The Associated Press.

Buller, D.B. & Burgoon, J.K. (1986, Fall). "The Effects of Vocalics and Nonverbal Sensitivity on Compliance: A Replication and Extension." *Human Communication Research*, Vol. 13, No. 1, pp.126–144.

Burgoon, J.K., Birk, T. & Pfau, M. (1990, Fall). "Nonverbal Behaviors, Persuasion, and Credibility." *Human Communication Research*, Vol. 17 No.1, pp.140–169.

Burns, K.L. & Beier, E.G. (1973). "Significance of Vocal and Visual Channels in the Decoding of Emotional Meaning." *The Journal of Communication*, 23, pp.118–130.

Burriss, L.L. (1987). "How Anchors, Reporters and Newsmakers Affect Recall and Evaluation of Stories." *Journalism Quarterly*, 64 (2/3, Summer/Autumn), pp. 514–519, 532.

"Bush Daughter Jenna Hager Joins TODAY Staff." (2009, 31 August). Associated Press.

Calabrese, A. (2005). "The Trade in Television News." In J. Wasko (Ed.), *A Companion to Television*. Malden, MA; Oxford, UK: Blackwell Publishing, pp. 270–288.

Calhoun, C. (1992). "Introduction: Habermas and the Public Sphere." In C. Calhoun (Ed.), *Habermas and the Public Sphere*. Cambridge: MIT Press, pp.1-48.

Cali, D. (2002) "Journalism after September 11: Unity as Moral Imperative." *Journal of Mass Media Ethics,* 17(4), pp. 290–303.

Campbell, R. (1991). "News as Narrative, Reporter as Character." *60 Minutes and the News: A Mythology for Middle America* (Urbana: University of Illinois Press, 1991), pp. 25–42.

Cappella, J.N. & Jamieson, K.H. (1997). *Spiral of Cynicism: The Press and the Public Good.* New York: Oxford University Press.

Carey, J.W. (2000). "Journalism and Technology." *American Journalism*, 17 (4, Fall), pp. 129–135.

Carlson, M. (2006). War Journalism and the "KIA Journalist": The Cases of David Bloom and Michael Kelly. *Critical Studies in Media Communication*, 23(2), pp. 91–111.

———. (2007). "Making Memories Matter: Journalistic Authority and the Memorializing Discourse around Mary McGrory and David Brinkley." *Journalism: Theory, Practice, & Criticism,* 8(2), pp. 165–83.

Carr, D. (2006, 2 October). "A Reporter Who Scoops His Own Paper." *New York Times.* http://www.nytimes.com/2006/10/02/business/media/02carr.html

Carter, B. (2001, 20 December). "Katie Couric Signs NBC Contract Said to Be Largest in TV News." *New York Times.* http://www.nytimes.com/2001/12/20/business/katie-couric-signs-nbc-contract-said-to-be-largest-in-tv-news.html

———. (2006, 5 April). "Couric Announces Departure from 'Today' Show." *New York Times.* http://www.nytimes.com/2006/04/05/business/media/06katiecnd.html

———. (2006a, 26 June). "The 40-Year-Old Virgin Executive." *New York Times.* http://www.nytimes.com/2006/06/26/business/media/26msnbc.html

———. (2007, 6 February). "A New Boss at NBC, and Even Newer Issues." *New York Times.* http://www.nytimes.com/2007/02/06/business/media/06nbc.html

Carter, B. & Steinberg, J. (2005, January 19). "CBS Plans to Change Evening News Format." *New York Times.* http://www.nytimes.com/2005/01/19/arts/television/19cbs.html

———. (2006, 29 March). "News Media: Anchor-Advocate on Immigration Wins Viewers." *New York Times.* http://www.nytimes.com/2006/03/29/politics/29dobbs.html

"CBS Says Photo Tech Altered Couric Image." (2006, 31 August). *Chicago Sun-Times.* http://www.suntimes.com/output/television/cst-ftr-couric31.html.

Cbscorporation.com (2006, 5 April) "Katie Couric Is Joining CBS News: Couric Will Become Anchor and Managing Editor of the CBS Evening News with Katie Couric." CBS Press Release.

Cecil, M. (2002, January). "Bad Apples: Paradigm Overhaul and the CNN/Time 'Tailwind' Story." *Journal of Communication Inquiry*, vol. 26, no. 1, pp. 46–58.

Chambers, D., Steiner, L., & Fleming, C. (2004). *Women and Journalism.* New York and London: Routledge.

Chase, R. (1983, 25 July). "World News Tonight." ABC News Transcripts.

Chen, J. (2000). "Interview with CNN's Joie Chen—December 2000." JournalismJobs.com.

Clark, L. (2006). (co-producer). "Witness to History: Walter Cronkite." "American Masters: Walter Cronkite Feature Essay." PBS.org: http://www.pbs.org/wnet/americanmasters/database/cronkite_w.html. Accessed on September 21, 2006.

Clark-Flory, T. (2006, 29 March). "Broadsheet: Katie Couric Grabs Her Gravitas." Salon.com.

Cloud, S. & Olson, L. (1996). "Modern Celebrity Journalism Is Born." *American Enterprise*, Mar/Apr, Vol. 7, Issue 2, pp. 32–34.

"CNN Anchor Bernard Shaw Leaving the Network." CNN, 11 November, 2000. http://archives.cnn.com/2000/SHOWBIZ/TV/11/10/shaw.retire/index.html

"CNN Correspondent John Holliman Dies in Car Crash: 'One of the Most Loved Members of the CNN Family.'" (1998, 12 September). CNN.com: http://www.cnn.com/US/9809/12/holliman.obit.02/index.html

Cohen, N. (2006, 4 December). "With Brash Hosts, Headline News Finds More Viewers in Prime Time." *New York Times*. http://www.nytimes.com/2006/12/04/business/media/04headline.html

Cojocaru, Steven. (2004). "Style Watch: Steven Cojocaru Says…." People.com. http://people.aol.com/people/fashion/stylewatchsays/0,10684,185175,00.html

"Colleagues: Cronkite 'Consummate Newsman.'" United Press International, July 17, 2009. http://www.upi.com/Top_News/2009/07/17/Colleagues-Cronkite-consummate-newsman/UPI-57951247886176/

Conan, N. (host) (2003, 12 June). "Sam Donaldson Remembers David Brinkley, Who Passed Away at Age 82." National Public Radio Transcript, "Talk of the Nation."

Conboy, M. (2002). *The Press and Popular Culture*. Thousand Oaks, CA: Sage.

Conconi, C. (1996, August). "Camera Ready. (How Television Anchors and Reporters Keep in Shape)." *Washingtonian*, vol. 31, no. 11, pp. 86–90.

Cooke, R. (2000, 28 February). "'This Is My First Pregnancy,' So No War Zones for Now: At 42, CNN's Christiane Amanpour's Life Is about to Change. She's Having a Baby and Her Husband Is Finally Moving In, She Tells Rachel Cooke." *The Ottawa Citizen*, p. A12.

Cooper, C. (n.d.). "Bree Walker Interviewed by Chet Cooper." *Ability Magazine*. http://abilitymagazine.com/walker_interview.html

Cordtz, D. (1987, 3 April). "Why TV News Is So Expensive." *New York Times*, p. A31.

Corry, J. (1983, 26 September). "TV: '60 Minutes' and News Anchors." *New York Times*, p. C20.

———. (1984, 2 February). "PBS Reports on a Network Anchor." *New York Times*, p. C18.

Coulter, A. (2002). *Slander: Liberal Lies About the American Right*. New York: Crown Publishers.

"Couric Delays Flight." (2006, 31 July). SFGate.com: http://www.sfgate.com/cgi-bin/blogs/sfgate/detail?blogid=7&entry_id=7586.

"Craft Retrial Starts Today." (1984, 4 January). *New York Times*, p. C17.

Crawford, C.B. & Strohkirch, C.S. (2000). Organizational Innovation: Understanding of Agents of Technological Influence. *The Electronic Journal of Communication*, Vol. 10, Numbers 1 and 2. http://www.cios.org/EJCPUBLIC/010/1/01019.html

Cronkite, W. (1990). "Reporting Presidential Campaigns: A Journalist's View." In D. Graber, D. McQuail & P. Norris (Eds.), *The Politics of News, The News of Politics*, 1998, Washington, D.C.: Congressional Quarterly Press.

Cross, A. (1999, May). "Losing Moral Ground." *The Quill*, V. 87 i3. p. 32(1).

"Dan Rather Signs Off with 'Courage': Anchor Leaves Post as Colleagues Fire Salvos." (2005, 10 March). The Associated Press.

"Dan Rather Signs Off 'CBS Evening News'." (2005, 10 March). The Associated Press.

Deggans, E. (2007, 4 March). "Anchor ABCs: Katie Couric's Brief, Rocky Tenure Holds Lessons about TV News." *St. Petersburg Times.* http://www.sptimes.com/2007/03/04/Floridian/Anchor_ABCs.shtml

Delli Carpini, M. (2003). *And the Walls Came Tumbling Down: The Eroding Boundaries Between News and Entertainment and What They Mean for Mediated Politics in the 21st Century.* Unpublished manuscript.

Delli Carpini, M.X. & Williams, B. (2004). *And the Walls Came Tumbling Down: Media Regimes and the Blurring of News and Entertainment.* Unpublished manuscript.

Democracy Now (2004, 2 November). "National Election Pool: How the Networks Are Calling the 2004 Election." www.democracynow.org/article.pl?sid=04/11/02/1523240

Diamond, E. (1980, 23 March). "Television's 'Great' Anchors and What Made Them Rate." *New York Times*, p. D35.

———. (1991). *The Media Show: The Changing Face of the News, 1985–1990.* Cambridge, MA: The MIT Press.

"Diane Sawyer Tops Gallup Poll of Popular TV News, Talk Personalities." (2006, 9 August). The Associated Press.

Dobbs, L. (2009, 11 November). "Transcript: Lou Dobbs Says He's Leaving CNN." http://www.cnn.com/2009/US/11/11/lou.dobbs.statement/index.html.

Dowell, B. & Holmwood, L. (2007, 5 October). ''Kaplinsky Now Highest Paid Anchor in Britain.'' *The Guardian.* http://www.guardian.co.uk/media/2007/oct/05/channelfive.television.

Downie, L. & Kaiser, R. (2002). *The News about the News: American Journalism in Peril.* New York: Knopf.

Downs, H. (1968, 21 July). "'…It Ceases to Be Journalism.'" *New York Times*, p. D23.

Dvorkin, J.A. (ombudsman) (n.d.). "Bernard Goldberg's 'Bias': Any Lessons for NPR?" National Public Radio http://www.npr.org/yourturn/ombudsman/020109.html

Edwards, B. (2004). *Edward R. Murrow and the Birth of Broadcast Journali*sm. Hoboken, NJ: John Wiley & Sons, Inc.

Eichel, L. (2006, 5 January). "How the Media Got It Wrong." *Philadelphia Inquirer.* http://www.philly.com/mld/philly/news/nation/13553174.htm.

Ekman, P. (1971). "Universals and Cultural Differences in Facial Expressions of Emotion." Nebraska Symposium on Motivation. pp. 207–283.

Ekman, P. & Friesen, W.V. (1969). "Nonverbal Leakage and Clues to Deception." *Psychiatry*, 32. pp. 88–105.

Elliott, S. (1993, 2 December). "Advertising: A Newscaster-Turned Spokeswoman Raises Issues of Credibility." *New York Times*, p. D21.

———. (1994, 6 April). "Advertising: CBS News Bends a Rule and Lets a Television Anchor Continue to Make Commercials for Radio." *New York Times*, p. D20.

———. (2006, 5 October). "CNN Turns to Event Marketing to Strut Its Brand." *New York Times.* http://www.nytimes.com/2006/10/05/business/media/05adco.html

Emerson, R.M., Fretz, R.I., & Shaw, L.L. (1995). *Writing Ethnographic Fieldnotes.* Chicago: The University of Chicago Press.

"Encore Presentation: Interview with Bree Walker, Jim Lampley." (2004, 19 December) CNN *Larry King Live*, CNN Transcripts. http://transcripts.cnn.com/TRANSCRIPTS/0412/19/lkl.01.html

Entman, R. (1989). "The Dilemma of Journalism: Democracy without Citizens" and "Improving Journalism by Enhancing Citizenship." In *Democracy Without Citizens*. New York: Oxford University Press, pp. 17–29 & 125–140.

———. (2004). "Debating War against Iraq." In R. Entman (Ed.), *Projections of Power: Framing News, Public Opinion and U.S. Foreign Policy*. Chicago: University of Chicago Press, p. 94.

Epstein, E.J. (1973) *News from Nowhere: Television and the News*. New York: Random House.

Epstein, M. (n.d.). "Friendly, Fred W." The Museum of Broadcast Communications. http://www.museum.tv/archives/etv/F/htmlF/friendlyfre/friendlyfre.htm

Ericson, R.V., Maranek, P.M., & Chan, J.B.L. (1987). "Visualizing Deviance: A Study of News Organization." In H. Tumber (Ed.) (1999) *News: A Reader*. Oxford and New York: Oxford University Press, pp. 97–101.

Eyre, H. (2006, 19 February). "Sophie Raworth: The Autocutie with Brains." *The Independent*. http://www.independent.co.uk/news/people/profiles/sophie-raworth-the-autocutie-with-brains-467007.html

Fallows, J. (1997). *Breaking the News: How the Media Undermine American Democracy*. New York: Pantheon Books.

Farhi, P. (2008, 12 December). "WUSA Moves to One-Person News Crews." *Washington Post*, p. C1.

Fengler, Susanne. (2003) "Holding the News Media Accountable: A Study of Media Reporters and Media Critics in the United States." *Journalism & Mass Communication Quarterly*, 80, pp. 818–832.

Fensch, T. (Ed.) (1993). *Television News Anchors: An Anthology of Profiles of the Major Figures and Issues in United States Network Reporting*. Jefferson, NC: McFarland.

Ferri, A. J. (1989). "Perceptions of Broadcast News Positions by TV Anchors." *Mass Communication Review*, 16 (3), pp. 39–42.

Fish, S. (1980). *Is There a Text in this Class? The Authority of Interpretive Communities*. Cambridge, MA: Harvard University Press.

"Fishbowl NY: Update: Couric's $110K Fee Donated to Charity." (2006, 15 May). Mediabistro.com. http://www.mediabistro.com/fishbowlny/tv/update_courics_110k_fee_donated_to_charity_36887.asp

Fishkin, J. (1992). "Talk of the Tube: How to Get Teledemocracy Right." *The American Prospect*, 3(11), www.prospect.org.

Fishman, M. (1980). "The Practice and Politics of Newswork." *Manufacturing the News*. Austin: University of Texas Press.

———. (1980a). "Manufacturing the News." In H. Tumber (Ed.), *News: A Reader*. New York: Oxford University Press, 1999, pp. 102–111.

Fiske, J. (1987). *Television Culture*. New York: Methuen.

Fiske, J. & Hartley, J. (1978). *Reading Television*. London: Methuen.

Foege, A. (2005, 13 June). "Surrounding the Story." *Mediaweek.* http://www.mediaweek.com/mw/esearch/article_display.jsp?vnu_content_id=1000955364

"Former Friendly Rivals Remember Jennings." (2005, 1 September). ABC News.

Fowler, R. (1991). *Language in the News.* London & New York: Routledge.

Fowler, R., Hodge, B., Kress, G., & Trew, T. (1979). *Language and Control.* London: Routledge & Kegan Paul.

Fox News Watch. (2004, 3 February). www.foxnews.com/story/

Frank, R. (1991). *Out of Thin Air: The Brief Wonderful Life of Network News.* New York: Simon & Schuster.

Freidson, E. (1984). "The Changing Nature of Professional Control." *Annual Review of Sociology*, 10, pp. 1–20.

Fretts, B. (1993, 18 June). "Dan Rather: Used-Car Salesman?" *Entertainment Weekly*, no. 175, p. 33.

Friedman, J. (2009, 26 June). "Katie Couric's Palin Triumph Didn't Last." MarketWatch.com. http://www.marketwatch.com/story/since-her-palin-triumph-couric-has-lost-the-buzz

"*Frontline* Journalist Has Baby." (2000, 29 March). *The Times* (London).

Furedi, F. (2004). *Therapy Culture: Cultivating Vulnerability in an Uncertain Age.* New York: Routledge.

Gaber, I. (2001, 26 October). "Hacks vs 'Experts' in War of Words." *The Times Higher Education Supplement*, No.1510, p. 35.

Gamson, J. (1994). *Claims to Fame: Celebrity in Contemporary America.* Berkeley: University of California Press.

Gans, H. (1979). *Deciding What's News.* New York: Pantheon.

———. (2003). *Democracy and the News.* New York: Oxford University Press.

Garfinkel, J. (2006, 6 July). "An Exclusive Interview with Dan Abrams." Jack Myers mediaVillage.com. http://www.mediavillage.com/jmentr/2006/07/06/Jacki-07-06-06/.

Gates, G.P. (1978). *Air Time: The Inside Story of CBS News.* New York: Harper & Row.

Gay, V. (2004, 4 February). "Shriver Tells NBC News Hasta la Vista." *Newsday* (New York), p. A12.

Geiber, W. (1964). "News Is What Newspapermen Make It." In H. Tumber (Ed.), *News: A Reader*, 1999. Oxford: Oxford University Press, pp. 218–223.

Gerard, J. (1989, 20 February). "Deciding Who Makes a Million in TV News." *New York Times*, p. D1.

Gerbner, G. (1973). "Cultural Indicators: The Third Voice." In G. Gerbner, L. Gross, & W. Molody (Eds.) *Communications Technology and Social Policy: Understanding the New 'Cultural Revolution.'* New York: Wiley, pp. 555-573.

"Gibson to Step Down as Anchor of 'World News:' 'Good Morning America' Host Sawyer to Replace Him in January." (2009, 2 September). Associated Press.

Giles, R.H. (1999, February). "The Struggle to Regain Credibility." *World and I*, V.14 i2. p. 92(1).

Glaberson, W. (1994, 31 January). "Journalists' Acceptance of Big Fees for Speeches Brings Another Round of Questions about Objectivity." *New York Times*, p. D6.

Glaser, B. & Strauss, A. (1967). *The Discovery of Grounded Theory: Strategies for Qualitative Research.* New York: Aldine De Gruyter.

Glasser, T. & Ettema, J. (1989). "Common Sense and the Education of Young Journalists." *Journalism Educator,* 44 (Summer), pp. 18-25, 75.

"GM Drops Its Lawsuit against NBC News and NBC News Anchors Were Forced to Make a Public Apology." (1993, 10 February). CBS Evening News Transcripts.

"GMA Anchors Recall Peter Jennings." (2005, 1 September). ABC News.

Goffman, E. (1959). *The Presentation of Self in Everyday Life.* New York: Anchor Books (Doubleday).

———. (1981). *Forms of Talk.* Philadelphia: University of Pennsylvania Press.

Goldberg, B. (2002). *Bias: A CBS Insider Exposes How the Media Distort the News.* Washington, DC: Regnery Publishing. .

Golding, P. & Elliott, P. (1979). "Making the News." In H. Tumber (Ed.), *News: A Reader.* Oxford: Oxford University Press, pp. 112–120.

Goldthwaite Young, D. & Tisinger, R. (2006). "Dispelling Late-night Myths: News Consumption among Late-night Comedy Viewers and the Predictors of Exposure to Various Late-night Shows." *The Harvard International Journal of Press/Politics,* Vol. 11, No. 3, pp. 113-134.

Goodman, I.R. (1990). "Television News Viewing by Older Adults." *Journalism and Mass Communication Quarterly,* 67 (1, Spring), pp. 137–141.

Goodman, W. (1982, 23 December). "TV Notebook; Weighing Anchors and Newburgers." *New York Times,* p. C15.

———. (1994, 27 November). "What's Bad for Politics Is Great for Television." *New York Times,* p. H33.

Gordon, D. (2004, 20 September). "Newsmakers: Rush into His Lovin' Arms." From Newsweek Entertainment on MSNBC.com.
http://www.msnbc.msn.com/id/5971843/site/newsweek/

Gordon, M. (2005, 6 June). "Duel at Sunrise." *New York Magazine.*
http://nymag.com/nymetro/news/media/features/11909/

Gough, P. (2006, 5 April). " 'Today' Is Yesterday, CBS Is Tomorrow for Couric." *The Hollywood Reporter:*
http://www.hollywoodreporter.com/thr/article_display.jsp?vnu_content_id=1002277148

Gould, J. (1953, 24 April). "Television in Review: Four Personalities of the Medium Are Discussed—Program Breaks for P.W. News Criticized." *New York Times,* p. 35.

———. (1954, 11 June). "Stop the Presses! 'The Big Story' Turns Out to Have Been Just That." *New York Times,* p. 32.

———. (1955, 13 May). "TV: Corporate Courage: Alcoa, Retiring Sponsor of 'See It Now,' Cited for Aiding Freedom of Opinion." *New York Times,* p. 33.

———. (1955a, 19 May). "TV Is Improving, Critic Declares: But the Medium Will Always Have to Compromise, Jack Gould Tells Teachers." *New York Times,* p. 59.

———. (1964, 8 March). "Friendly Rival." *New York Times,* p. X27.

———. (1968, 11 February). "Should Huntley and Brinkley Don Leotards?" *New York Times,* p. D17.

Grossberg, J. (2002, January 8). "Zahn Spot Too Hot for CNN." E! Online: http://www.eonline.com/News/Items/0,1,9343,00.html

Gunter, B. (2000). *Media Research Methods: Measuring Audiences, Reactions and Impact.* Thousand Oaks, CA: Sage.

Haas, T. (2006, October). "Critical Forum: Mainstream News Media Self-Criticism: A Proposal for Future Research." *Critical Studies in Media Communication*, Vol. 23, No. 4, pp. 350–355.

Habermas, J. (1989). *The Structural Transformation of the Public Sphere: An Inquiry into a Category of Bourgeois Society.* Cambridge, MA: The MIT Press.

Hackett, R.A. (1984). "Decline of a Paradigm? Bias and Objectivity in News Media Studies." *Critical Studies in Mass Communication*, Vol. 1, No. 3, pp. 229–259.

Haiken, E. (1997). *Venus Envy: A History of Cosmetic Surgery.* Baltimore and London: The Johns Hopkins University Press.

Halberstam, D. (1979). *The Powers That Be.* New York: Laurel Books.

Hall, C. (1980, 28 April). "Turner's Talent Hunt; Cable News Raids the Broadcast Ranks." *Washington Post*, p. B1.

Haller, S. (1983, 7 November). "The Two Faces of a Newswoman: Everything People Thought Jessica Savitch Was, She Wasn't." *People Weekly*, pp. 48–52.

Hallin, D.C. (1986). *The 'Uncensored War': The Media and Vietnam.* Berkeley, Los Angeles, and London: University of California Press. In Tumber, H. (Ed.) *News: A Reader.* New York: Oxford University Press, 1999, pp. 329–339.

Hallman, T. (2006, January). "Print Journalists: Be Prepared to Hit Airwaves." *Quill.*

Hammersley, M. & Atkinson, P. (1995). *Ethnography: Principles in Practice*, 2nd Ed. New York: Routledge.

Hanson, C. (1996). "Where Have All the Heroes Gone?" *Columbia Journalism Review*, March/April, Vol. 34, Issue 6, p. 45 (4).

Harris, C. (n.d.). "National Association of Broadcasters." The Museum of Broadcast Communications. http://www.museum.tv/archives/etv/N/htmlN/nationalassob/nationalassob.htm

Hartley, J. (1996). *Popular Reality: Journalism, Modernity, Popular Culture.* London: Arnold.

Hayes, A., Singer, J., & Ceppos, J. (2007). "Shifting Roles, Enduring Values: the Credible Journalist in a Digital Age." *Journal of Mass Media Ethics*, 22, pp. 262–279.

Healy, M. (2003, 14 July). "'Katie Couric Effect' Boosts Colonoscopy Rates." *USAToday.com*: http://www.usatoday.com/news/health/2003-07-14-katie-usat_x.htm

Heise, D.R. & Calhan, C. (1995) "Emotion Norms in Interpersonal Events." *Social Psychology Quarterly*, 58, pp. 223–240.

Henningham, J. (1985). "Journalism as a Profession: A Reexamination." *Australian Journal of Communication*, 8, pp.1–17.

Herman, E. & Chomsky, N. (1988). *Manufacturing Consent.* Pantheon Books.

Hindman, E.B. (2005, June). "Jayson Blair, *The New York Times*, and Paradigm Repair." *Journal of Communication*, Vol. 55, No.2, pp. 225–241.

Holloway, D. (2005, 3 November). "CNN Goes Younger, Hipper with Cooper." *Austin American Statesman.* http://www.Austin360.com.

Horton, D. & Wohl, R.R. (1956). "Mass Communication and Para-social Interaction: Observations on Intimacy at a Distance." *Psychiatry*, 19, pp. 215–229.

IFC (2009). The 2009 IFC Make Media Matter Panel Discussion. The Newseum, Washington, DC. May 28, 2009. Quotes used directly or paraphrased in the book were elicited in person by the author in questions asked directly to panelists Greta Van Susteren (Fox News), George Stephanopoulos (ABC), John King (CNN), Tucker Carlson, Juan Williams (NPR), Marcus Brauchli (Executive Editor, *Washington Post*), and Norm Ornstein (*Washington Post*).

"In Praise of Couples Who Stay the Course." (2004, 16 February). *Washington Post*, p. C3.

Jackaway, G.L. (1995). *Media at War: Radio's Challenge to the Newspapers, 1924–1939*. Westport, CT: Praeger.

Jaffe, H. (2006, 21 April). "If Condi Rice Is Such Good TV, Why Do None of the Networks Want to Cover the State Department?" *The Washingtonian*. http://washingtonian.com/buzz/2006/0421.html.

Jamieson, K. H. (1992). *Dirty Politics: Deception, Distraction, and Democracy*. New York, London: Oxford University Press.

"Jane Pauley Sues New York Times over Ad Supplement." (2006, 26 October). The Associated Press.

Jefferson, M. (1995, 25 June). "SUNDAY VIEW; Michael, Lisa, Diane and a Greek Chorus." *New York Times*, Section 2, p. 5.

Jensen, B. (2006, 22 August). "ABC Names New Morning News Anchor." *New York Times*: http://query.nytimes.com/gst/fullpage.html?res=9901EEDD123EF931A1575BC0A9609 C8B63

"John Chancellor—In Memoriam." (1996, 15 July) PBS Transcripts. http://www.pbs.org/newshour/bb/remember/john_chancellor.html

Johnson, P. (1997, 23 January). "Women Stalwarts to Spend Rare Air Time with Walters." *USA Today*, p. 3D.

———. (2005, 7 March). "Veteran Anchor to Step Down Wednesday." *USA Today*.

———. (2005a, 9 November). "Couric Quiet as NBC, CBS Make Changes at Top." *USA Today*: http://www.usatoday.com/life/columnist/mediamix/2005-11-29-mediamix_x.htm

Johnson, T. (2006, 3 May). "Can Your Personality Get You Hired or Fired?" ABC News: http://abcnews.go.com/GMA/Careers/story?id=1915016&page=1

Johnston, R., Hagen, M., & Jamieson, K.H. (2004). *The 2000 Presidential Election and the Foundations of Party Politics*. New York: Cambridge University Press.

Jones, A. (1989, 17 August). "Black Journalists Seek New Gains in Newsroom." *New York Times*, p. B10.

Justin, N. (2004, 2 December). "Tom Brokaw: Goodnight America." *Minneapolis Star Tribune*, p. 1A.

Kafka, P. (1999, 22 March.). "Anchors Away." *Forbes*, v. 163, i.6, p. 248.

"Katie Couric Demanded Delay in Takeoff." (2006, 30 July). Airliners.net: http://www.airliners.net/discussions/general_aviation/read.main/2909476

"Katie Couric Moves to CBS." (2006, 5 April). Online NewsHour: a NewsHour with Jim Lehrer Transcript. http://www.pbs.org/newshour/bb/media/jan-june06/couric_4-5.html

Katz, E. (1962). "The Social Itinerary of Technical Change: Two Studies on the Diffusion of Innovation." *Studies of Innovation and of Communication to the Public*, Stanford University, Institute for Communication Research: Studies in the Utilization of Behavioral Science, Volume II.

———. (1989). "Journalists as Scientists: Notes Towards an Occupational Classification." *American Behavioral Scientist*, Vol. 33, No. 2, November/December, pp. 238–246.

Katz, P. (2004, 10 December). "Dan the Man: EW lists Dan Rather's memorable moments – Here's what we'll remember most about the retiring anchor's 24-year career at CBS." *Entertainment Weekly*, Issue No. 796. http://www.ew.com/ew/article/0,,845688,00.html#

"Kelly Ripa Tells It Like It Is." (2005, 5 January). *USAToday.com*. http://www.usatoday.com/life/gallery/2005/ripa/flash.htm

Kempner, M. (March 15, 2002). "Ex-actress Quits CNN after Stint as Anchor." *The Atlanta Journal-Constitution*, p.1F.

Kennedy, D. (1995, June 16). "Women on the Verge." *Entertainment Weekly*, n279, p. 16 (2).

Kerr, P. (1984, 14 January) "Jury Awards Christine Craft $325,000." *New York Times*, p. 43.

Kiernan, P. (2001, 14 June) "TV Journalism Analysis." CNNfn Transcript 061403cb.l27.

Kilborn, R. (1994). "How Real Can You Get?': Recent Developments in 'Reality' Television." *European Journal of Communication*, 9 (4, December), pp. 421–439.

Kimball, P. (1994). *Downsizing the News: Network Cutbacks in the Nation's Capital*. Baltimore and London: The Johns Hopkins University Press.

Kimbrough-Robinson, C. (2006, January). "Curiosity, Courage Keys to Diverse Journalism." *Quill*, 94.1, p. 38.

Kitch, C. (2003). "Generational Identity and Memory in American Newsmagazines." *Journalism*, 4 (2, May), pp. 185–202.

Klaidman, S. & Beauchamp, T. (1987). *The Virtuous Journalist*. New York: Oxford University Press.

Koch, T. (1991). *Journalism in the 21st Century: Online Information, Electronic Data Bases and the News*. Twickenham, UK: Adamantine Press.

Kohut, A. (2002, September/October) "WASHINGTON 2002: Attitude Adjustment: The 9/11 Effect Is Starting to Fade." *Columbia Journalism Review*, Issue 5. http://www.cjr.org/issues/2002/5/wash-kohut.asp

Koppel, T. (2000). *Off Camera: Private Thoughts Made Public*. New York: Alfred A. Knopf.

Kramer, S.C. (2002, 7 January). "Van Susteren Latest Prize in Cable News Battle: Fox's Ailes Answers Call and Hires CNN Veteran Programming." *Cable World*, p. 1 (Programming).

Krauss, R.M., Apple, W., Morency, N., Wenzel, C., & Winton, W. (1981). "Verbal, Vocal, and Visible Factors in Judgements of Another's Affect." *Journal of Personality and Social Psychology*, Vol. 40, No. 2., pp. 312–320.

Kurtz, H. (1998, 8 January) "A Tough Sell for David Brinkley; Colleagues Are Uneasy with Ex-Newsman's Enterprising Role." *Washington Post*, p. B1.

———. (2005, 2 May). "Media Crime & Punishment." *Washingtonpost.com*: http://www.washingtonpost.com/wp-dyn/content/blog/2005/03/03/BL2005040701351.html

———. (2006, 29 January). "Two for the Road: ABC's Elizabeth Vargas and Bob Woodruff, On the Job but Often Away from Their Desk." *Washington Post*, p. D1.

———. (2006a, 6 February) "Why Anchors Matter." *Washingtonpost.com*: http://www.washingtonpost.com/wp-dyn/content/blog/2006/02/06/BL2006020600462.html

———. (2006b, 6 March) "Steady as He Goes: In the Anchor Chair, Bob Schieffer Buoys CBS." *Washington Post*, p. C1.

———. (2006c, 3 April). "A Gadfly with Buzz: MSNBC's Olbermann, Exercising the Right." *Washingtonpost.com*: http://www.washingtonpost.com/wp-dyn/content/article/2006/04/02/AR2006040201273.html

———. (2006d, 19 April). "Moving to the Right: Brit Hume's Path Took Him from Liberal Outsider to the Low-Key Voice of Conservatism on Fox News." *Washington Post*: http://www.washingtonpost.com/wp-dyn/content/article/2006/04/18/AR2006041801943.html

———. (2006e, 1 May). "Tony Snow's Washington Merry-Go-Round." *Washington Post*: http://www.washingtonpost.com/wp-dyn/content/article/2006/04/30/AR2006043001185.html

———. (2006f, 30 May). "Katie Couric, Thinking about Tomorrow." *Washington Post.com*: http://www.washingtonpost.com/wp-dyn/content/article/2006/05/29/AR2006052901102.html

———. (2009, 11 February). "As Mainstream Exits D.C., Niche Media Tide Rises." *Washington Post*, p. C1.

Kushman, R. (2005, 9 March). "No Easy Take on Rather." *Sacramento Bee*, p. E1.

Lang, T. (2005, 31 May). "Sawyer, Couric, and Fried Twinkies in the Morning." *CJR Daily*. http://www.cjrdaily.org/magazine_report/sawyer_couric_and_fried_twinki.php

Lang, K. & Lang, G.E. (1956). "The Television Personality in Politics: Some Considerations." *Public Opinion Quarterly*, Vol. 20, p. 103.

Langer, J. (1998). *Tabloid Television: Popular Journalism and the "Other News."* London: Routledge.

LaRocque, P. (2006, January). "Scripted TV Dialogue, Journalese Turn off Viewers." *Quill*.

Larson, M.S. (1977). *The Rise of Professionalism: A Sociological Analysis*. Berkeley: University of California Press.

Learmonth, M. (2006, 26 March). "The Non-power of the Press: Bush Aides Check Star Status of White House Journos." *Variety.com*.

Leiby, R. (2004, 3 September). "Reliable Source: The Bush Twins, Ready to Rock." *Washington Post*, p. C03.

Levin, G. (1997, August 11). Television News Folk Fast Becoming 'Mag Hags.' *Variety*, v.369, no. 1, p. 1(2).

Levi-Strauss, C. (1966). *The Savage Mind*. Chicago: University of Chicago Press.

Levy, M.R. (1979). "Watching TV News as Para-social Interaction." *Journal of Broadcasting*, 23, pp. 69–80.

Lindlof, T.R. (1988). "Media Audiences as Interpretive Communities." *Communication Yearbook*, 11, pp. 81–107.

Lippmann, W. (1922). "The World Outside and the Pictures in Our Heads." *Public Opinion*, pp. 3–32. New York: Harcourt, Brace.

Lisheron, M. (2007, February/March). "Is Keith Olbermann the Future of Journalism?" *American Journalism Review*. http://www.ajr.org/Article.asp?id=4268

Livingston, S. & Bennett, L.W. (2003). "Gatekeeping, Indexing, and Live-Event News: Is Technology Altering the Construction of News?" *Political Communication*, 20, pp. 363–380.

Lorando, M. (1995, 2 April). "NBC News Show Hotter than Ever." *New Orleans Times Picayune*, p. T7.

Lowry, B. (2004, 13 December). "The Fluff Factor." *Broadcasting & Cable*, p. 48.

Mancini, P. (1988). "Simulated Interaction: How the Television Journalist Speaks." *European Journal of Communication*, Vol. 3, pp. 151–166.

Marc, D. (1989). *Comic Visions: Television Comedy and American Culture*. Boston: Unwin Hyman.

Marc, D. & Thompson, R. (1992). *Prime Time Prime Movers*. Boston: Little, Brown Publishers.

Martin, J.L. (2003, July). "What Is Field Theory?" *American Journal of Sociology*, vol. 109, no.1, pp. 1–49.

Matusow, B. (1983). *The Evening Stars: The Making of the Network News Anchor*. Boston: Houghton Mifflin.

McChesney, R.W. (2006, 18 January). "Communication Research and Media Politics." Talk presented at The Annenberg School for Communication, University of Pennsylvania.

McClellan, S. (2004, 23 February). "At Today Show, What Happens Tomorrow?" *Broadcasting & Cable*, p. 1.

Mehrabian, A. & Wiener, M. (1967). "Decoding of Inconsistent Communications." *Journal of Personality and Social Psychology*, Vol. 6, No. 1, pp. 109–114.

Meadows, S. (2006, 25 December) "Lara Logan: How a former swimsuit model became CBS' chief foreign correspondent." *Newsweek*, p. 82.

Melani, D. (2003, 16 September). "'Extreme Makeover' Closer to the Truth." *Rocky Mountain News*, p. 6D.

Meltzer, K. (1999). "Justifications for Uses of Deception in the Media." Honors Thesis. Emory University.

———. (2004). "Student Newsmakers." Unpublished manuscript. The Annenberg School for Communication, University of Pennsylvania.

———. (2006). "From the Other Side: Challenges Former Journalists Face in Studying Journalism in the Academy." Presentation to the Eastern Communication Association annual conference, Philadelphia, PA, April 28.

Merritt, R.L. & Merritt, A.J. (Eds.) (1985). "Innovation in the Public Sector: An Introduction." In *Innovation in the Public Sector*. Beverly Hills: Sage Publications, pp. 9-16.

Merton, R. K. (1957). "The Role-Set: Problems in Sociological Theory." *British Journal of Sociology*, 8, pp. 294–303.

Meyers, O. (2003). *Israeli Journalists as an Interpretive Memory Community: The Case Study of Haolam Hazeh*. Doctoral Dissertation, The Annenberg School for Communication, University of Pennsylvania.

Millage, M. (2002, April). "Native Son." *Communicator.* http://www.rtnda.org/members/communicator/nativeson.asp
———. (2003, April). "Face of the Nation." *Communicator.* http://www.rtnda.org/members/communicator/april03_a.asp
Miller, M. J. (n.d.) "Canadian Television Programming in English." The Museum of Broadcast Communications, http://www.museum.tv/archives/etv/C/htmlC/canadianproge/canadianproge.htm.
Mitchell, A. (2005). *Talking Back...to Presidents, Dictators, and Assorted Scoundrels.* New York: Viking.
———. (2005a, 28 November). Public talk at book signing of *Talking Back*, University of Pennsylvania bookstore, Philadelphia.
Molotch, H. & Lester, M. (1974, February). "News as Purposive Behavior: On the Strategic Use of Routine Events, Accidents and Scandals." *American Sociological Review*, 39, pp. 101–112.
Moraes, L. (2006, 6 April). "Ins and Outs of a Sweetheart's Deal." Washingtonpost.com.
"More 'Power Couples.'" (1998, 4 January). *Chicago Sun-Times*, p. 21.
Morgan, G. (1986). *Images of Organization.* Newbury Park, CA: Sage Publications.
Mutz, D. (2002). "The Consequences of Cross-cutting Networks for Political Participation." *American Journal of Political Science*, 46, pp. 838–855.
"My Big Dumb TV Anchor: TV's Dumbest, Meanest, Laziest and Vainest News personalities." (2005, Summer). *Radar Magazine.*
Naureckas, J. (1989). "Cronkite for Hire." *Extra!* October/November. Fairness and Accuracy in Reporting (FAIR).
Nee, R.C. (2004). *FabJob Guide to Become a Television Reporter.* FabJob.com.
Newkirk, P. (2000). *Within the Veil: Black Journalists, White Media.* New York: New York University Press.
Newman, M.Z. (2009, 26 March). "Cultural Legitimacy and Technologies of Agency." Paper presented at "Unthinking Television: Visual Culture[s] Beyond the Console," The Sixth Annual Visual Cultures Symposium at George Mason University.
Newport, F. & Carroll, J. (2006, 8 August). "Americans Rate Television News and Talk Personalities: ABC's Diane Sawyer Tops the List." The Gallup Poll. http://poll.gallup.com/
"Nothing Will Stop Katie Couric." (2006, 29 July). Mediabistro.com: http://www.mediabistro.com/tvnewser/couric_watch/nothing_will_stop_katie_couric_41037.asp.
Noveck, J. (2006, 4 June). "Vargas' Career Pause Ignites Debate: Demotion or Choice? Either Way, Some Fear Tougher Times for Women." The Associated Press.
Oates, T.P. & Pauly, J. (2007) "Sports Journalism as Moral and Ethical Discourse." *Journal of Mass Media Ethics*, 22, pp. 332–47.
O'Brien, M. (2006). "Lost Cause? Network Executives Say Evening News Shows Remain Viable." *Quill*, January/February, pp. 24–31.
"O'Brien: Two Girls plus Twins Keeps Things Busy." (2004, 15 September). CNN.com: http://www.cnn.com/2004/HEALTH/09/14/soledad.twins/

"Obituary: Peter Jennings." (2005, 8 August). BBC News. http://news.bbc.co.uk/1/hi/entertainment/tv_and_radio/4131006.stm

O'Connell, V. (2006, 5 August). "What They're Wearing: Couric Hits the 'Muted' Button." *Wall Street Journal* online. http://online.wsj.com/public/article/SB115472900218527333-mrWoqLQTcJfY0vlfnY_ETXsJhq4_20070805.html?mod=blogs

O'Connor, J. (1972, 23 October). "The Geraldo Rivera Case and the Rights of TV Newsmen to Speak Their Mind." *New York Times*, p. 62.

———. (1992, 14 May). "Onscreen Journalism: Show Biz or News?" *New York Times*, p. C17.

Ojito, M. (2006, 30 April). "Voice of (Hispanic) America." *New York Times*: http://www.nytimes.com/2006/04/30/arts/television/30ojito.html

Oldenburg, D. (2006, 13 May). "Big Names on Campus: Schools Go All Out in the Quest for Star Commencement Speakers." *Washingtonpost.com*: http://www.washingtonpost.com/wp-dyn/content/article/2006/05/12/AR2006051202054.html

"One Call Too Many?" (2000, 14 November). CBS News.com: http://www.cbsnews.com/stories/2000/11/14/politics/main249357.shtml

O'Reilly, B. (2006, 9 August). "The O'Reilly Factor." Fox News.

"Osbourne Sued over Show." (2002, 27 July). *St. Petersburg Times* (Florida), p. 2B.

Ostrow, J. (2005, 16 June). "Morning in America: Is It Really a Couric and Sawyer Catfight?" *Denver Post*.

Overbea, L. (1981, 27 July). "Network TV's Only Black Anchor Man Says News Distorts US Image." *Christian Science Monitor*, p. 15.

Paige, S. (1998, 11 May). "Anchors or Actors?" *Insight on the News*, vol. 14, no. 17, pp. 8–10.

Palmer, N.D. (2004, November). "How I Got Where I Am: Determination, Persistence, or Just Pure Luck—These Local Stars Tell Us How They Found Success." *Washingtonian Magazine*, pp. 89–111.

Papper, B. & Gerhard, M. (2000, July). "Nine Who Changed the Face of News." *Communicator*. http://www.rtnda.org/diversity/wmnwcfon.html.

Pappu, S. (2004, March/April). "On the Heir." *Arrive: The Magazine for Northeast Business Travelers*, pp. 21–24. www.amtrak.com.

Peterson, R. (2004, 16 January). "Watercooler." *TVguide.com*.

Pew Project for Excellence in Journalism (2009). "The State of the News Media 2009." http://www.stateofthenewsmedia.org/2009.

"Picture-Perfect from the Waist up" (1995, 18 September). *People Weekly*, vol. 44, no. 12, pp.140–144.

"Pioneer Newsman David Brinkley Dies at 82." (2003, 12 June). CNN.com: http://www.cnn.com/2003/SHOWBIZ/TV/06/12/obit.brinkley/index.html

Powers, R. (1978). *The Newscasters*. New York: St. Martin's Press.

Project for Excellence in Journalism, The (2004). "The State of the News Media 2004." www.stateofthemedia.com/2004

Project for Excellence in Journalism, The (2005). "The State of the News Media 2005." www.stateofthemedia.com/2005

"Questions Surround Star Jones Reynolds' 'View' Departure: Who Will Replace Outspoken Host on 'The View?'" (2006, 29 June). ABC News, "Good Morning America." http://abcnews.go.com/GMA/Entertainment/story?id=2132898

Rather, D. (1977). *The Camera Never Blinks*. New York: Ballantine Books.

"Ratherisms." (2004). CBSNews.com: http://www.cbsnews.com/elements/2005/03/03/eveningnews/timeline677966.shtml

Reese, S.D. (1990, December). "The News Paradigm and the Ideology of Objectivity: A Socialist at the *Wall Street Journal*." *Critical Studies in Mass Communication*, 7(4) (special Theories of Journalism issue), pp. 390–409.

Reeves, B. & Nass, C. (1996). *The Media Equation: How People Treat Computers, Television, and New Media Like Real People and Places*. Stanford, CA: CSLI Publications.

Reider, R. "More Honor, Few Honoraria." (1996, March). *American Journalism Review*, Vol. 18, No. 2, p. 6.

"Remembering Walter Cronkite." CBS News, July 19, 2009. http://www.cbsnews.com/stories/2009/07/19/broadcasts/main5173249_page2.shtml

Rendall, S. & Hart, P. (2002, March/April). "Bias Short on Substance: Former CBS Reporter Claims TV Has "Leftward" Slant." *Extra!* Fairness and Accuracy in Reporting (FAIR).

"Report: Blacks Get Less Air Time." (2002, May). *Quill*, Vol. 90, Issue 4, p. 33.

Rice, L. & Weiner, A.H. (2001, 3 August). "Anchor Away? With Her Contract up in a Year, Katie Couric Considers a Morning After." *Entertainment Weekly*, i.607, p. 8+.

Roberts, R. (1997, 7 April). "The Groom's Lips Were Sealed; Greenspan Weds Mitchell with a Kiss to Remember." *Washington Post*, p. D1.

Robins, J. M. (1998, 8 August). "Anchor's price tags: strings attached." *TV Guide*, v. 46, no. 32, pp. 49–51.

Rodden, J. (1989). *The Politics of Literary Reputation: The Making and Claiming of "St. George" Orwell*. New York: Oxford University Press.

Rogers, E.M & Kim, J. (1985). "Diffusion of Innovations in Public Organizations." In R.L. Merritt & A.J. Merritt (Eds.), *Innovation in the Public Sector*. Thousand Oaks, CA: Sage Publications, pp. 85–108.

Rogers, E.M. (1986). *Communication Technology: The New Media in Society*. New York: The Free Press.

Rohrlich, M. (2002, 25 August). "More Couples Opt for Candid Camera." *New York Times*, Section 9, p.15.

Romano, A. (2006, 14 August). "Couric to Revamp Newscast." *Broadcasting & Cable*, http://www.broadcastingcable.com/article/98387-Couric_To_Revamp_Newscast.php

Rosen, J. (2005, 5 December). "Why the Bloggers Matter if You Care about Democracy and the Press." Talk presented at The Annenberg School for Communication, University of Pennsylvania.

Rosenstiel, T. & Kovach, B. (2005, 2 October). "Media Anger Management." *Washington Post*, http://www.washingtonpost.com/wp-dyn/content/article/2005/10/01/AR2005100100928.html

Rubin, R.B. & McHugh, M.P. (1987). "Development of Parasocial Interaction Relationships." *Journal of Broadcasting and Electronic Media*, 31, pp. 279–292.

Rubin, A.M., Perse, E.M., & Powell, R.A. (1985). "Loneliness, Parasocial Interaction, and Local Television News Viewing." *Human Communication Research*, 12, pp. 155–180.

Ruggiero, T.E. (2004). "Paradigm Repair and Changing Journalistic Perceptions of the Internet as an Objective News Source." *Convergence: The International Journal of Research into New Media Technologies*, 10, pp. 92–106.

Rutherford, Paul. (n.d.) "Kirck, Harvey." The Museum of Broadcast Communications, http://www.museum.tv/archives/etv/K/htmlK/kirckharvey/kirckharvey.htm.

Saen, M. (n.d.). "Producer in Television." Museum of Broadcast Communications. http://www.museum.tv/archives/etv/P/htmlP/producerint/producerint.htm

Savitch, J. (1982). *Anchorwoman*. New York: G.P. Putnam's Sons.

Schmitt, E. (1996, 12 May). "Five Years Later, the Gulf War Story Is Still Being Told." *New York Times*, p. 41.

Schudson, M. (1978). *Discovering the News: A Social History of American Newspapers*. New York: Basic Books.

———. (1982, Fall). "The Politics of Narrative Form: The Emergence of News Conventions in Print and Television." *Daedalus*, pp. 97–112.

———. (1992). "The Limits of Teledemocracy." *The American Prospect*, 3(11), www.prospect.org.

———. (1995). "Why Conversation Is Not the Soul of Democracy." *Critical Studies in Mass Communication*, 14, pp. 297–309.

———. (2002). "What's Unusual about Covering Politics as Usual." In B. Zelizer & S. Allan (Eds.), *Journalism after September 11*. New York: Routledge, pp. 36–47.

Schumach, M. (1955, 12 June). "Eric Sevareid of CBS: Commentator Explains Considerations Involved in His Sunday Programs." *New York Times*, p. X9.

Schutt, R. K. (2001). *Investigating the Social World: The Process and Practice of Research*, Third Edition. Thousand Oaks, CA: Pine Forge Press.

Schwartz, T. (1980, 29 June). "TV View Cable News Network—In Search of an Identity." *New York Times*, Section 2, p. 27.

———. (1981, 11 March). "Cronkite Defends Taking Pan Am Post." *New York Times*, p. C25.

Sengupta, S. (1997). "The Connie Chung Phenomenon." *Media Studies Journal*, 7 (1 & 2, Winter/Spring), pp. 149–154.

Shafer, J. (2006, 21 February). "TV's Aryan Sisterhood: They Know Only One Hair Color: Blonder!" Slate.com.

Shales, T. (1983, 5 September). "All Hands on Deck for the New News; The Big Three Anchors Fly Solo, McNeil/Lehrer Expands and the Battle Heats Up." *Washington Post*, p.E1.

———. (2006, 6 September). "No News Not the Best News for Katie Couric's Debut." *Washington Post*, p. C01.

Shanley, J. (1958, 31 August). "Early Bird on TV." *New York Times*, p. X9.

Shaw, D. (2005, 17 April). "The Network Nnews Anchor Isn't Ready for Past Tense." *Los Angeles Times*, p. E-31.

Shelley, J. (1966, 28 September). "RTNDA and The Men Who Helped It Grow." RTNDA Annual Conference, Chicago. From RTNDA Newsroom Resources: http://members.rtnda.org/resources/speeches/shelley.shtml

Shepard, A.C. (1997, September). "Celebrity Journalists." *American Journalism Review*, Vol. 19, No. 7, pp. 26–32. Page numbers in citations correspond to online version.

———. (1995, June). "Take the Money and Talk." *American Journalism Review*, http://www.ajr.org/Article.asp?id=1611

Shuster, A. (1955, 27 May). "C.B.S. Head Urges TV Survey." *New York Times*, p. 45.

Sigal, L.V. (1973). "Reporters and Officials: The Organization and Politics of Newsmaking." In H. Tumber (Ed.), *News: A Reader*, 1999, Oxford: Oxford University Press, pp. 224–234.

Silverman, S. M. (2000, 27 November). "Katie Couric's Courtship," and "Katie Couric's New Life." *People.com*.

———. (2002, 7 February). "Nipped, Tucked and Talking." *People*.com.

———. (2003, 14 May). "Katie: America's Late-Night Sweetheart." *People.com*.

———. (2004, n.d.). "Dan Rather Apologizes." *People.com*.

Silverman, S. (2006, 2 April). "NBC's Campbell Brown Gets Married." *People.com*.

Simpson, B. (2002, 18 February). "Is She a 'Babe' Yet?" WorldNetDaily.com. http://www.worldnetdaily.com/news/article.asp?ARTICLE_ID=26505

Skillset.org (2003). "National Occupational Standards: Radio Production: R19 Produce Live Radio Broadcasts." http://www.skillset.org/uploads/pdf/asset_1080.pdf?1

Sklar, Z. (1975, 5 January). "Is It News? Is It Showbiz? It's 'A.M. America!'" *New York Times*, p. D1.

Smith, S.B. (1983, 6 August). "TV Newswoman's Suit Stirs a Debate on Values in Hiring." *New York Times*, p. 1.

———. (1983a, 11 August). "News vs. Entertainment: Kansas City Suit Raises the Sex Bias Issue and Questions of Show Business Influence." *New York Times*, p. C20.

Smolkin, R. (2006, August/September). "Hold that Obit." *American Journalism Review*.

Snyder, R.W. (2003). "American Journalism and the Culture of Celebrity." *Reviews in American History*, 31(3), pp. 440–448.

"Soledad O'Brien Gives Birth to Twins." (2004, 31 August). *USAToday.com*: http://www.usatoday.com/life/people/2004-08-31-soledad-twins_x.htm

Stahl, L. (1999). *Reporting Live*. New York: Touchstone.

Stanley, A. (2005, 25 April). "The TV Watch: 'Today' Seeks Yesterday's Glory." *New York Times*: http://www.nytimes.com/2005/04/25/arts/television/25watc.html

———. (2005, 22 November). "With Little Fanfare, an Anchor Says Goodbye." *New York Times*: http://www.nytimes.com/2005/11/22/arts/television/22watc.html

———. (2006, 6 April). "Amid Banter, Reminders of the Shoes to be Filled." *New York Times*: http://www.nytimes.com/2006/04/06/arts/television/06watch.html

———. (2006a, 22 June). "The Jolie Interview: The Humble Star and Eager Newsman." *New York Times*: http://www.nytimes.com/2006/06/22/arts/television/22watc.html

———. (2006b, 6 September). "The TV Watch; for the New Face of CBS News, a Subdued Beginning." *NewYorkTimes.com*: http://www.nytimes.com/2006/09/06/arts/television/06watch.html?ref=television

"Star Jones Says 'View' Partners Planned to Deceive Audience." (2006, 30 June). *Buffalo News*, p. C5.

Stecklow, S. (2009). Talk/Q&A with Pulitzer Prize winner Steve Stecklow. Hosted by the DC Penn Club. Annenberg Public Policy Center, Washington, DC, June 1, 2009. Quotes used directly or paraphrased in the book were elicited in-person by the author in questions asked directly to Mr. Stecklow at this event.

Steinberg, J. (2005, March 31). "Ted Koppel to Leave 'Nightline' and ABC News." *New York Times.com*: http://www.nytimes.com/2005/03/31/business/media/31cnd-koppel.html

———. (2005a, 8 August). "Peter Jennings, Urbane News Anchor, Dies at 67." *New York Times*: http://www.nytimes.com/2005/08/08/business/media/08jennings_obit.html

———. (2005b, 18 August). "CBS Moving to Find a New Look for News." *New York Times*: http://query.nytimes.com/gst/fullpage.html?res=980CE4DC133EF93BA2575BC0A9639C8B63

———. (2005c, 23 November). "War Zone 'It Girl' Has a Big Future at CBS News." *New York Times*: http://www.nytimes.com/2005/11/23/arts/television/23loga.html

———. (2005d, 28 February). "After Transition to Williams, NBC Still 1st in Ratings." *New York Times*, p. C1.

———. (2006, 15 March). "Mike Wallace Says He Will Retire from '60 Minutes' in Spring." *New York Times*: http://www.nytimes.com/2006/03/15/business/media/15mike.html

———. (2006a, 1 May). "A Deal among Friends Brought Rosie O'Donnell to 'The View.'" *New York Times*: http://www.nytimes.com/2006/05/01/arts/television/01view.html

———. (2006b, 24 May). "ABC Rejects Dual Anchors in Second Shuffle." *New York Times*: http://www.nytimes.com/2006/05/24/business/media/24anchor.html

———. (2006c, 21 June). "Rather Leaves CBS." *New York Times*: http://www.nytimes.com/2006/06/21/business/media/21rather.html

———. (2006d, 4 August). "Arts Briefly; Anchor Leaves CNN to Start Web Site." *New York Times*: http://query.nytimes.com/gst/fullpage.html?res=9B07E4DD113FF937A3575BC0A9609C8B63

———. (2006e, 20 August). "CBS Is All Katie, but Rivals Aren't Standing by." *New York Times*: http://www.nytimes.com/2006/08/20/us/20evening.html

———. (2006f, 9 November). "Ed Bradley, Veteran CBS Newsman, Dies." *New York Times*: http://www.nytimes.com/2006/11/09/business/media/10bradleycnd.html

———. (2007, 3 January). "Sawyer Signals Commitment to Morning Show." *New York Times*: http://www.nytimes.com/2007/01/03/arts/television/03sawy.html

———. (2007b, 18 January). "Not a Front-Runner, but Moving Ahead in Polls." *New York Times*: http://www.nytimes.com/2007/01/18/arts/television/18abc.html

———. (2009, 19 August). "Don Hewitt, Creator of '60 Minutes,' Dies at 86." *New York Times*: http://www.nytimes.com/2009/08/20/business/media/20hewitt.html

Steinberg, J. & Carter, B. (2006, 18 October). "As Couric Stays in Third, CBS Stresses the Positive." *New York Times*, p. E1.

Steinmetz, J. (1975, 12 October). "'Mr. Magic'—The TV Newscast Doctor." *New York Times*, p. 153.
Stengren, B. (1955, 17 April). "Unseen Man Behind 'See It Now.'" *New York Times*, p. X15.
Stone, V. A. (2001). "Minorities and Women in Television News." [Electronic version]. http://www.missouri.edu/~jourvs/tvfnds.html
Studio Briefing (2006, 24 April). "State Department—Too Boring for TV?"
Sullivan, P. (2006, 29 January). "'60 Minutes' Director Arthur Bloom, 63." *The Washington Post*, p. C11.
Swarns, R. (2006, 15 February). "Dobbs's Outspokenness Draws Fans and Fire." *New York Times*, p. E4.
Swartz, M. (1995, September). "Catherine Crier: A Role Model for Women in the Media." *Texas Monthly*, vol. 23, no. 9, pp.110–113.
Talbot, S. (2007, 27 February). "News War: What's Happening to the News." PBS Frontline. http://www.pbs.org/wgbh/pages/frontline/newswar/view/
"Television Criticism (Journalistic)." The Museum of Broadcast Communications. http://www.museum.tv/archives/etv/T/htmlT/televisioncr/televisioncr.htm
Thomas, K. (2006, 6 July) "'The View' from Here on Out: Who Will It Be?; Guest Co-hosts Are Lining Up." *USA Today*, p. 3D
Traister, R. (2004, 18 March) "The Cruella Syndrome." Salon.com. http://dir.salon.com/story/mwt/feature/2004/03/18/katie_couric/index.html
Trimboli, A. & Walker, M.B. (1987, Fall). "Nonverbal Dominance in the Communication of Affect: A Myth?" *Journal of Nonverbal Behavior*, 11(3), pp.180–190.
Tuchman, G. (1972, January). "Objectivity as Strategic Ritual." *American Journal of Sociology*, 77, pp. 660–679.
———. (1978). *Making News*. New York: Free Press.
Tunstall, J. (1971). *Journalists at Work; Specialist Correspondents: Their News Organizations, News Sources, and Competitor-Colleagues.* Beverly Hills, CA: Sage Publications.
Turner, G. (2004). *Understanding Celebrity*. Thousand Oaks, CA: Sage.
Turow, J. (1984). *Media Industries: The Production of News and Entertainment.* New York: Longman.
Tyndall, A. (2004, 29 November). "The Mobile Anchor." *Broadcasting & Cable*, Vol. 134, Issue. 48, p. 20.
———. (2005, 28 March). "CBS' Newly Arrived Evening News Anchor Breaks Rank." *Broadcasting & Cable*. http://www.broadcastingcable.com/article/156599-CBS_Newly_Arrived_Evening_News_Anchor_Breaks_Rank.php
Ugland, E. & Henderson, J. (2007). "Who Is a Journalist and Why Does It Matter? Disentangling the Legal and Ethical Arguments." *Journal of Mass Media Ethics*, 22, pp. 241–261.
Underwood, D. & Stamm, K. (2001, Winter). "Are Journalists Really Irreligious? A Multidimensional Analysis." *Journalism & Mass Communication Quarterly*, Vol. 78, Issue 4, p. 771 (16).
Ursell, G.D.M. (2001). "Dumbing Down or Shaping Up? New Technologies, New Media, New Journalism." *Journalism*, 2(2), pp. 175–196.

USC/Annenberg (2002) http://www.aaja.org.html/news-html.
Valenti, J. (1984, 10 July). "The Scourge of Teleprompters." *New York Times,* p. A23.
Vanacore, A.H. (2006, June/July). "Nightly News Obituaries." *American Journalism Review.* http://www.ajr.org/article.asp?id=4156.
Van de Ven, A.H. & Rogers, E.M. (1988, October). "Innovations and Organizations: Critical Perspectives." *Communication Research,* Vol. 15, No. 5, pp. 632–651.
Walden, C. (2008, 7 February). "Natasha Kaplinsky: I Look OK on Screen, but I'm No Autocutie." Telegraph.co.uk. http://www.telegraph.co.uk/news/features/3635556/Natasha-Kaplinsky-I-look-OK-on-screen-but-Im-no-autocutie.html
Walker, J. (1949, 12 March). "148 Man-hours Produce 15 Minutes of TV News." *Editor and Publisher,* p. 50.
Walker, M.B. & Trimboli, A. (1989). "Communicating Affect: The Role of Verbal and Nonverbal Content." *Journal of Language & Social Psychology,* 8 (3–4), pp. 229–248.
Walsh, M.A. (1996, 9 March). "Television's Women." *America,* vol. 174, no. 8, pp. 4–6.
Waters, L. (1999, 29 January) "Woman News Anchor Discriminated for Gender, Age Discusses $8.3 Million Victory." CNN Today. CNN Transcripts.
Weaver, D. & Wilhoit, G. (1986). *The American Journalist: A Portrait of U.S. News People and Their Work.* Bloomington: Indiana University Press.
Weber, M. (1947). *The Theory of Social and Economic Organization.* New York: Free Press.
Westin, D. (2005, March/April). "The Truth about TV News; When Opinion Dominates, Everything Becomes Opinion." *Columbia Journalism Review,* p. 8.
"What Color Is Diane Sawyer's Lipstick: Inquiring GMA Viewers Get Sneak Peek into Hosts' Dressing Rooms." (2006, 5 February). ABC News.com: http://abcnews.go.com/GMA/WaterCooler/story?id=124592&page=1
"Where Have All the Anchors Gone? Longtime TV News Stars Bowing Out." (2005, 4 April). The Associated Press.
White, D.M. (1950). 'The "Gatekeeper": A Case Study in the Selection of News." *Journalism Quarterly,* Vol. 27, No.1, pp. 383–90.
"Who Do Celebrities Love Most? Themselves." (2006, 7 September). The Associated Press, accessed on CNN.com: http://www.cnn.com/2006/SHOWBIZ/Movies/09/06/celebrity.narcissism.ap/index.html
Williams, B. (2006, 4 January). "The Day After." The Daily Nightly, MSNBC.com. http://dailynightly.msnbc.com/2006/01/the_day_after.html
Winston, B. (1993). "The CBS Evening News, 7 April 1949: Creating an Ineffable Television Form." In Glasgow University Media Group, J. Eldrige (Ed.), *Getting the Message: News, Truth and Power.* London and New York: Routledge. pp. 181–209.
Wolf, B. (2005, 20 September). "Would America Miss Miss America?: Pageants Shaped the Lives of Oprah and Other Prominent Women but Have Fallen on Troubled Times." ABCNews.com: http://abcnews.go.com/Entertainment/WolfFiles/story?id=1162837.
Wutkowski, K. (2006, 12 May). "SEC's 'Katie Couric' Clause Draws Fire as Studios Seek to Keep Stars' Salaries Private." http://www.usatoday.com/money/media/2006-05-12-hollywood-pay_x.htm
Yellin, T. & McGrady, P. (2005) "Peter Jennings: Reporter." ABC News video.

Yoakam, R.D. (1993). Television News Anchors: An Anthology of Profiles of the Major Figures and Issues in United States Network Reporting. (book review) *Journalism Quarterly*, Winter, v.70, no.4, p. 994(2).

YouTube. (2009, 12 January). YouTube Forum on "Broadcasting the World: The New Ecosystem for News Online." Google offices, Washington, DC.

Zelizer, B. (1989). "What's Rather Public about Dan Rather: TV Journalism and the Emergence of Celebrity." *Journal of Popular Film and Television*, Summer, pp. 74–80.

———. (1990). "Where Is the Author in American TV News? On the Construction and Presentation of Proximity, Authorship and Journalistic Authority." *Semiotica*, 80 (1–2), pp. 37–48.

———. (1992). *Covering the Body: The Kennedy Assassination, the Media, and the Shaping of Collective Memory*. Chicago: The University of Chicago Press.

———. (1992a). "CNN, the Gulf War, and Journalistic Practice." *Journal of Communication*, 42(1) Winter, pp. 66–81. In H. Tumber (Ed.), *News: A Reader*. Oxford: Oxford University Press, 1999, pp. 340–354.

———. (1993). "Has Communication Explained Journalism?" *Journal of Communication*, 43(4), pp. 80–88.

———. (1993a). "Journalists as Interpretive Communities." *Critical Studies in Mass Communication*, 10, pp. 219–237.

———. (1993b). "American Journalists and the Death of Lee Harvey Oswald: Narratives of Self-Legitimation." In D.K. Mumby (Ed.), *Narrative and Social Control: Critical Perspectives*. Sage Annual Reviews of Communication Research, Vol. 21, pp. 189–206. Newbury Park, CA: Sage Publications.

———. (1994). "The Making of a Journalistic Celebrity, 1963." In R. Cathcart & S. Drucker (Eds.), *American Heroes in a Media Age*. Cresskill, NJ: Hampton Press, pp. 97–110.

———. (1997, 17 February). "Journalism in the Mirror." *The Nation*, p.10.

———. (2004). *Taking Journalism Seriously*. Thousand Oaks, CA: Sage.

Zengerle, J. (2005, 14 March). "Presumed Guilty: Trial by Fury." *The New Republic Online*. http://www.tnr.com/doc.mhtml?i=20050314&s=zengerle031405

Zillmann, D. & Bryant, J. (1985). *Selective Exposure to Communication*. Hillsdale, NJ: Erlbaum.

Zoglin, R. (2004, 6 December). "Ten Questions for Tom Brokaw." *Time Magazine*, p. 8.

Index

A

Abrams, Dan, 90, 131
ABC, 1, 31, 35, 36, 38, 44, 52, 53, 56, 58, 60, 62, 64, 65, 78, 85, 89, 99, 101, 107, 133, 135, 142, 149, 153, 154, 161, 162, 164, 165
 ABC News, 46, 78, 93, 100, 109, 110, 116, 122, 129, 132, 164, 177
 ABC Radio, 114
 ABC World News Tonight, 1, 44, 62, 64, 100, 131, 134, 137
Amanpour, Christiane, 39, 75, 107
Anchorman, 26, 30, 71, 97, 135
Arnett, Peter, 39, 159, 160

B

Banfield, Ashleigh, 61, 74
Bartiromo, Maria, 151
Blair, Jayson, 121, 157
Blitzer, Wolf, 39, 131, 135, 163
Blog (blogging, bloggers), 44, 45, 87, 92, 170, 171, 173, 179
Bloom, David, 110, 111
Bradley, Ed, 39, 152, 177
Brinkley, David, 31, 51, 52, 57, 63, 70, 71, 76, 96, 100, 111, 142, 153, 154, 163
Brokaw, Tom, 1, 28, 30, 38, 39, 44, 45, 46, 71, 74, 77, 78, 85, 93, 97, 99, 111, 122, 143, 152, 165, 178
Brown, Aaron, 2, 74, 78, 88

C

Camel News Caravan, 17

CBS, 1, 15, 16, 17, 19, 2830, 32, 33, 35, 37, 57, 59, 61, 62, 64, 70, 71, 73, 76, 77, 78, 97, 101, 121, 125, 129, 132, 133, 151, 153, 154, 155, 156, 160, 162, 167, 168, 175, 177
 CBS Early Show, 74, 99
 CBS Evening News, 1, 22, 26, 38, 44, 78, 93, 99, 103, 134, 144, 156, 160, 176
 60 Minutes, 2, 33, 34, 40, 56, 92, 109, 110, 121, 134, 136, 160, 175, 177
 See it Now, 22, 70, 148
Chancellor, John, 51, 52, 71, 110
Chung, Connie, 35, 39, 63, 70, 99, 137, 142
Citizen journalism, citizen media, 42, 171, 173
CNBC, 40, 151
CNN, 2, 19, 28, 38, 39, 43, 47, 51, 58, 59, 61, 77, 78, 85, 89, 96, 106, 107, 110, 111, 114, 115, 118, 131, 133, 135, 151, 153, 155, 159, 160, 165, 167, 174, 177
 Headline News, 47, 58, 90, 177
 iReport.com, 175
 Larry King Live, 152
 Reliable Sources, 118, 159
Colbert Report, The. 42, 79
Collingswood, Charles, 62
Consultants, news, 35, 53, 54, 55, 72, 113, 126
Cooke, Janet. 64, 121, 157
Cooper, Anderson, 2, 78, 79, 88, 89, 106

Couric, Katie, 1, 2, 26, 27, 28, 41, 44, 58, 59, 60, 61, 66, 70, 74, 77, 78, 93, 96, 98, 101, 103, 106, 113, 132, 143, 144, 150, 152, 154, 165, 167, 168, 176, 177
 "Katie Couric clause", 144
 "Couric effect", 150
Court TV, 55, 61, 89, 90, 131
Craft, Christine, 56, 57
Crier, Catherine, 55
Cronkite, Walter, 19, 26, 30, 31, 32, 33, 34, 37, 38, 44, 51, 52, 53, 57, 62, 70, 71, 85, 91, 93, 97, 106, 121, 135, 149, 150, 153, 155, 156, 177, 178
Cultural authority, journalistic, 11, 22, 49, 94, 101, 108, 109, 110, 111, 114, 115, 117, 152, 172
Curry, Ann, 74, 100, 150

D

Daily Show with Jon Stewart, 42
Dateline, 34, 55, 158, 159, 160, 166
Discrimination, 54, 56, 57, 62, 65
Dobbs, Lou, 114, 115, 177

E

Edwards, Douglas, 17, 18, 25
Ellerbee, Linda, 154
Equal Opportunity Act, 35

F

Fee speeches, 163, 164, 165, 166
Financial compensation, 57, 95, 141, 152, 169
Fox News, 40, 43, 47, 61, 69, 107, 113, 115, 116, 126, 128, 132, 159
Friendly, Fred, 22, 70, 71

G

Garroway, Dave, 30, 70

Gatekeeping, 14
George, Phyllis, 58
Gibson, Charles, 1, 44, 78, 100, 101, 103, 136, 177
Goldberg, Bernard, 155, 162
Good Morning America, 30, 44, 60, 78, 100, 101, 154, 177
Goode, Mal, 64
Gould, Jack, 18, 20, 76, 117, 148
Grace, Nancy, 89, 90, 91
Greenfield, Jeff, 165
Gulf War, 39, 96, 111, 159
Gumbel, Bryant, 98, 99, 143, 154

H

Happy talk, 72, 113, 129
Harris, Leon, 19
Hart, Mary, 58
Hewitt, Don, 19, 30, 33, 40, 55, 177
Hume, Brit, 116, 132, 163
Hurricane Katrina, coverage of; reporting on, 88, 89
Huntley, Chet, 31, 52, 70, 71, 76, 82, 100, 142, 154

I

Interpretive community, journalists as, 5, 6, 7, 9, 10, 14, 52, 119, 170, 171

J

Jennings, Peter, 1, 28, 31, 38, 39, 53, 62, 64, 70, 71, 75, 86, 97, 101, 109, 110, 111, 113, 122, 134, 135, 143, 152, 161, 165, 178

K

Kagan, Daryn, 166, 167
Kaplinsky, Natasha, 112, 113
Kennedy assassination, 8, 31, 34, 85
Kennedy-Nixon debate, 19

Index

Killed-in-Action (KIA) journalist, 110
King, John, 174
Koppel, Ted, 1, 82, 100, 108, 114, 115, 118, 127, 143, 152, 155, 156, 165, 177
Kuralt, Charles, 52, 154
Kurtz, Howard, 116, 118, 133

L

Late Show with David Letterman, 73, 85
Lauer, Matt, 78, 100, 152
Lehrer, Jim, 33, 165
Logan, Lara, 58
Lunden, Joan, 151, 154

M

Maddow, Rachel, 91, 179
Magid Associates, Frank N., 53, 72
McCarthy, Senator Joseph, 31
"Memogate" scandal, CBS, 111, 156, 160
Mickelson, Sig, 30
Mitchell, Andrea, 31, 39, 40, 82, 87, 107, 118, 123, 129, 130, 131, 137, 156, 163, 166
Moonves, Les, 28, 78
MSNBC, 40, 43, 47, 61, 90, 91, 115, 131, 166, 179
Mudd, Roger, 39, 45, 46, 71, 99
Multimedia journalist, 176
Murrow, Edward R., 15, 16, 17, 22, 30, 31, 51, 69, 70, 77, 148, 162

N

National Association of Broadcasters (NAB), 29, 30, 119
NBC, 17, 26, 28, 30, 31, 38, 41, 44, 56, 60, 64, 70, 71, 76, 77, 78, 85, 91, 92, 93, 100, 107, 110, 116, 118, 129, 130, 131, 133, 137, 142, 143, 144, 153, 154, 158, 164, 166, 177
NBC Nightly News, 1, 44, 93, 99

New York Times, 2, 18, 19, 20, 37, 42, 53, 67, 70, 71, 76, 100, 114, 117, 118, 123, 125, 148, 155, 164, 175, 177
Newman, Edwin, 51, 52
Newsreel, 17
News aggregators, 42
Nielsen ratings, 53, 56
Nightline, 1, 34, 100, 114, 132, 155
Norville, Deborah, 57, 154

O

Objectivity; objective model of journalism, 14, 16, 18, 56, 80, 81, 82, 85, 92, 94, 106, 147, 148, 149. 150, 160, 175
O'Dell, Nancy, 58
"Operation Tailwind" story, CNN, 159, 160
O'Reilly, Bill, 115
Osgood, Charles, 154, 155

P

Paradigm repair, 11, 147, 148, 157, 158, 160
Parasocial relationship, 20, 52, 68
Pauley, Jane, 30, 57, 158, 159, 160, 177
Peckinpaugh, Janet, 56, 57
PBS, 33, 109, 153, 159, 173, 177
The Newshour with Jim Lehrer, 26
Phillips, Stone, 55, 79, 168, 159, 160
Producer, television, 16, 21, 22, 25, 26, 27, 28, 29, 30, 41, 45, 46, 47, 55, 68, 70, 74, 99, 120, 121, 130, 138, 139, 158, 159, 160, 167, 175, 179
Project for Excellence in Journalism (PEJ), 5, 119

Q

Q Scores, 71

R

Radio-Television News Directors Association (RTNDA), 29, 119, 162
Rather, Dan, 1, 19, 21, 28, 31, 32, 37, 38, 39, 45, 46, 52, 57, 62, 66, 71, 72, 73, 74, 75, 76, 77, 78, 85, 93, 99, 106, 111, 121, 122, 132, 134, 143, 151, 152, 156, 160, 162, 165, 177, 178
"Ratherisms", 73
Reasoner, Harry, 36, 51, 52, 57, 99
Reed, Dorothy, 64
Reynolds, Frank, 39, 64, 85, 97, 161, 162
Reynolds, Star Jones, 99, 100
Ripa, Kelly, 107
Rivera, Geraldo, 75, 89, 104, 106, 149, 150, 151
Roberts, Robin, 60, 89
Robinson, Max, 39, 64, 70, 131, 161, 162
Roker, Al, 63, 99, 100
Rose, Charlie, 177
Rosen, James, 126, 127, 128, 140
Rosenstiel, Tom (and Bill Kovach), 89, 90
Russert, Tim, 116, 177

S

Savitch, Jessica, 55, 56, 58
Sawyer, Diane, 39, 56, 58, 60, 67, 75, 96, 100, 142, 152, 177
Schieffer, Bob, 1, 36, 39, 76, 77, 78, 97, 118, 132, 156, 165, 177
Schudson, Michael, 7, 13, 86, 89, 90
Scott, Willard, 154
September 11, 2001, 73, 85, 86, 87, 168
Sevareid, Eric, 15, 18, 19, 51, 97
Shaw, Bernard, 35, 39, 110, 151
Shriver, Maria, 166
Society for Professional Journalists (SPJ), 14, 35, 119
Stahl, Lesley, 35, 39, 55, 56, 57, 85, 118, 125, 126, 156

State Department correspondent; beat, 133
Stephanopoulos, George, 116, 178
Sullivan, Kathleen, 154
Swayze, John Cameron, 17, 18, 154

T

TelePrompter, 18, 36, 37, 59, 135
Thompson, Andrea, 58
Today Show, 1, 27, 28, 30, 35, 41, 42, 44, 57, 60, 63, 70, 74, 77, 92, 93, 98, 133, 177
Tolliver, Melba, 64
Tonight Show with Jay Leno, 151

U

Unavision, 65

V

Van Susteren, Greta, 61, 75, 113, 131
Vargas, Elizabeth, 1, 65, 100, 101, 136
Vieira, Meredith, 44, 74, 75, 76, 78, 100, 136
Vietnam War, 31, 32, 34, 68, 96, 135149, 150, 159
View, The, 44, 75, 78, 93, 99, 100

W

Walker, Bree, 62, 77, 167
Wall Street Journal, 107, 118, 123, 162, 164, 165, 173
Wallace, Mike, 2, 21, 51, 57, 75, 97, 110, 143
Walters, Barbara, 30, 35, 44, 57, 70, 97, 99, 105, 106, 142, 143, 152, 177
Washington Post, The, 64, 101, 118, 123, 125, 127, 141, 156, 164, 165, 174, 175
Watergate, 32, 33, 68, 103, 128, 156, 160
Westin, David, 100, 112

White House correspondent, 125, 126, 131, 132, 133, 135
Williams, Brian, 1, 78, 92, 115, 133, 136
Williams, Mary Alice, 151, 153
Winfrey, Oprah, 44, 58
Woodruff, Bob, 1, 100, 101, 134, 135
Woodward, Bob, 156
World War II, 15, 16

Z

Zahn, Paula, 58, 59, 75, 150, 151
Zelizer, Barbie, 5, 6, 7, 8, 21, 31, 104, 108, 172, 178

Kimberly Meltzer is a Visiting Assistant Professor at Georgetown University in the graduate program in Communication, Culture & Technology. She earned her Ph.D. and M.A. from The Annenberg School for Communication at the University of Pennsylvania. Prior to her academic career, Dr. Meltzer worked for news organizations including CNN and NBC.